44 DAYS

FOR OLIVIER REBBOT

44

IRAN AND THE REMAKING OF THE WORLD

DAVID BURNETT

EDITED BY ROBERT PLEDGE & JACQUES MENASCHE

DAYS

FOCAL POINT

NATIONAL GEOGRAPHIC
WASHINGTON, D.C.

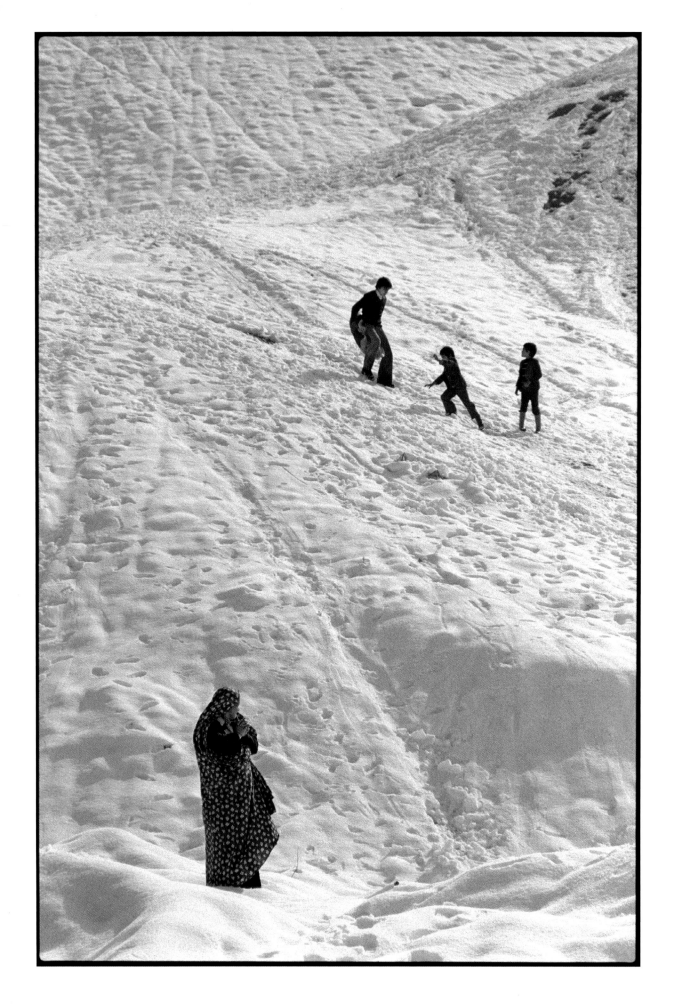

CONTENTS

FOREWORD . . . 8
CHRISTIANE AMANPOUR

INTRODUCTION . . . 10
JOHN KIFNER

PART ONE . . . 20
THE KING'S LAST DAYS
DECEMBER 26,1978 – JANUARY 16,1979

PART TWO . . . 100
AFTER THE FALL
JANUARY 16,1979 – JANUARY 31,1979

PART THREE . . . 174
THE NEW ORDER
FEBRUARY 1,1979 – FEBRUARY 7,1979

EPILOGUE . . . 211
THE U.S. EMBASSY ATTACK

AFTERWORD BY DAVID BURNETT . . . 218
CONTRIBUTOR BIOGRAPHIES . . . 222
ACKNOWLEDGMENTS . . . 223

Foothills of the Elburz Mountains. Northern outskirts of Tehran, January 1979

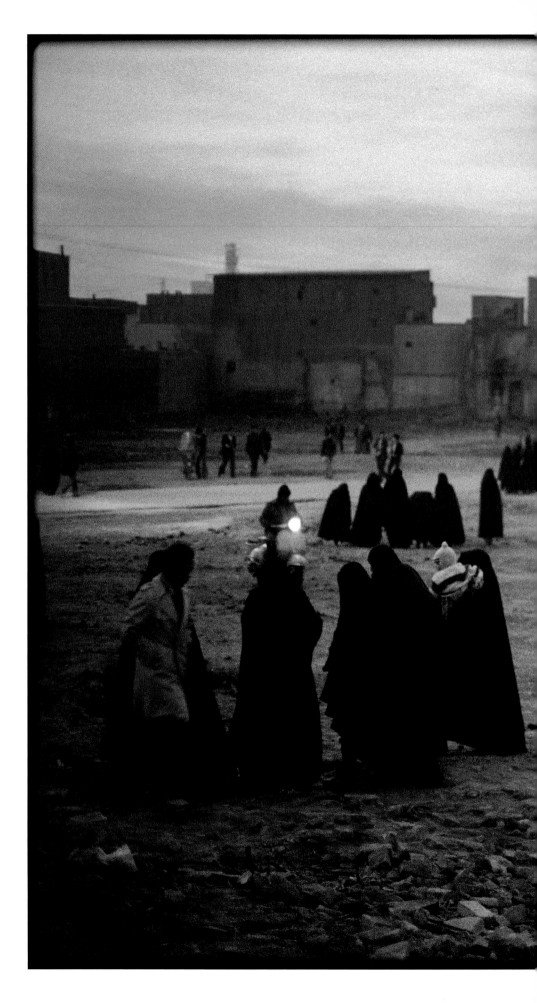

The Sepahsalar mosque. Tehran, January 1979

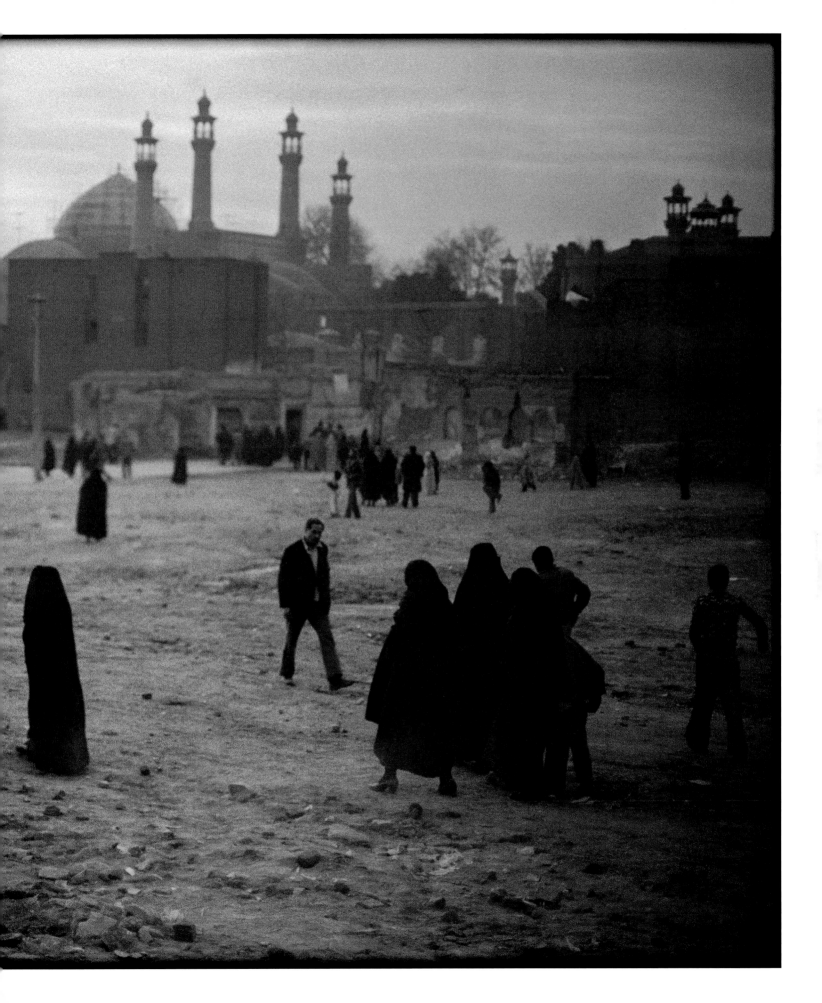

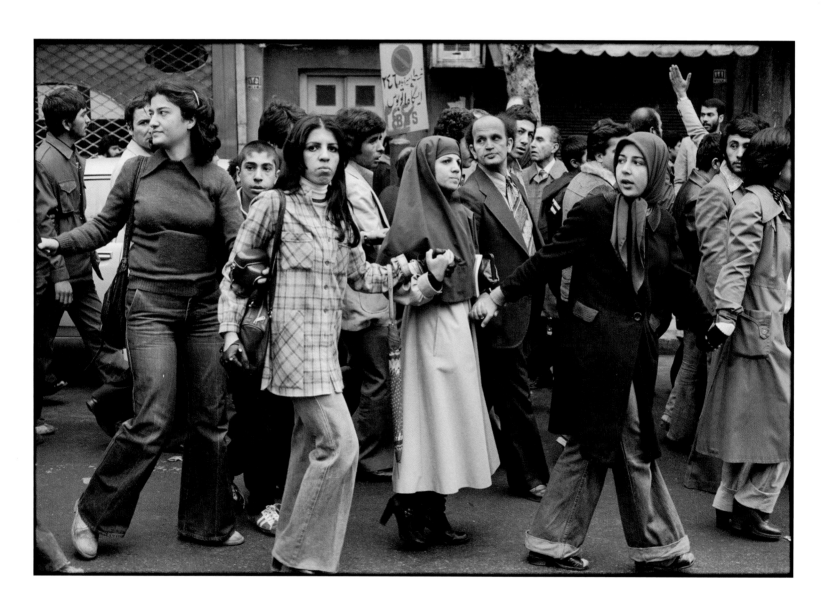

Anti-shah demonstrators. Tehran, December 1978

FOREWORD In the summer of 1978, revolution was rumbling across my country, Iran. Sitting in the living room of our family home in Tehran, my father stared out of the window into the beyond, and said to me "it's all over, nothing will be the same again." I did not know exactly what he meant, but I knew I was afraid. I was 20 years old, but it was my political awakening. I had suddenly become an adult in a turbulent world, after a calm and privileged childhood growing up in the shah's Iran, where we did not do politics.

I remember the fire that August at the Rex Cinema in Abadan. So many people trapped inside were killed, burnt to death in their seats. The revolutionaries and the royalists blamed each other.

I remember Black Friday in September, when a protest at Tehran's Jaleh Square turned deadly.

I remember martial law and not being allowed out of the house after 9 p.m. Once I was, and came face to face with soldiers on our sidewalk, their rifles and bayonets drawn.

I remember sitting with my parents and sisters on our porch, listening to the sounds from the nearby mosque at prayer time. Ayatollah Khomeini's voice, on secretly smuggled audiotapes, rang low and determined through our neighborhood.

He was still in exile in France.

What would happen when he returned? To our country? To us?

The rest, of course, is history. David Burnett's magnificent photographic record of the revolution reminds us, 30 years later, of what my father told me: that nothing would be the same again. The first modern Islamic revolution has since inspired millions around the world. It has antagonized millions of others. Thirty years after the Islamic Republic of Iran took American diplomats hostage for 444 days, relations between Iran and the U.S. remain ruptured. Today, the need to repair that relationship has never been greater.

As for myself, the Islamic revolution at home catapulted me into journalism, because of pictures like David's. Even as I was living it personally, I knew then and there that I wanted to be in the middle of these seismic global events, but as a witness, as a storyteller, as a reporter who would tell the world the truth.

CHRISTIANE AMANPOUR
CNN, Chief International Correspondent

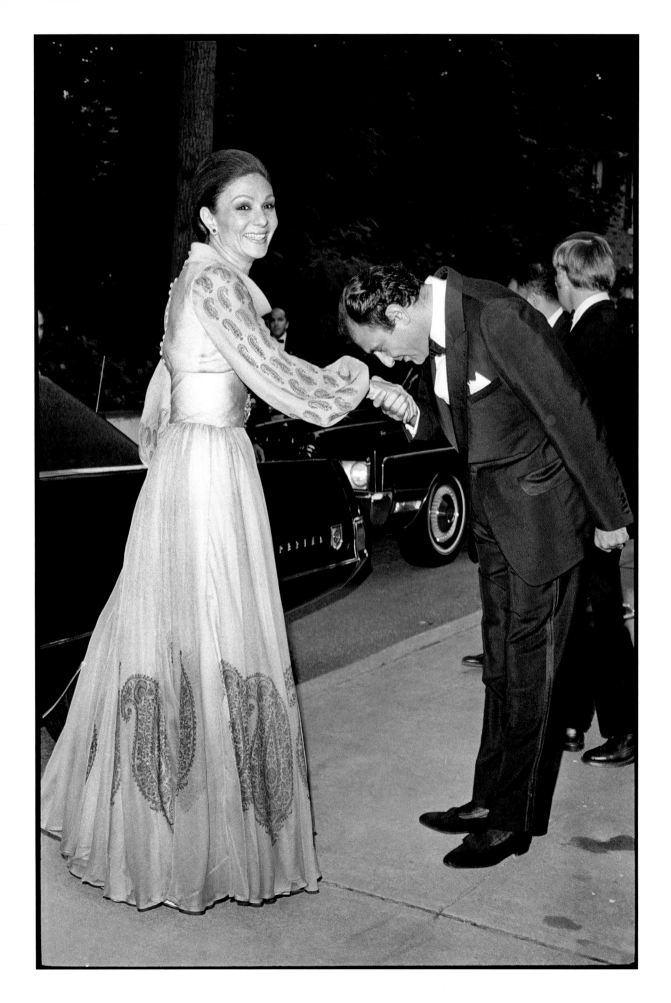

INTRODUCTION Everything changed.

For years, decades, America had depended on Mohammad Reza Pahlavi—Shah of Shahs, King of Kings, Light of the Aryans—as its best friend in the Middle East, policeman of the Gulf and, not least, guarantor and provider of much of the world's oil supply. Indeed, so much so that when he was briefly overthrown in 1953, the Central Intelligence Agency blandly organized a plot—using street demonstrations led by hired strongmen from local gyms—to restore him to the Peacock Throne.

But on February 1, 1979, a bearded old holy man only a tiny handful of Americans had ever heard of—Ayatollah Ruhollah Khomeini—who had literally been phoning in his tirades from a Paris suburb, stepped off a plane to a rapturous greeting by some two million people. Two weeks before, the shah had slunk off for what no one believed was a short vacation, carrying with him a jar of Persian soil and a small dog the Iranians loved to portray in their revolutionary posters, using the motifs of traditional miniatures, for to Muslims dogs are unclean. It was a new phenomenon—the beginning of the Islamic Republic.

As David Burnett's remarkable photographs show, there are two narratives at work here. The first is the toppling of the shah after 37 years of absolute and frequently cruel rule in a mounting set of increasingly bloody street protests that were met with gunfire from soldiers and even helicopter gunships. The second is the struggle over the revolution itself between purely religious and more secular elements resulting in the consolidation of power by Ayatollah Khomeini and his fellow clerics. Burnett pictures the shah at the height of his power, the massive, passionate crowds that opposed him, and Khomeini beginning his seizure of control.

It is almost impossible to overestimate the extent to which the shah was hated in Iran and the national emotion that led to his overthrow. Although regarded by successive American presidents as a modernizer and a bulwark against communism, the shah and his circle were viewed by most Iranians with the revulsion reflected in the Persian poet Reza Barahani's book *The Crowned Cannibals*. The shah's agricultural "reform" bankrupted small farmers, leaving them in shantytowns on the edges of cities; his industrialization benefited only a handful of Iranians and, above all, foreign companies; his attempts at westernization broke down the old values but replaced them with little. The shah—draped in a gold-braided uniform and unearned arrogance—and his entourage were notoriously corrupt and ostentatiously decadent, and behind it all was the shadow of the secret police, the SAVAK, with its network of

Empress Farah Diba is greeted by Iran's ambassador to the U.S., Ardeshir Zahedi. Washington, D.C., July 25, 1973

informers and hideous torture apparatuses. Burnett finds one of these creepy torture installations with Iranian families visiting it in that bizarre revolutionary period "as if they were visiting an art gallery on a leisurely Sunday."

And it is almost impossible to overestimate the extent to which the revolution was viewed as a dual victory—a victory not only over the shah, but over the United States. For it was America, in the Iranian view, that supported and propped up the shah, that took the oil, that profited from the enormous sales of arms, and that created and trained the SAVAK. The shah, in the Iranian view, was a creature of the United States.

A key issue was called "capitulation," an agreement the shah had made with the United States that Iranian courts would have no jurisdiction over American military and civilian advisers. (The same issue is at the heart of disagreements between the American military and the fledgling Iraqi authorities in negotiations over America's role there.) At one point there were at least 1,200 American military advisers and 8,000 civilian contractors. From his exile in Iraq, where he soon attracted dissident pilgrims, Ayatollah Khomeini thundered, "You have extirpated the very roots of our independence."

The American role was evident in Isfahan, perhaps the most beautiful of Iranian cities, just after the revolution, where the blue-tiled Mosque of the King, built by Shah Abbas I in the early 17th century, sits by a long mall and a traditional bazaar where black-robed women buy frankincense and myrrh. It had become a company town, the company being Bell Helicopter. Row upon row, acre after acre of Cobra gunships squatting like camouflage-painted dragonflies stretched as far as the eye could see along the flat plain. On the outskirts of town, a small city was being built to house the Americans, along a rare divided highway decorated with a statue of a soaring eagle, a piece of American Air Force iconography. The expenditure on American military equipment was immense, from a quarter to a third of the official national budget—nearly $8 billion in the year before the revolution—with other items tucked away. The accompanying corruption was in proportion.

"If you knew the amount of money they were wasting, it would bring tears to your eyes," an Iranian army officer, echoing complaints from helicopter pilots, told me at the time.

The Americans were not unaware that bribery was part of the deal. A 1977 Pentagon study said, "The past conduct of U.S. corporations seeking multimillion-dollar contracts indicates that the stakes are so high and the temptation so great that they will continue in the future to pay agents funds which can be shared by Iranian officials."

But beyond revulsion over brutality and corruption, the Iranian revolution had a very distinct character—that of Shiite Islam.

This was difficult for outsiders to grasp. As protests mounted in the fall of 1978, the Tehran-based correspondent of the *Financial Times*, Robert Graham, published a book titled

The Illusion of Power, an extraordinarily detailed searing indictment of the shah's regime. In it, Ayatollah Khomeini merited just two paragraphs in 228 pages, describing how he was sent into exile in 1963 after denouncing the shah's "White Revolution"—a supposed plan for modernization and land reform that consolidated more power in the monarchy. He did not mention that the ayatollah's initial arrest sparked rioting in Qom and other cities in which hundreds of people were killed, some hurled from rooftops by the army. This is not meant as a criticism of probably the most thorough and hard-working correspondent at the time, but as a prime example of how hard it was for Westerners then to grasp the power of Shiite Islam. (He did put more emphasis on religion in later writings.) Indeed, one of the difficulties for reporters and diplomats was the tremendous class division in Iranian society, meaning that almost anybody you could talk to, by virtue of being westernized, was completely unrepresentative. Everybody hates the mullahs, they would assure you, while clearly millions didn't.

As the ayatollah was flying to Tehran, so was I, on the first Iran Air flight out of New York after a nationwide strike of just about everything that had finally ousted the hated shah. As the engines warmed up at Kennedy Airport, the passengers, many of them newly bearded students—Iranians made up one of the largest foreign student groups in America—broke into a chant of prayer for the welfare of the Prophet Muhammad and his family.

Sitting next to me was a stocky, well-educated oil engineer who had been stranded while taking an advanced technical course in Texas. In excellent English, he talked rapidly of how the Iranians would control their own oil, would be their own people, their own nation, free of foreign powers. The students gathered around to listen.

"The first thing we need is complete educational reform," he said. "What is going on now is terrible."

What is to be done? I asked.

"This is just awful," he went on angrily. "These young men come into the classrooms, and all around them are girls with their heads uncovered and even their arms in short sleeves."

Around us, the students were nodding in agreement. Clearly, I thought, not for the last time, something different is afoot here.

Packing, I had thrown into my rucksack, along with newly purchased works on Iran and Islam, an old favorite from college, *The Anatomy of Revolution,* by the historian Crane Brinton, first published in 1938, much to the amusement of some of my new colleagues. Comparing the American, French, and Russian revolutions along with the Cromwellian movement in England he describes successive stages in which the initial moderate leaders are proven inept and become marginalized, leading to a "reign of virtue and terror." But it turned out to be uncannily prescient. The final stage was a war with a rival power. Saddam Hussein would take care of that.

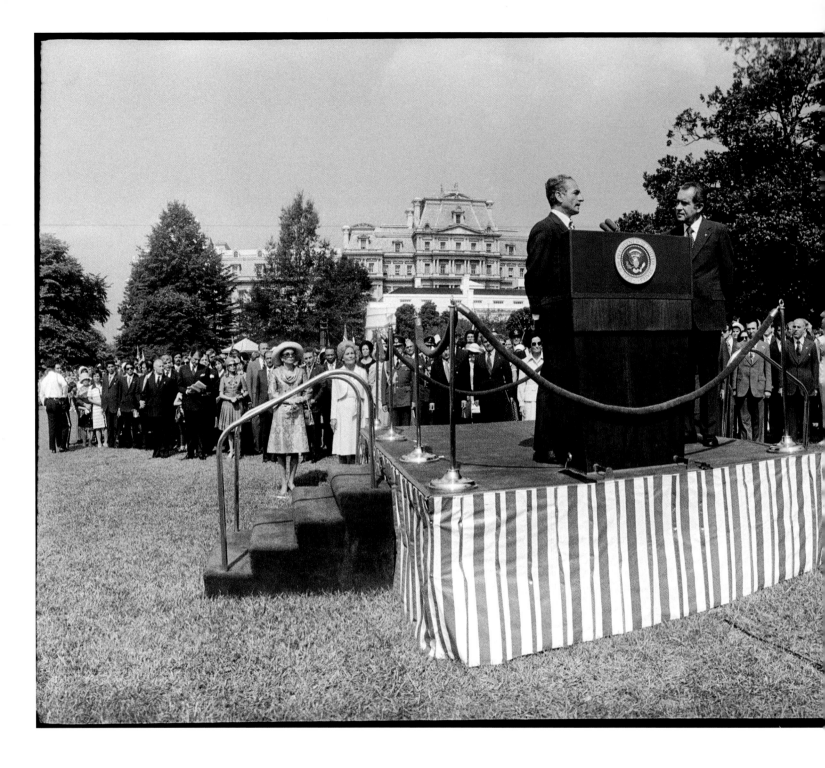

Shah Mohammad Reza Pahlavi with President
Richard Nixon at the State Arrival Ceremony,
South Lawn, White House. Washington, D.C.,
July 24, 1973

As events unfolded, too, I was reminded of an essay by the sociologist Max Weber entitled "The Charismatic Leader and the Bureaucracy," on the difficulty of institutionalizing a revolution. But here, I found, Ayatollah Khomeini, the charismatic leader, had his own built-in bureaucracy in the vast network of Shiite mosques encompassing most of the country. From exile, he had phoned in denunciations of the shah, which, taped, were rebroadcast at Friday prayers. On his return, the mosques organized neighborhood vigilante groups called *komiteh*s that enforced the revolution and grew into the Pasdaran, or Revolutionary Guards, which became its main military force.

The hold Shiite Islam had on Iran—and on much of present-day Iraq—has been difficult for Americans to grasp. "Who ever took religion seriously? one mystified State Department official said. Months later, at a crucial stage of the revolution, when student militants seized the American Embassy, many officials seemed to be seeing it in old-fashioned "red menace" terms. President Carter's spokesman, Jody Powell, said the students were following "a rather radical and certainly Marxist line." When I called the embassy, where the phone was answered "nest of spies," for comment, I was told none of the leaders were available. "They're all at prayers," it was explained.

The two touchstones of the messianic brand of Shiite Islam practiced in Iran are the martyrdom of Hussein, the seventh-century religious leader, at the hands of the rival caliphate at Karbala in the desert of Iraq, and the Mahdi, the redeemer, the 12th or Hidden Imam who disappeared as a child in a cave in the ninth century and will someday return, in a kind of end of days to order the perfect society.

The first—the martyrdom of Hussein—is what the anthropologist Michael M. J. Fischer calls the Karbala paradigm, the fascination with the death of the son of Imam Ali, a successor to the Prophet. His death left Islam split between a majority Sunni branch and a minority of Shiites. For Shiites, this left a kind of permanent guilt complex for the failure of Hussein's supporters to come to his aid, a sense of being oppressed, and an obsession with martyrdom. Hussein's death is celebrated each year at the feast of Ashura with ritual flagellation. During the anti-shah demonstrations, as one of David's photos shows, protestors would dip their hands in the blood of their slain cohorts. Later, during the war with Iraq, a martyrs' cemetery was adorned with a Fountain of Blood, colored water, really, but chillingly realistic.

The doctrine of the Hidden Imam holds, essentially, that all temporal authority is illegitimate until the Hidden Imam returns from occultation—a kind of suspended animation—as the Mahdi, or redeemer. (It was in Samarra, in present-day Iraq, where he was hidden; the golden-domed shrine that was bombed there was a pilgrimage place for his worshippers, which explains the outburst of violence against Sunnis that followed.) In the interpretation that gathered power among clergymen in Iran through the 1960s and '70s it meant the Shiite mullahs had an adversary relationship to the government, a moral obligation to criticize and correct.

Indeed, the strongest political tradition in Iran, through successive dynasties, has been the religious opposition to foreign domination and economic exploitation—first by Russia and Britain, then by the United States. The shah's father, Reza Shah, tried to break the power of the clergy; the words of one of the leaders he had executed came back to haunt his son: "Our religion is our politics, our politics is our religion."

The clergy were at the forefront of four major rebellions in Iranian history. The first uprising against foreign domination began in 1872 when Baron Julius de Reuter, the founder of the wire service, was granted a monopoly of mines, forests, railroads, banks, customs, canals and public works of every description that the British statesman Lord Curzon described as "the most complete and extraordinary surrender of the entire industrial resources of a kingdom into foreign hands that has ever been dreamed of, let alone accomplished."

The clergy succeeded in cancelling that concession as it did again in 1891 during an uprising against a British tobacco monopoly. That presaged perhaps the most important, the clergy-led Constitutional Revolt of 1906, which imposed a constitution on the Qajar dynasty. The first, brief, overthrow of the shah in 1953 was backed by important elements of the clergy.

But, like the revolution that ousted the shah, each was made up of two contradictory factions joined against a common foe. The coalition consisted, on the one hand, of the clergy, the masses of the faithful, and the traditional merchants of the bazaar and, on the other, the emerging class of westernized but nationalist students, intellectuals, government servants, and military men.

In the past, the victories were short-lived; usually the dominant foreign power aligned with westernized domestic groups—often government officials or intellectuals who looked on the clergy as backward—to restore some measure of the old order. The constitutional movement was thwarted when the British backed a coup by the shah's father, at the time an officer of a cavalry regiment. Later, when he developed Nazi sympathies early in World War II, the British packed him off and installed his young son in 1941.

It is against this historic background that the austere, implacable Ayatollah Khomeini grew from a symbol of resistance to a charismatic leader, honing his revolutionary theories in exile. And it is against this background that the struggle within the revolution would play out.

The unrest mounted, modestly enough in 1977 when, in response to President Jimmy Carter's call for human rights, small numbers of intellectuals and reformers petitioned the shah for changes. But President Carter never did anything more than talk about human rights; indeed during some of the worst of the bloodshed he telephoned the shah to express his support, earning the bitter enmity of many Iranians. The shah visited President Carter in Washington that fall and was greeted by some 4,000 protesters, mostly students.

Then, in January 1978, the regime made what would be a fatal error, clearly underestimating the strength and appeal of the religious opposition.

It planted an article in the semiofficial newspaper slandering Ayatollah Khomeini, calling him "an adventurer, without faith, and tied to the centers of colonialism…a man with a dubious past, tied to the more superficial and reactionary colonialists." The article ended by suggesting that the British—who are still particularly loathed in Iran—were paying him large sums of money to oppose the shah.

The next day theological students in Qom began two days of protests, broken up by the security forces, that killed at least 70 people. The protests quickly spread to other cities; in Tabriz in February rioters went on a rampage setting fire to movie theaters, banks, and government buildings. About a hundred people were killed there. Religious tradition helped fuel the protest: in a 40-day cycle of mourning, a protest would be mounted to mark the deaths of those previously killed. More people would be killed, requiring a renewed protest 40 days later. The traditional merchants of the bazaar, suspicious of the shah's modernizing efforts, swung their weight behind the religious leadership. The protests spread rapidly. By late summer the oil fields were shut down in a strike. On Black Friday—September 8—troops opened up on a huge crowd in Tehran's Jaleh Square; estimates of the dead ranged from 500 to 900. By fall, people from the wealthier neighborhoods were joining the protests in Tehran. Virtually the whole country, it seemed, had turned on the shah. His fate was finally sealed when his own Javadan palace guard—the Immortals, named for a Persian legend—refused to fire on revolting Air Force cadets and technicians.

But the revolution was an untidy thing.

It was composed of many elements and over the next year and a half or so, many would turn on each other, sometimes in violent street clashes. Religious mobs would hound out the young leftist guerrillas—the Marxist fedayeen and the Islamic mujahideen—who had fought the shah and would close down the universities. The 444-day seizure of the American Embassy and its diplomatic hostages would be a key turning point, used by the mullahs to vanquish their more Western-leaning foes.

The strains were evident from the beginning. There was an official government, with the formal trappings of authority. But the real power was held by a secret Revolutionary Council of senior clerics. Mehdi Bazargan, the provisional prime minister, was a longtime democracy advocate, himself so religious that he had a large knob on his forehead from striking the ground in prayer. When the ayatollah learned that tea was still being served in the prime minister's office, he thundered, "You are weak old man."

The first days were chaotic. A closed revolutionary court led by Ayatollah Sadegh Khalkhali—who became known as the hanging judge—put the leading figures of the old regime on trial for charges like "corruption on the earth" and each morning the front page of the newspapers was filled with grisly pictures of those who had been executed. Self-appointed vigilantes from the neighborhood komitehs enforced their own version of Islamic virtue, beating or arresting people

found to be drinking or improperly dressed. One day I ran into Dr. Ebrahim Yazdi, a former professor at Baylor University in Texas and one of a group of civilian aides Khomeini brought with him from Paris, rushing about corralling the unruly komitehs into a new organization to be called the Revolutionary Guards. Little did he realize he was preparing the end of his early prominent role in the revolution, for they would become a force loyal to the clerics.

Abolhasan Bani-Sadr, inventor of an Islamic economic scheme, was another civilian aide in the ayatollah's original Paris circle. He was overwhelmingly elected the country's first president but became a target of the students holding the embassy, which so crippled him that a joke went around that his name, which means "son of leader," should be changed to Bani-Harf, "son of talk." By July 1981, he was so unpopular he had to be smuggled out of the country.

Initially, excited crowds gathered around the government palace, which was guarded by the young air force technicians in honor of their role in the revolution, many bearing requests for favors or redress from any number of grievances. Improbably enough, there was even a group of unemployed SAVAK agents, trying to get back pay. But the crowds dwindled as it became clear that the official government could do little, if anything, and by June the sidewalks around the ornate wrought-iron gate were empty, watched over by only a single bored police-man. Prime Minister Bazargan went on television to decry his lack of power and complain that this was a land "of a hundred sheriffs."

It was Ayatollah Khomeini who was in charge and he thundered out his orders and proc-lamations before adoring crowds at his headquarters in the holy city of Qom, an ayatollah's kind of town, its dusty streets crowded with theological seminaries and the cloaks and tur-bans of clerics. In the building fight with secular forces, he denounced the reporting of the most independent newspaper, *Ayandegan,* as "depraved." Its offices in three provincial cities were promptly attacked by mobs and the paper shut down. He banned all music from Iranian radio and television because, he said, it is "no different from opium." Above all, he inveighed against "The Great Satan," America. (My personal favorite: "There is no difference between America and Russia. Each is worse than the other.")

In the first heady days of the revolution, before the splits became apparent, Dr. Yazdi was hard at work in a big, comfortable office in the prime minister's palace on a new Islamic con-stitution and eager to explain the nature of sharia law.

"But, but you can't do that," spluttered an American television reporter. "That's against the separation of church and state."

"Yes," Dr. Yazdi replied. "That's precisely the point."

JOHN KIFNER
Senior Correspondent, The New York Times

PART ONE

THE KING'S LAST DAYS

DECEMBER 26, 1978 – JANUARY 16, 1979

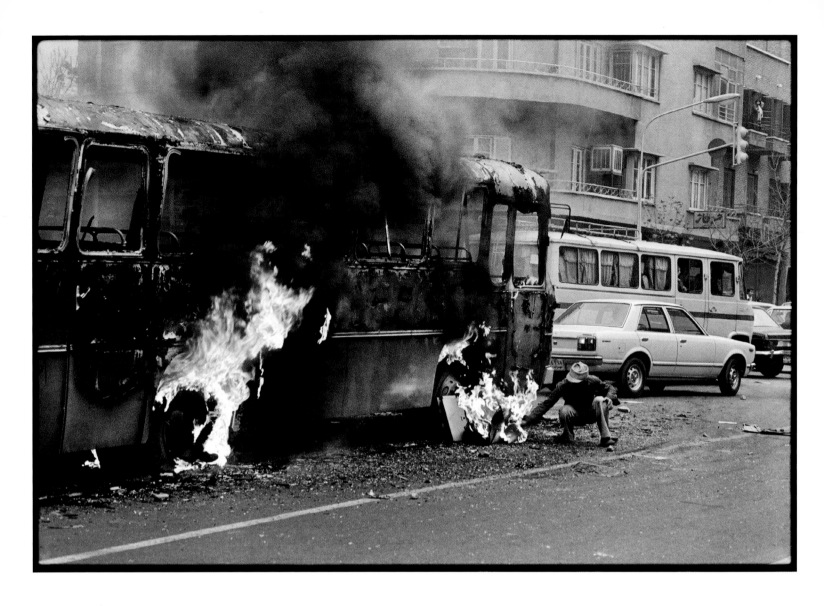

An anti-shah demonstrator sets a bus afire.
Downtown Tehran, December 26, 1978

DAY 1

DECEMBER 26, 1978 Back in New York I'd gotten the name of *Time*'s stringer in Tehran: Parviz Raein. He's the Tehran AP bureau chief, too, and runs their office out of his house, a couple of miles from the Intercontinental Hotel. In his late 40s, balding with a mustache, Parviz is elegant, gracious, and very well connected.

The Associated Press folks always know what's happening from day to day; they have tipsters everywhere. In fact, a few minutes after I show up, the phone rings. When Parviz puts it down, his manner is urgent.

"A demonstration near Shahyad Square has become violent."

Since my arrival in Tehran on yesterday's morning flight from Karachi, it's been clear that things are starting to fall apart here. The airport was virtually empty. No customs, no immigration, no border police with badges or lapel pins—no nothing. I entered the country without even getting my passport stamped.

Today I hop a ride with the AP reporters. Tehran is a big modern capital city, lots of cars and tall buildings, but the streets are virtually deserted. The stores and banks are all closed, with metal shutters drawn over the entrances. We arrive at the confrontation in minutes, a couple hundred students in an intersection marching and chanting and holding up placards denouncing the shah. They've blocked off traffic by setting a bus on fire, which they have to keep dousing with gasoline to keep alight.

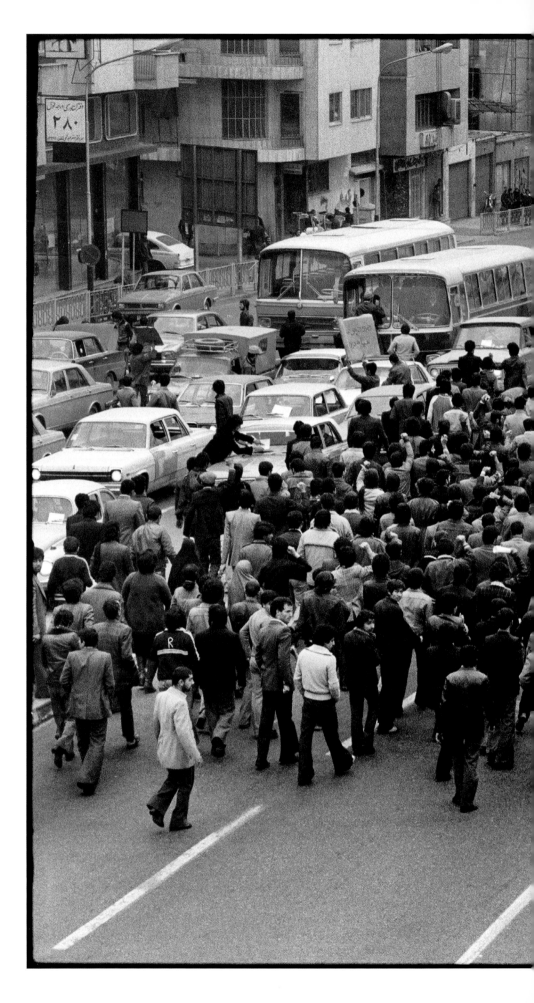

Demonstrators rally against the
shah and the United States.
Tehran, December 26, 1978

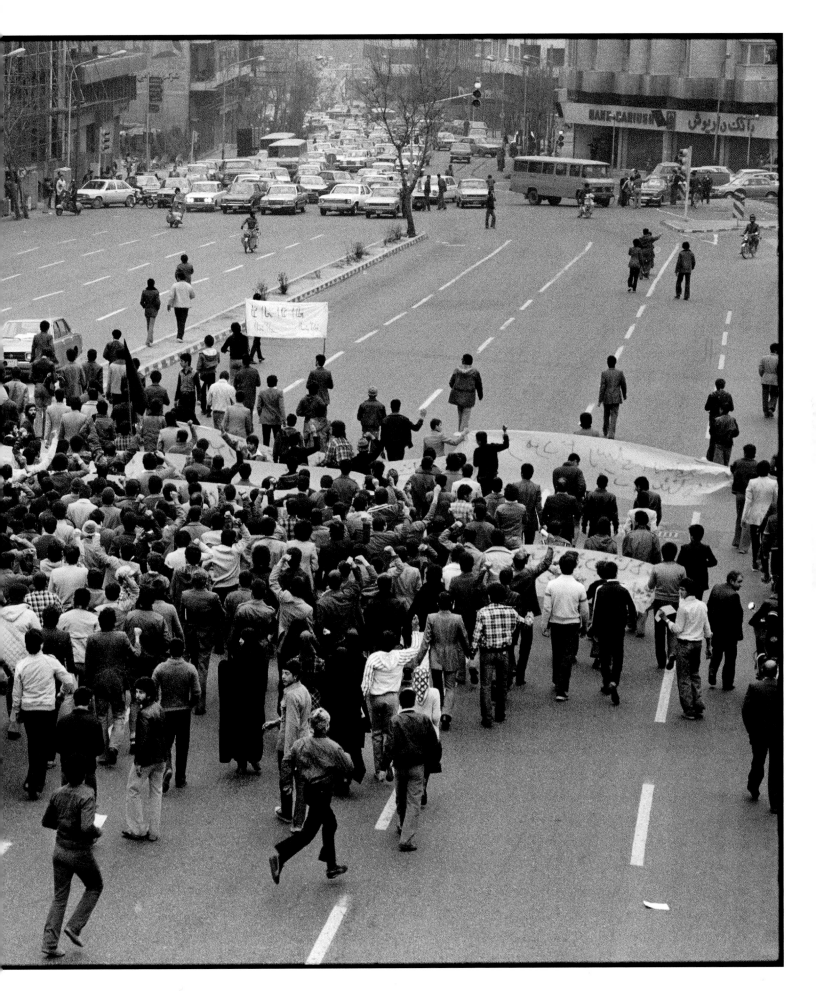

DEATH OF A PROFESSOR

On December 26, 1978, three people were killed in Tehran during a fresh round of protests against the rule of Shah Mohammad Reza Pehlavi. One of the victims was Dr. Karan Nejayatollahi, a 27-year-old professor at Tehran Polytechnic College, who was struck by a bullet during a teachers' sit-in strike.

The next morning, a crowd of several thousand people arrived at Tehran Hospital, where the professor's body had been kept overnight. First denied permission to hold a funeral march, they were finally able to proceed when a colonel in the Iranian army intervened and personally led the procession. Along with members of the professor's family and his colleagues at the university, the cortege proceeded to 24 of Esfand Square, named after the birthday of the shah's father, Reza Shah Pahlavi. There, despite the presence of the Iranian officer in the lead, awaiting soldiers opened fire, killing the colonel and five others.

From early 1978 onward, in cities throughout Iran this cycle of violence—killing/funeral/demonstration/killing—was often replayed, fanning the flames of revolution. Thus one "martyr" created another, galvanizing the opposition through impromptu graveside protests that frequently ended in bloodshed.

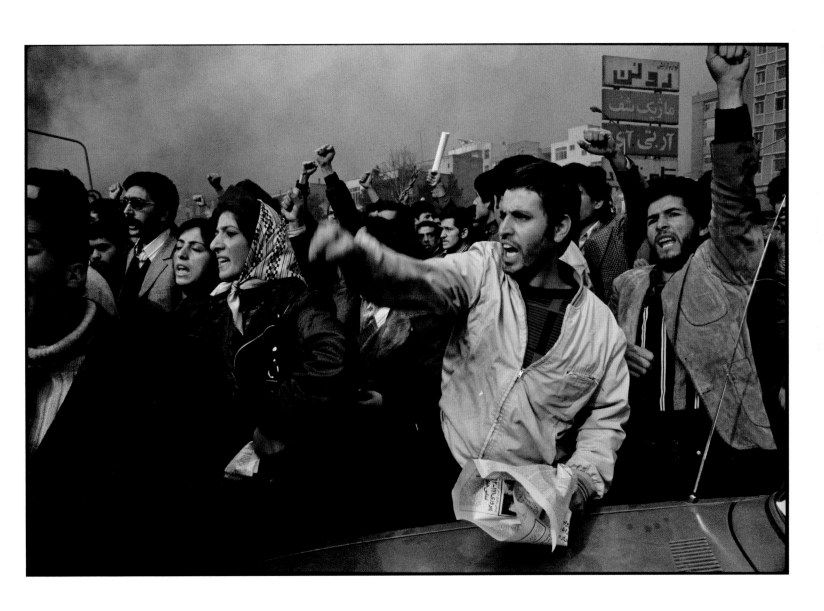

Anti-shah demonstrators in front of Pahlavi Hospital protest the previous day's killing of a 27-year-old professor. Tehran, December 27, 1978

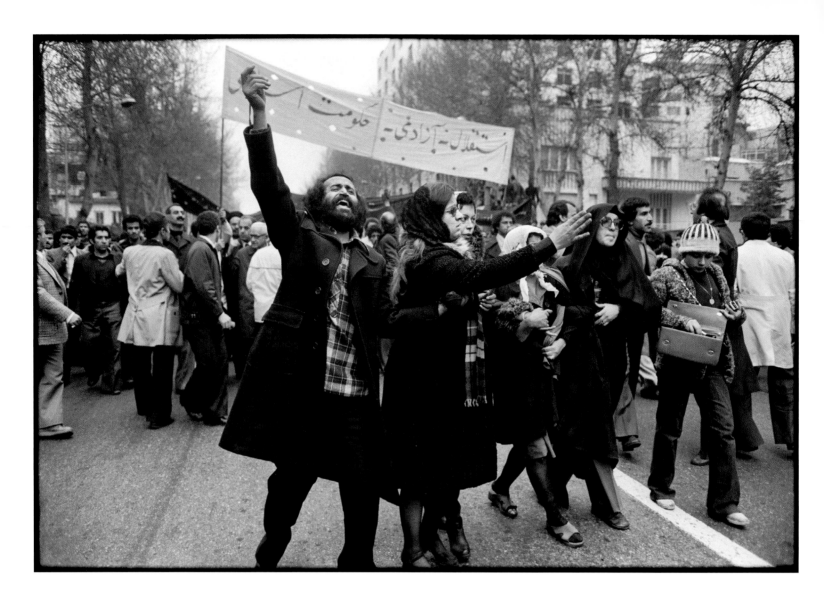

ABOVE: The family of a 27-year-old professor killed during a sit-in strike the day before leads the funeral cortege to 24 of Esfand Square. The banner says, "Independence and freedom with an Islamic republic."

OPPOSITE: Demonstrators in the cortege face the army. Tehran, December 27, 1978

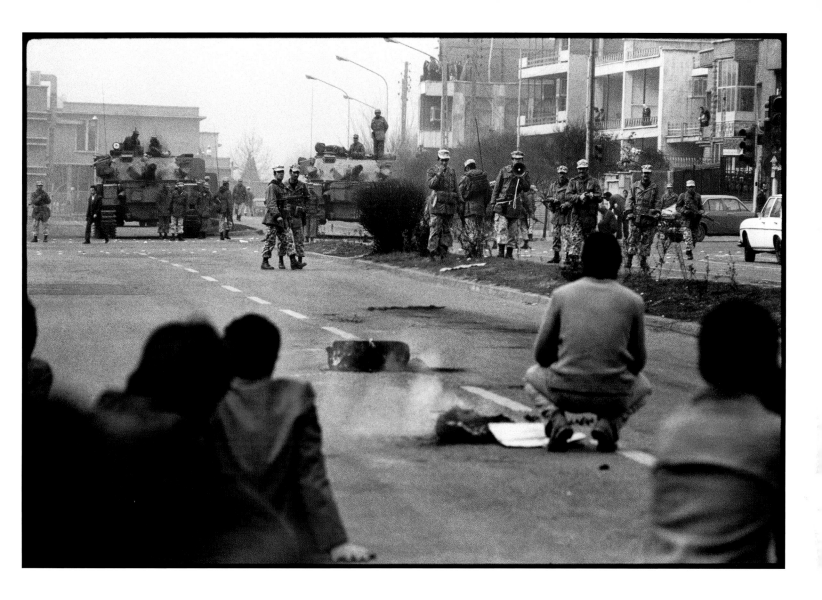

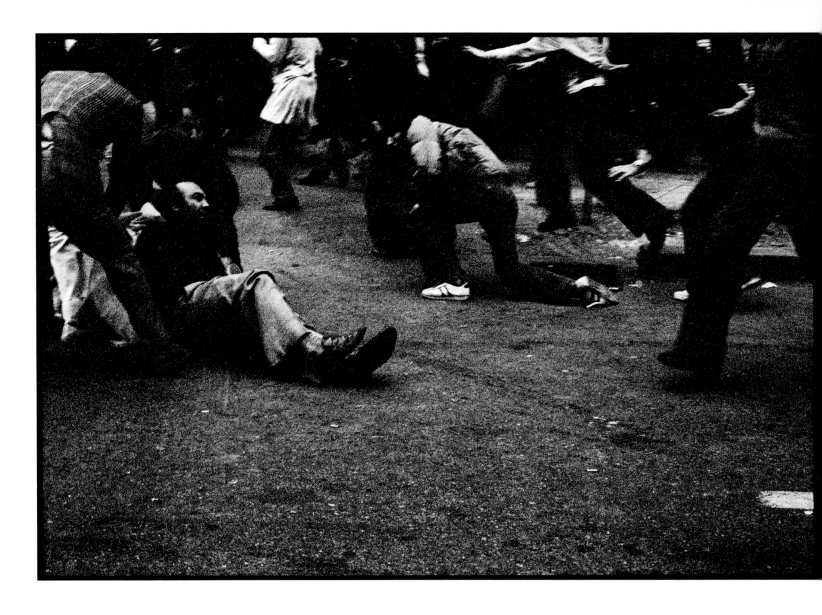

Wounded demonstrators on the ground after
the army fires on the funeral cortege.
Tehran, December 27, 1978

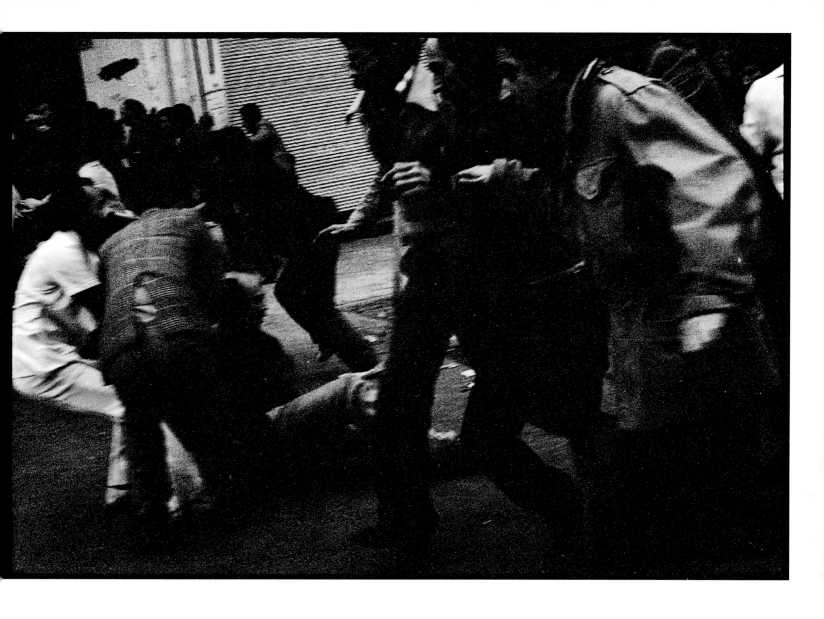

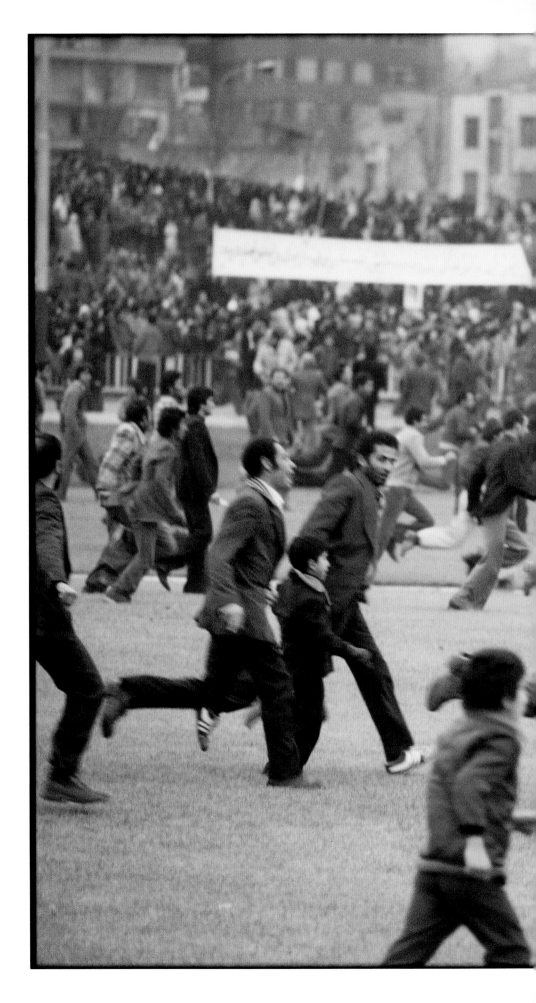

Anti-shah demonstrators in 24 of Esfand
Square on the run after the army opens fire.
Tehran, December 27, 1978

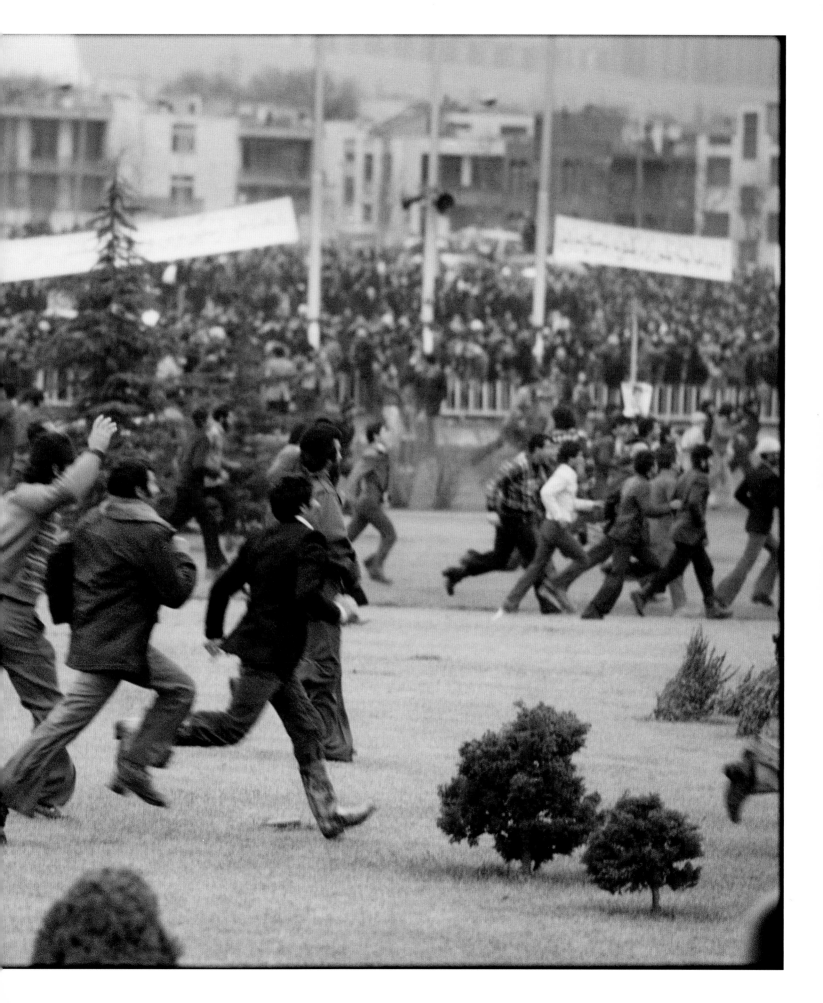

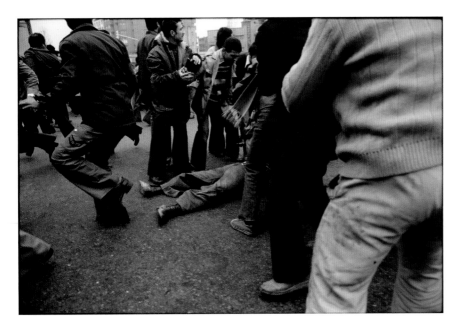

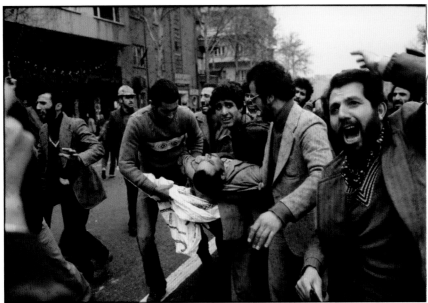

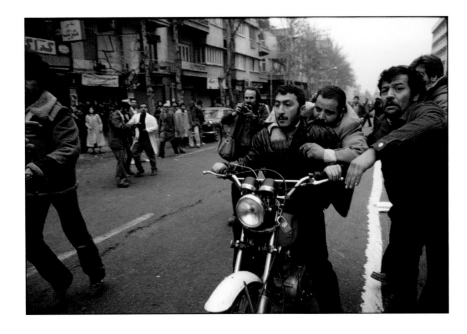

DAY 2

DECEMBER 27, 1978 Yesterday a young professor was shot and killed at the university. By morning, hundreds of demonstrators flank the boulevard leading up to Pahlavi Hospital, where his body is. They're mostly collegiate types, including some well-dressed women in Western-style clothes. Two tanks and a contingent of ranger troops in camouflage fatigues stand guard.

I get up onto the roof of a nearby building and watch some protestors build a barricade in the road out of scrap metal. Two soldiers tear it down to make way for the funeral procession. The professor's family, dressed in black, is at the lead, followed by a legion of white-coated doctors and nurses. Then comes the ambulance carrying the body and several thousand people.

I join the marchers. Despite being protected by the soldiers, many are carrying posters of Ayatollah Khomeini and chanting *"Allah akbar."* Then, as we approach 24 of Esfand Square, there's a sudden loud burst of automatic gunfire and everyone runs. In all directions, I see people jump for cover behind trees or cars, pressing themselves flat against the ground.

More soldiers arrive. They're immediately jumped by the demonstrators. I focus on one who's been grabbed. I can't tell if the protestors are trying to get him to drop his gun and join them, or preparing to lynch him. After a few minutes, though, he squirms away, no shots fired. Six or seven people carry a wounded man up the road away from the square and set him on the back of a motorcycle to get him to the hospital. People huddle in the street. Soldiers throw tear gas. The crowd disperses for a minute or so, then slowly reforms.

I've covered scores of political demonstrations in France, antiwar marches in the U.S., even a few protests in Vietnam during the 1972 presidential elections. But this is the first time I've seen a street march end in gunfire. For me, this is the story's "baptism of fire," the moment I realize it isn't another PTA meeting, some little local event about to pass without notice. This is a big deal. And I'm going to be part of it.

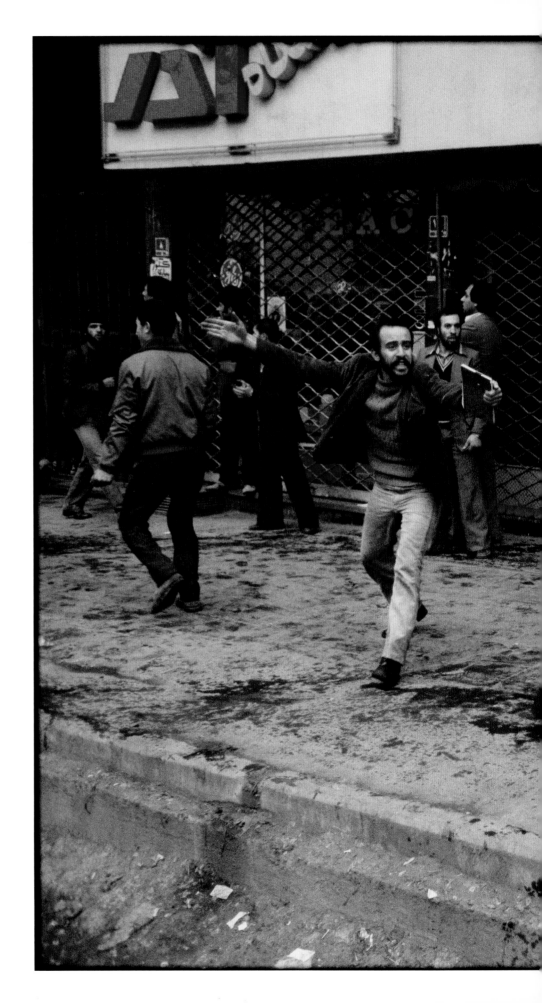

A young soldier is seized by demonstrators
in 24 of Esfand Square after the army opens
fire on the funeral cortege of a 27-year-old
professor killed the day before.
Tehran, December 27, 1978

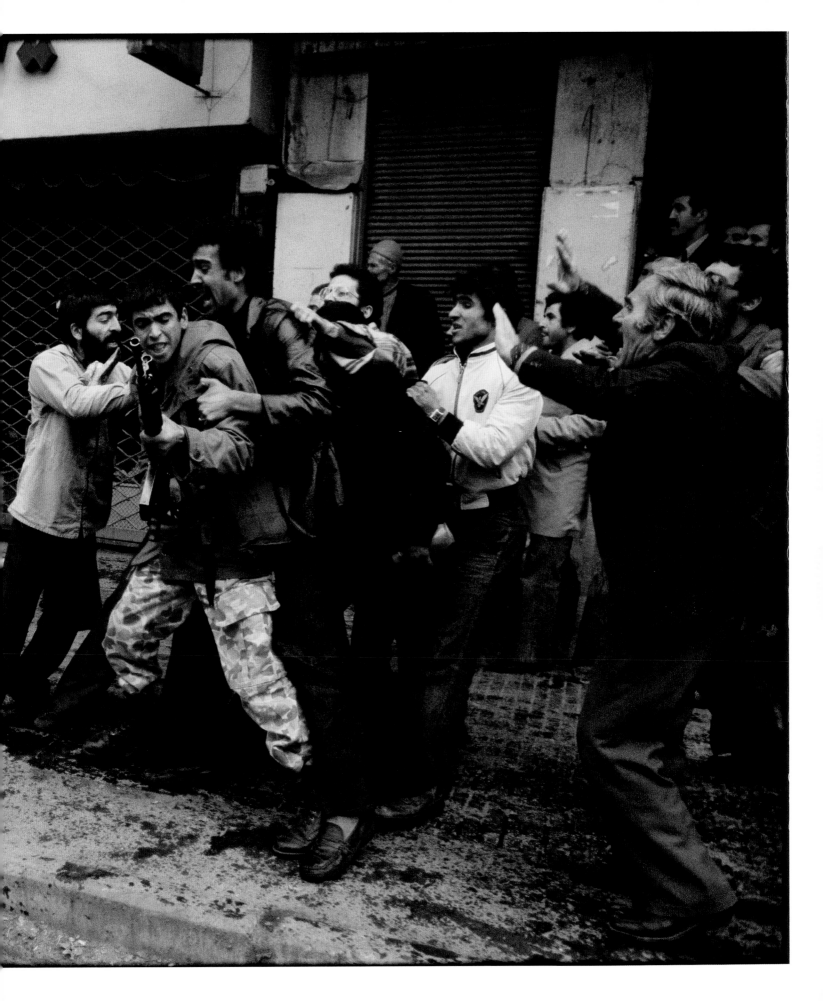

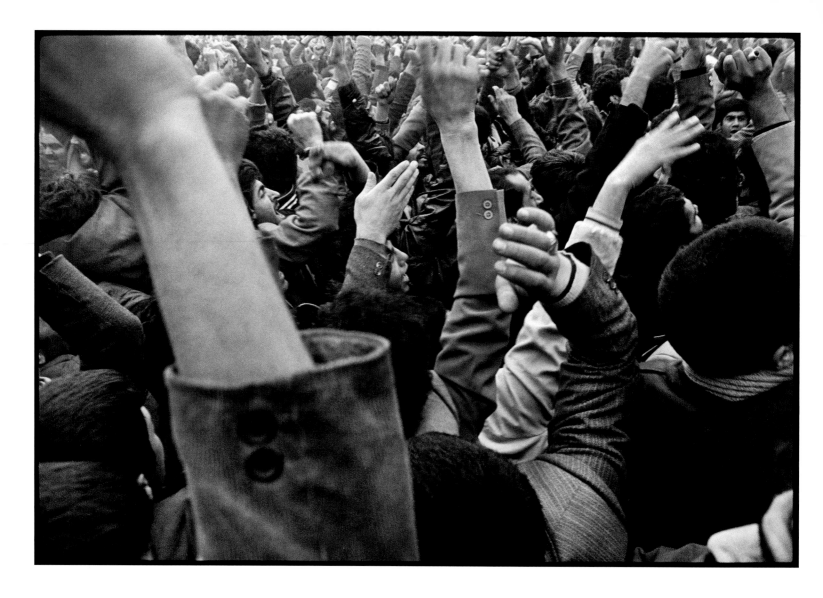

Mourners in Behesht e Zahra, the capital's main
cemetery, protest during funerals for those
killed in 24 of Esfand Square the day before.
Tehran, December 28, 1978

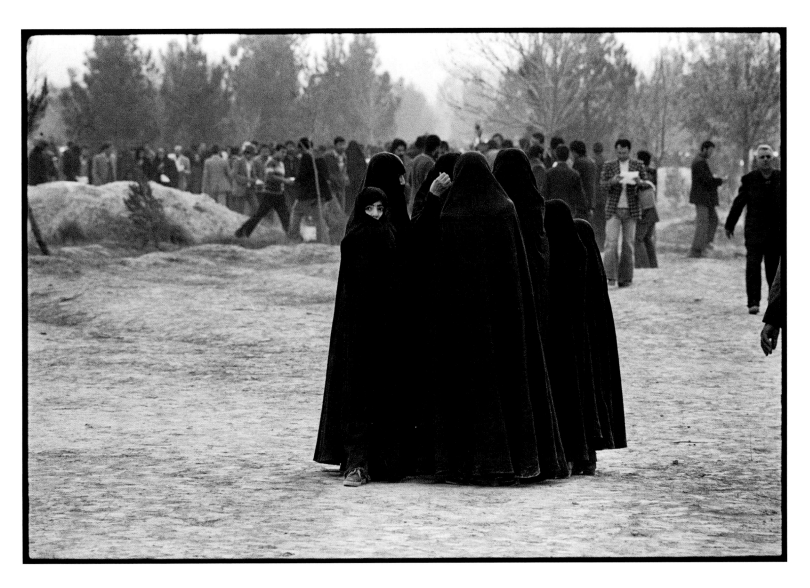

DAY 3 **DECEMBER 28, 1978** *Time*'s legendary former picture editor, the bearded nonconformist John Durniak, used to say you'd always make your best pictures the first couple days after you arrived somewhere. That's when things were at their freshest. Afterward, you'd start to get used to it—not the gunfire, maybe, but the demonstrations and marches would start to have a sameness, and you'd always be searching for how the new day might be different from the last.

The morning after the 24 of Esfand Square shooting, I head to Behesht e Zahra, Tehran's main cemetery, where the new "martyrs" are going to be buried. It's not on anybody's press release; it's just another angle on what's happening in the streets.

It's a long walk across the cemetery grounds for the noon burials. Through a field of dirt mounds and markers, broken here and there by a stone mausoleum, the white-shrouded bodies of yesterday's victims are borne overhead. What's most striking is that it isn't just memorializing somebody being laid in the ground; it's a political event. At each grave fiery speeches precede the burial, none of which I can understand. Still, I kind of know what they're about. Some of the first words I learn in Farsi are: *"Magbar Shah"* and *"Magbar America." "Khomeini I-Imam."* That's pretty much all I know. But after "Death to Shah," "Death to America," and "Khomeini is great," how much more do you need?

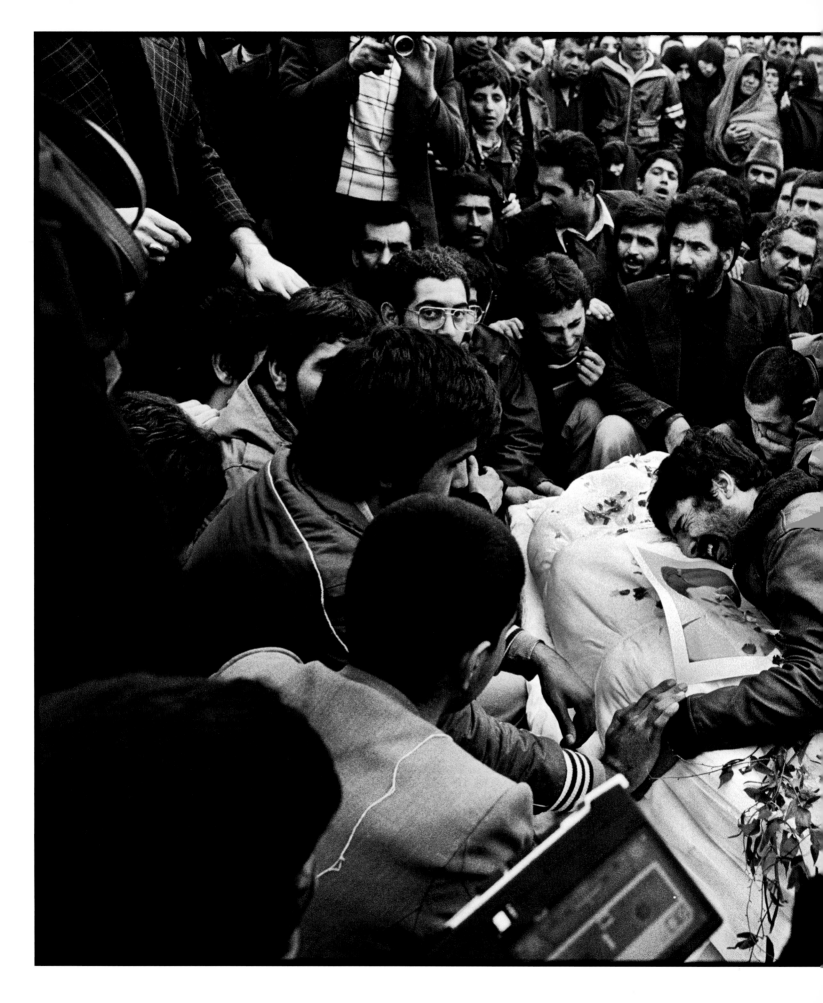

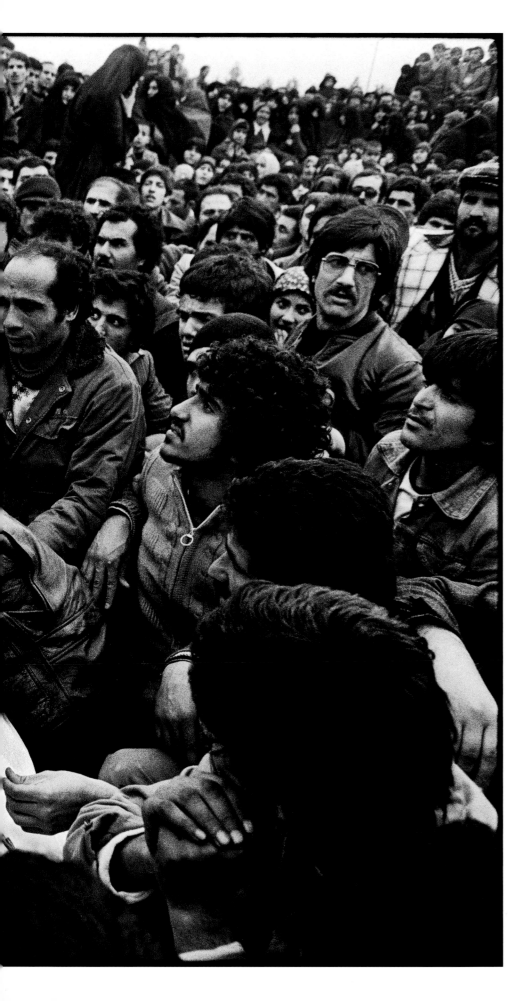

A funeral at Behesht e Zahra cemetery for
a victim shot in 24 of Esfand Square.
Tehran, December 28, 1978

Shapour Bakhtiar, the shah's rumored choice
for prime minister, in front of his townhouse.
Northern Tehran, December 30, 1978

DAY 5 **DECEMBER 30, 1978** While I am at the AP office, a call comes in with word that the shah has just appointed his political nemesis, Dr. Shapour Bakhtiar, to be the new prime minister. Parviz immediately gives the bureau driver his address, and Bob Dear, the British AP shooter, and I rush over.

Bakhtiar lives in a lovely suburban house in northern Tehran. Dear and I hop out of the car, stride to the front door, and knock twice, fully expecting no one to answer. To our surprise, the door opens and it's Bakhtiar himself. "No comment, no comment," he says in English before we manage to say a word.

In French I tell him, "We won't ask you anything, sir, no questions at all—we're photographers."

Hearing the French, a hint of recognition registers on his face, and he allows himself to be coaxed onto the front porch for a minute to be photographed. Bakhtiar is a bit stiff, quite official, and it reminds me of the fall of 1973 when I ran around Capitol Hill Senate and House offices photographing potential vice presidents after Spiro Agnew resigned. Gerald Ford, the minority leader from Michigan, absolutely convinced he wouldn't be Nixon's choice, couldn't have been nicer. "Don't waste your film on me," he'd said. "I'm not your man."

I shoot a roll of 36 black and white, a few color frames, then bid Monsieur Bakhtiar adieu and race to the car with my "scoop," rewinding as I go. A short time later, in the cramped office darkroom, I misload the film onto the plastic Patterson reel, drop it in the developer, and flip on the lights. Ten minutes later, instead of seeing frame after frame of Bakhtiar, I see nothing except for three shots at the very end of the roll.

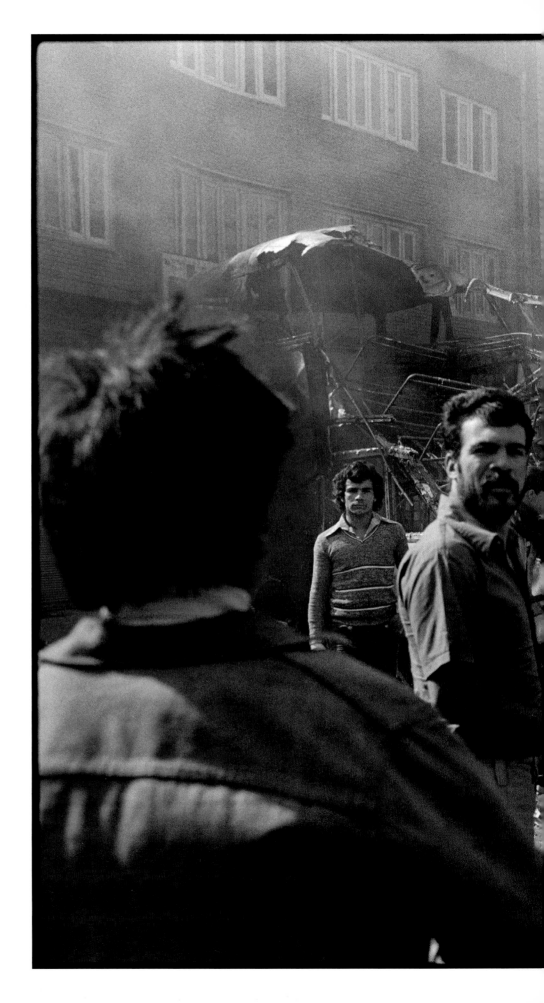

The capital after days of violence.
Downtown Tehran, December 30, 1978

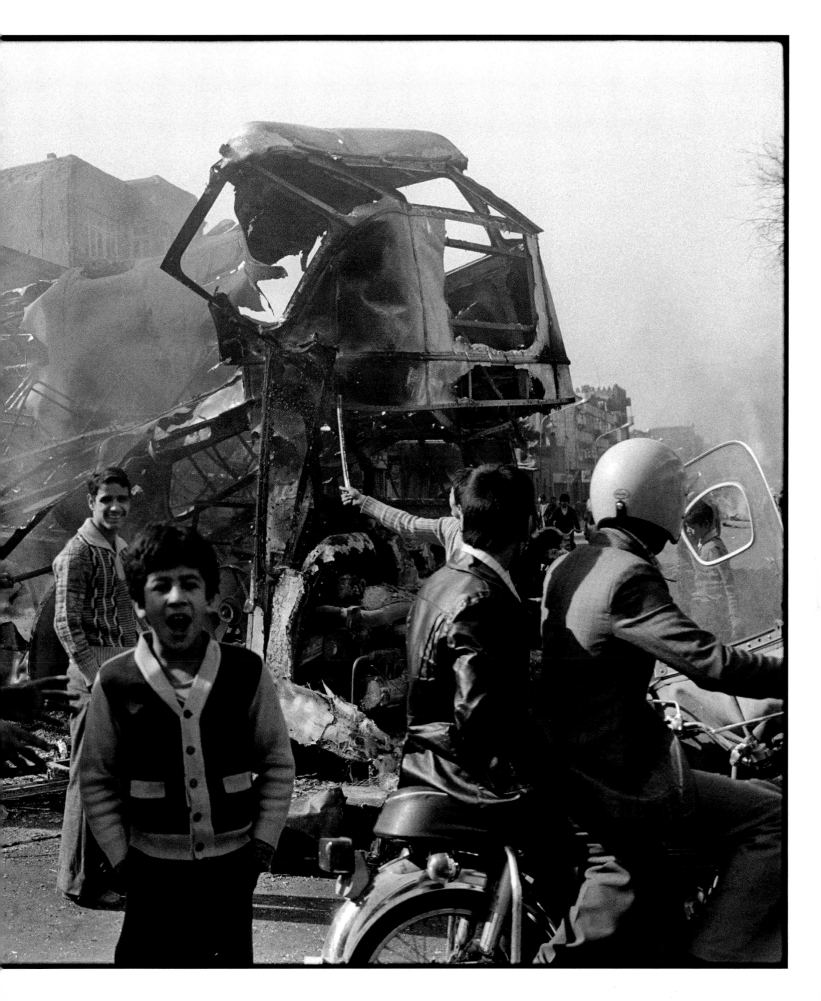

SAVAK / SECRET POLICE

In the mid-1970s, the shah's secret police, SAVAK, became synonymous with cruelty when several international reports found it responsible for executions, sadistic torture, and a sprawling army of agents and informers that kept Iranians in a constant state of fear.

Formed in 1957 with the aid of the U.S. Central Intelligence Agency to monitor opposition to the palace, by the time of the revolution SAVAK represented the worst of the monarchy: a shadowy extralegal organization that was everywhere and destroyed anyone the shah wished.

During the term of the United States' "human rights" President, Jimmy Carter, the shah responded to mounting public pressure from abroad and from revolutionary forces at home, dismissing the agency's head, Gen. Nematollah Nassari in June 1978, appointing him ambassador to Pakistan instead. This proved little balm to the revolutionaries. When two months later, a fire at the Rex Cinema in Abadan killed nearly 400 people, most Iranians blamed SAVAK for the tragedy, making the agency a special target of retribution during the revolution.

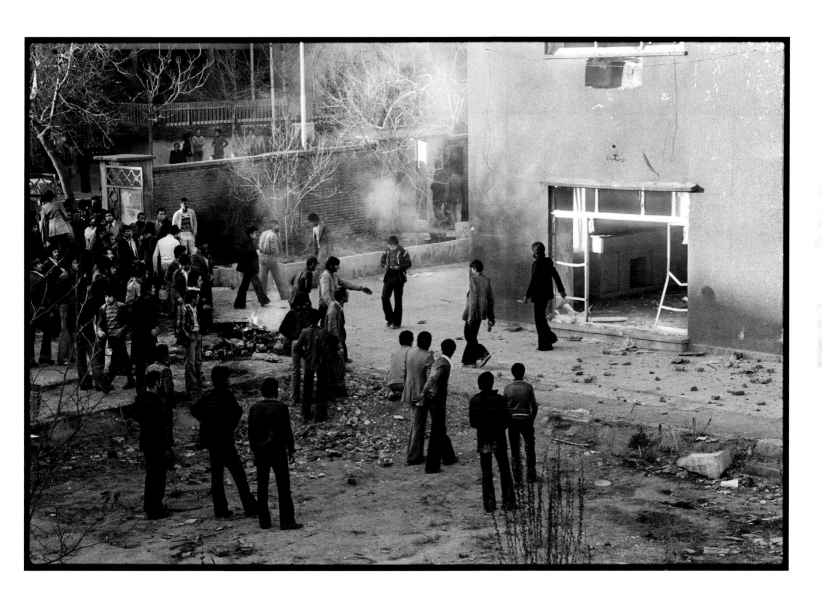

A house formerly occupied by SAVAK, burned by crowds over the weekend. Tehran, December 31, 1978

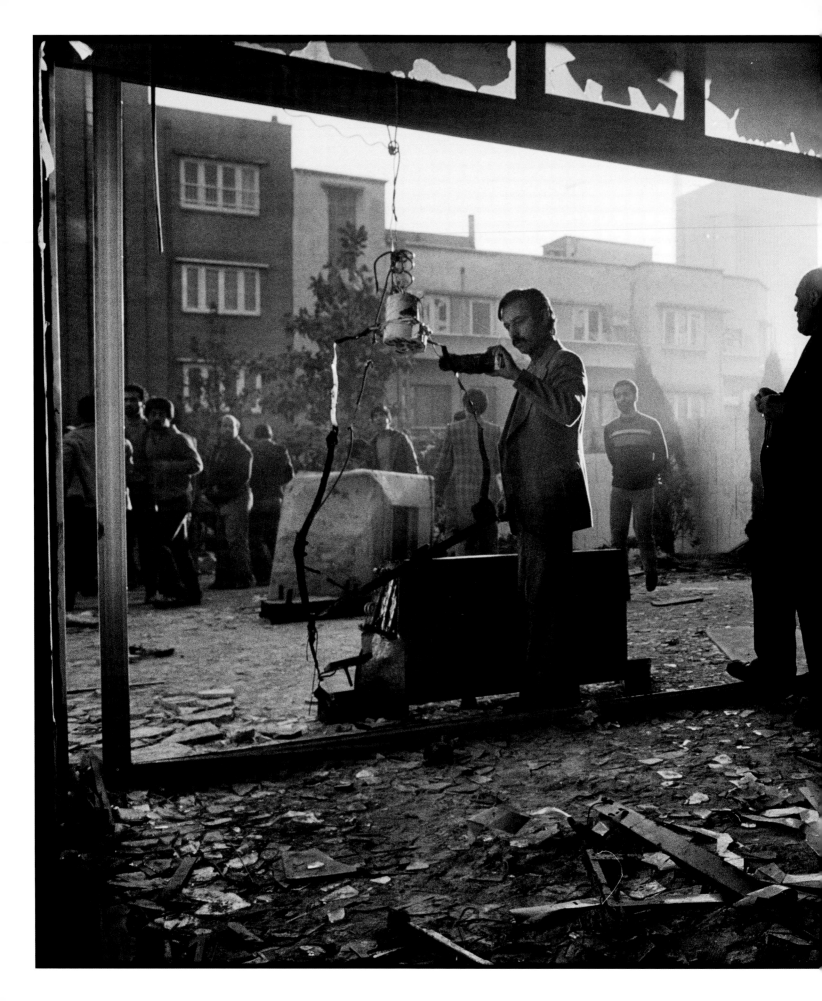

Crowds examine the torture apparatus
in a house formerly used by SAVAK.
Tehran, December 31, 1978

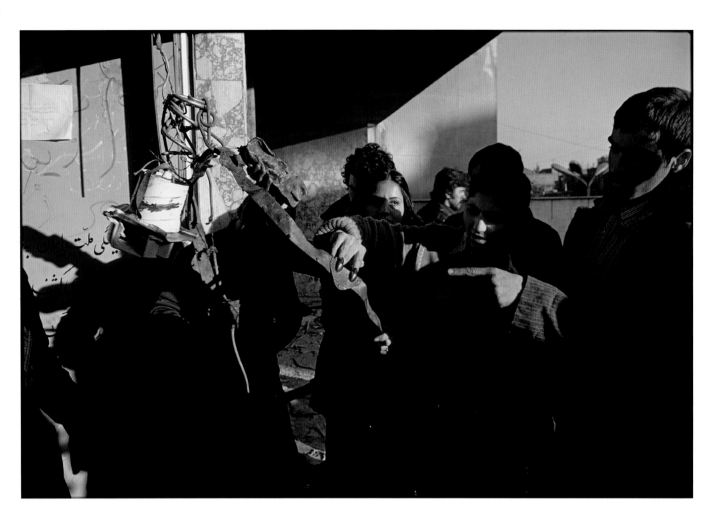

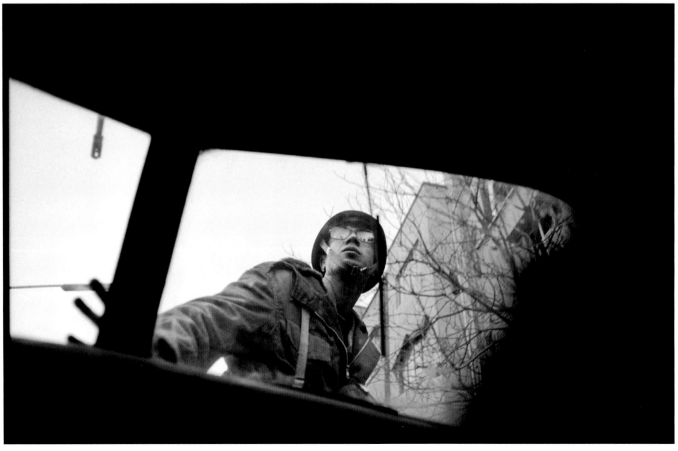

TOP: Torture apparatus is examined by curious passersby inside a former secret SAVAK prison.
BOTTOM: A soldier is surreptitiously photographed by David Burnett after his arrest at the SAVAK house. Tehran, December 31, 1978

DAY 6

DECEMBER 31, 1978 As a photographer, it's generally better to spend your time trying to make good pictures and to let the polemics take care of themselves. Still, you can't ignore the fact that most people feel there's a pretty high level of repression here. A huge anti-shah movement is bubbling up from under the surface, and there's clearly enough rage to drive people to some pretty severe action.

I get some of this firsthand on New Year's Eve, when just before the sun sets, I go to a house formerly belonging to SAVAK, the shah's secret police. I'd been told the house was trashed and burned by demonstrators over the weekend, and when I get there, the rooms are still smoldering. Just the same, families stroll through the house as if they were visiting an art gallery on a leisurely Sunday. Children, as unsure as they might be in a room of modernist sculpture, gaze up at the host of ghastly devices—electronic beds, finger squeezers, and other torture apparatuses—hanging from the walls. One young girl tentatively puts a finger in one of the instruments.

That's when I hear the rumble of the trucks. Before I know it, a group of soldiers has the place surrounded. Everyone runs, but I'm a step too slow. An officer takes me into custody. He's cordial, but insistent. He hauls me outside and makes me climb into the passenger seat of an army truck. A soldier sits in the back. Trying not to draw any attention to myself, I quietly stuff my exposed rolls of film into my socks and reload my camera. The officer sits on the hood and barks orders through his bullhorn. Hours pass. I grab a few surreptitious photographs through the windshield. Finally a driver gets behind the wheel and starts the engine. I have no idea where they are taking me.

Something of the chilling aura of the torture house mingles with my detainment in the truck, and my mind flashes back to September 1973 when I was arrested in Santiago, Chile, a few days after the coup d'état. General Pinochet's junta had just overthrown the elected president, Salvador Allende, and taking pictures represented a kind of dangerous independence. A soldier stopped me outside National Stadium, where hundreds of political prisoners had been brought. He stripped me of my cameras, took me inside, and made me stand with my hands up against a wall for an hour. I could hear the echoing screams of detainees being interrogated down the hall.

Held against your will, with no charges and no idea of what's in store, in a stadium or in a truck—this is just a taste of the fear that average Iranians have lived with for years—though in my case they merely drive me to another location in town, let me get out, and drive away. They don't even keep my cameras or film.

NIAVARAN PALACE

In October 1971, the shah hosted an enormous fete in Persepolis to commemorate the 2,500th anniversary of the Persian Empire. Featuring an elaborate tent city, a pageant of players dressed from Persia's history, a light show, and food prepared by Maxim's in Paris served on specially designed Limoges china, the lavish event attracted kings and presidents, but provoked the ire of many Iranians for its European-style extravagance.

Schooled in Switzerland, Mohammad Reza Pahlavi was brought to power when the British forced the abdication of his father, Reza Shah, in 1941, and was kept there by a CIA-aided coup in 1953. His tastes were aristocratic and his personal wealth in the millions, but for most Iranians, he was a remote figure. As the revolution gained momentum in the fall of 1978, he became increasingly remote, cloistering himself inside the grounds of his Niavaran Palace in the northern foothills of Tehran.

As events reached a crisis point, on January 1, 1979, the shah finally reemerged, meeting the press on the palace grounds. In the company of the Empress Farah Diba, he invited the media contingent inside. Asked if he would be willing to "take a vacation," he replied that he would love to, "if the situation permits."

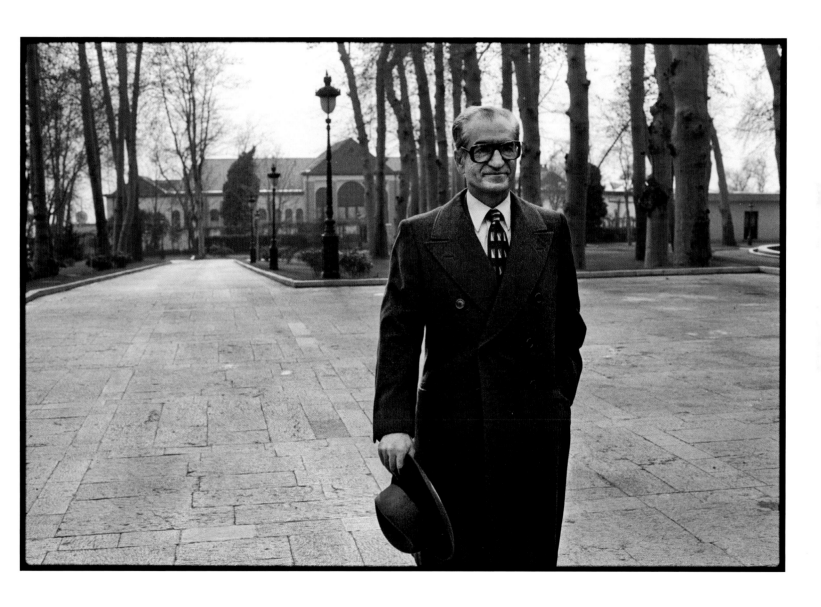

The shah emerges from Niavaran Palace to meet the press. Tehran, January 1, 1979

The shah and Empress Farah Diba meet the
press on the grounds of Niavaran Palace.
Tehran, January 1, 1979

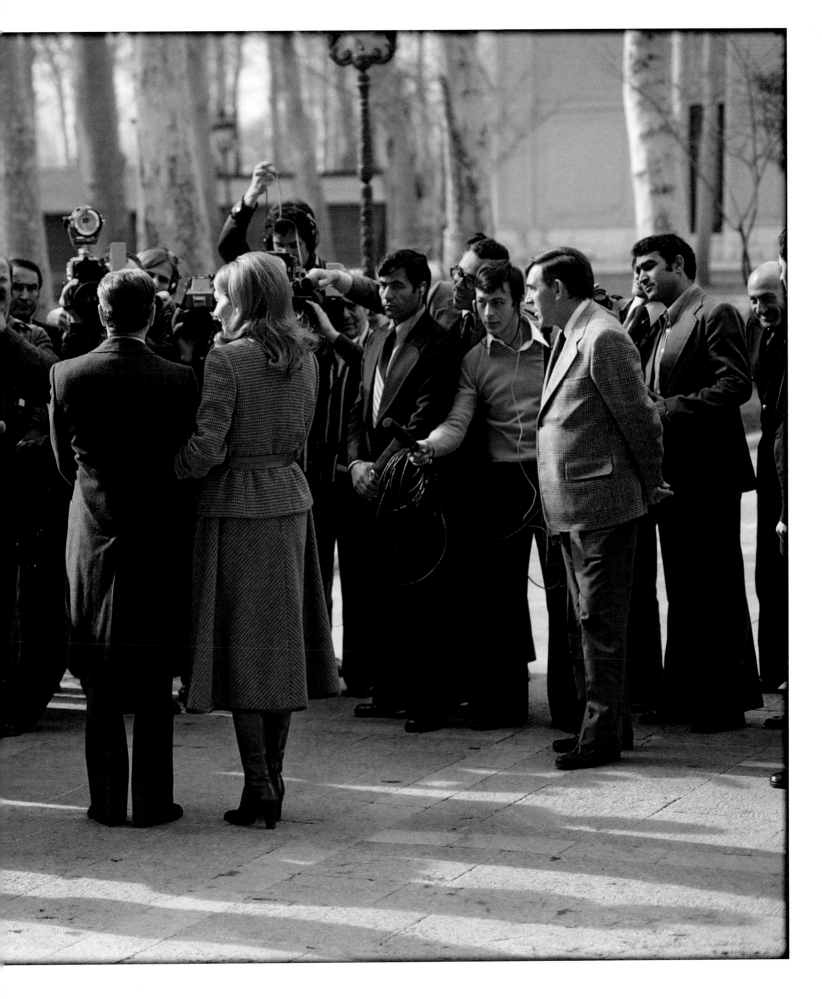

The shah and Farah Diba reenter Niavaran
Palace after meeting with the press.
Tehran, January 1, 1979

DAY 7

JANUARY 1, 1979 Niavaran Palace, where the shah lives, is in a wealthy section of northern Tehran at the foot of the snowy Elburz Mountains. I honestly don't know what the point of our visit is, except that the shah's people clearly want to show him engaged and in touch. No one has seen him for months.

Few journalists turn down an opportunity to meet a head of state, and there are a dozen or so waiting in the garden at the bottom of the palace footpath. Soon the shah appears, dressed in an elegant overcoat, and walks toward us. At his side is Ardeshir Zahedi, the Iranian ambassador to the United States. A sophisticated Washington-esque type who has the reputation of being a playboy, Zahedi was briefly linked with Elizabeth Taylor. I've seen him any number of times at diplomatic functions in D.C. The parties at the Iranian Embassy are known to have the best caviar and champagne, and plenty of them.

I saw the shah in Washington, too. It was with President Nixon during the summer of the Watergate hearings in 1973. There was an arrival ceremony on the South Lawn of the White House, a meeting in the Oval Office, and a State Dinner; then the next day the shah dressed in military clothes and went over to the Pentagon. At Andrews Air Force Base they let him fly one of the new F-14 fighters he was buying with his petrodollars, and the rumor was that during the flight he'd vomited all over the cockpit. In any case, he wasn't someone who gave you the feeling that you were in the presence of an electric personality.

After a little banter with the press, the shah heads back inside and returns with the Empress Farah Diba. She is as elegant as ever. When I worked with the French agency Gamma, in 1973-74, one of the photographers, Hughes Vassal, used to make regular trips to Tehran to photograph the empress and her children back when she was just another member of the international royalty set, a fixture in the gossipy magazines like *Jour de France* that reveled in the glamorous world of Caroline of Monaco and Princess Grace.

The circumstances today are radically different. The shah announces to the assembled reporters that he is willing to take a "vacation"—code for leaving the country, though personally, I don't think his departure is a done deal. The city seems too unsettled as yet.

After chatting a bit, the royal couple invites everyone to come inside the palace, and gives us a few minutes to wander around. Amazingly, there aren't a lot of people hovering—not like the White House with its scores of lurking agents, or the Élysée Palace in Paris with its elegantly dressed *huissiers*. The palace is very quiet—hushed tones, cool and calm—the complete opposite of the screaming, yelling, and chaos on the streets. Figuring I probably won't be returning any time soon, I just keep looking, keep shooting, and try to make sure not to knock anything over.

OPPOSITE AND ABOVE: A public reception room
inside Niavaran Palace. On the table is
a bust of the Empress Farah Diba.
Tehran, January 1, 1979

FLIGHT FROM CHAOS

In the early 1970s, with Iranian oil revenues booming, Shah Mohammad Reza Pahlavi embarked on a crash course in modernization he termed the "Great Civilization." Intended to put Iran on par with Western European nations within a decade, the program precipitated an influx of foreign "experts," including, by 1978, nearly 50,000 Americans.

U.S. citizens had been a major source of contention in Iran since 1964, when a law granting extraterritorial status to American military personnel set off a string of events that resulted in the exile of Ayatollah Ruhollah Khomeini, a fierce critic of the U.S.-Iran relationship. By the fall of 1978, surging anti-Americanism had become a staple of the revolution. Banks, cinemas, and other symbols of the West that evoked the wrath of Islamic and nationalist forces were set to the torch.

On December 29, six days after an American oil expert, Paul Grimm, was murdered in Ahwaz, the U.S. government finally advised all Americans to leave the country. By then only 15,000 remained.

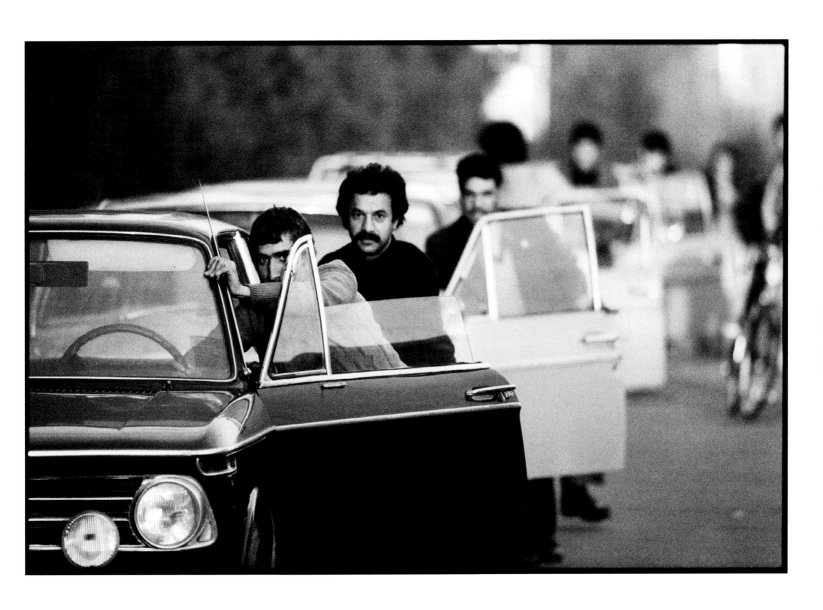

Following oil production stoppages, drivers push their vehicles in long queues for gasoline. Tehran, January 2, 1979

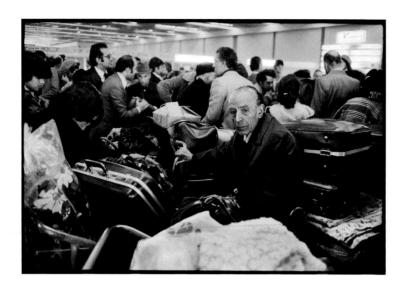 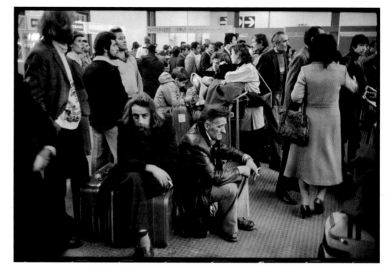

ABOVE AND OPPOSITE: Foreigners at Mehrabad Airport endure
long waits for flights to leave Iran.
FAR RIGHT: A stranded passenger at the Intercontinental
Hotel after the cancellation of her Pan Am flight.
Tehran, January 2, 1979

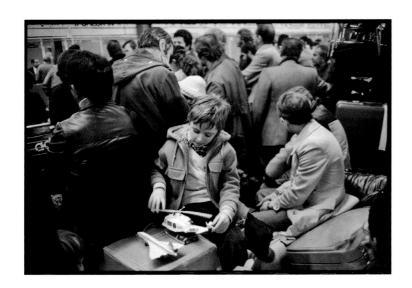 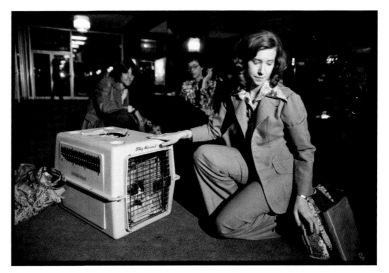

DAY 8 **JANUARY 2, 1979** After getting word that New York never received my first shipment of film, I grab a car to the airport. When I reach the Pan Am freight office, I discover that cargo stopped flying days ago, and miraculously find my film sitting amid a big jumble of packages in what would have been a very long wait. That's when I realize that you can just walk into the passenger waiting area. It's full of people trying to get out of the country, stacked like cordwood with their baggage, and I begin asking various passengers if they'll carry my film to London, Frankfurt, or anywhere else in Western Europe, trying to convince them that the whole history of Western democracy somehow depends on it getting to New York by Thursday. Finally I find someone heading to Paris willing to help. I forward the passenger's flight info to the office later that morning so someone can meet the "pigeon" and collect the film.

This becomes my general method of shipping film from Iran, a means long popular among French photographers when speed is of the essence and there's no other option.

Around this time, my friend Olivier Rebbot, a French photographer, arrives in Tehran. I know Olivier from New York, and we start going out to cover events together. Olivier is shooting for *Newsweek* and I am shooting for *Time,* but that doesn't faze either of us. We even start shipping our film together. We enter the passenger lounge and make a sport of trying to pick out the likely carriers for our film. Some obviously aren't interested. Some look willing, but turn us down for unspecified reasons. And now and then someone we label as "no chance" turns out to have a soft spot for the press and agrees to carry the package.

MASSACRE IN MESHAD

Although Tehran, Iran's capital and the home of the shah, was the center of the revolution, the growing conflict between government forces and the opposition shook the entire country. One of the period's bloodiest episodes took place in the city of Meshad, 500 miles east of the capital. Near the borders of the Soviet Union and northern Afghanistan, Meshad is home to the shrine of Imam Reza, the seventh descendant of the Prophet Muhammad, and is one of the holiest cities in Shiite Islam.

On the weekend of December 30-31, 1978, demonstrations there spun out of control. Three SAVAK agents were reported lynched, and six soldiers were killed by the crowds, including a colonel who was dragged from a tank and axed to death, and a major who was stabbed. A Pepsi-Cola plant and the American and British Libraries—symbols of Western influence—were destroyed.

According to a military spokesman, most of the violence occurred when a mob attacked a military garrison. Anti-shah opponents countered that army troops were shown the bodies of their mutilated companions to incite a rampage, after which they indiscriminately shot into the crowds and ran protestors over with tanks. After two days of fighting, the demonstrators held the town. The government reported 106 dead. The opposition claimed as many as 2,000.

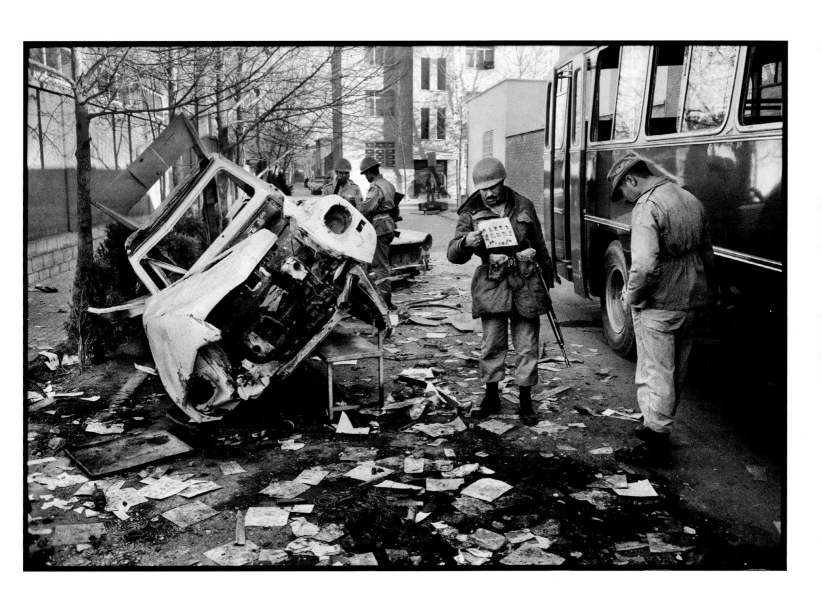

Soldiers patrol the streets after clashes between the army and anti-shah demonstrators killed scores. Meshad, January 3, 1979

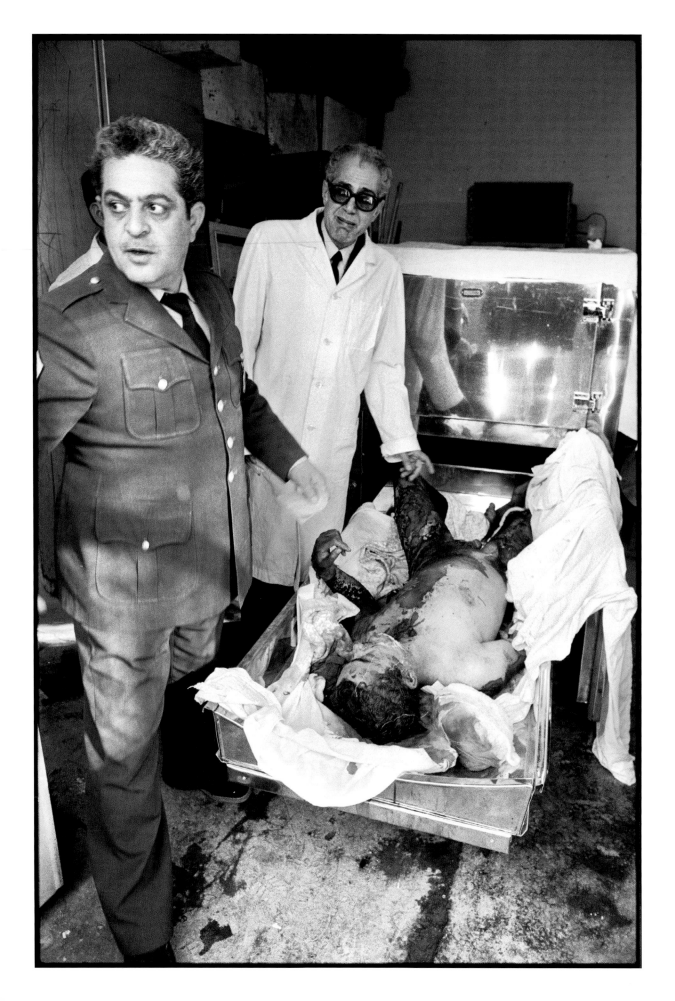

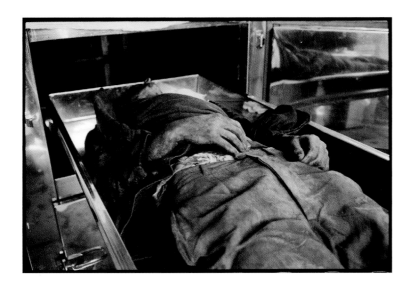

OPPOSITE AND ABOVE LEFT: The mutilated bodies of
soldiers lie in the morgue.
ABOVE RIGHT: Civilians watch soldiers on patrol.
Meshad, January 3, 1979

DAY 9 JANUARY 3, 1979 Over the weekend, there were some tremendous clashes

In Meshad. I hear about it on January 2, and along with a couple dozen other journalists, including Olivier Rebbot, I make my way there the following day. In an attempt to publicize the lawlessness of the mobs and get the government some positive press, the Ministry of Information has put together a C-130 flight of foreign press there and back.

After arriving at the Meshad airfield, we are taken to the army hospital to see some of the casualties. I see a soldier with his belly cut open and another with his ear sliced off. I see bodies in the morgue. In the city, truckloads of soldiers, part of a beefed-up military presence, roam the streets amid the smoldering ruins of tanks, police stations, and other symbols of authority.

There's fresh evidence of animosity toward the U.S., too: the Pepsi factory has been torched; a burned-out car is left at the bottom of the swimming pool at the USIS house; and all the Americans have left the Hyatt Omar Khayam Hotel, which has been taken over by former employees who are now calling it "Khomeini Hospital." To prevent the building from being destroyed by the demonstrators, they've tacked up a picture of the ayatollah on the front gate.

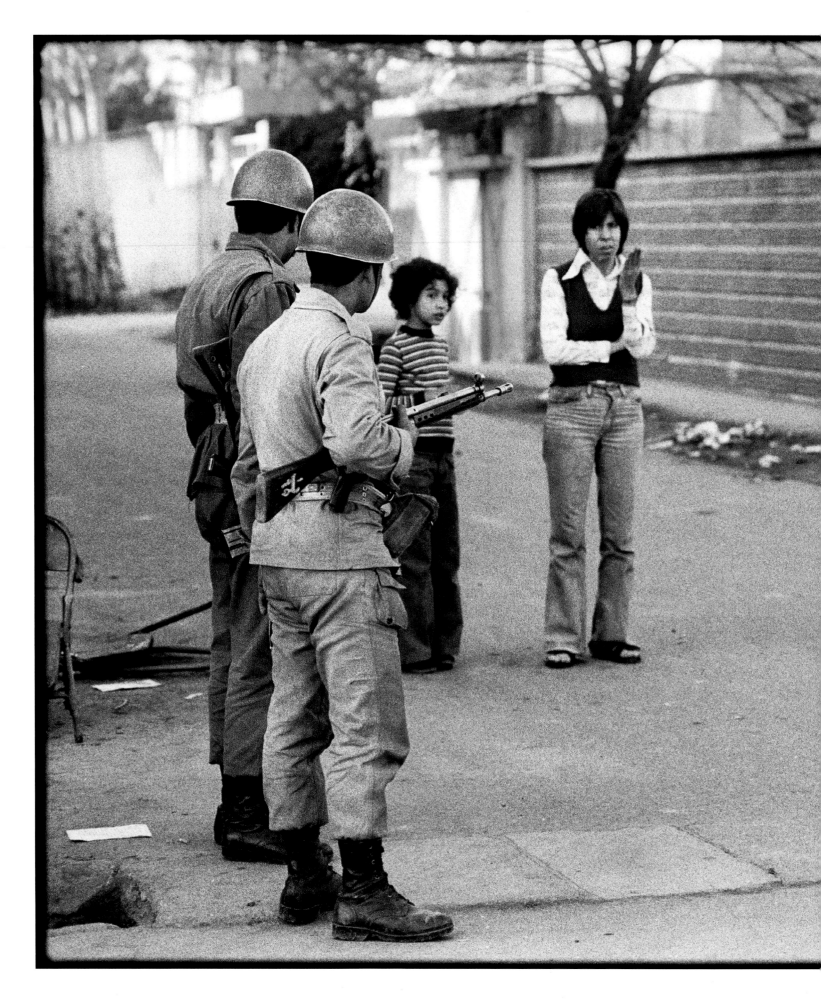

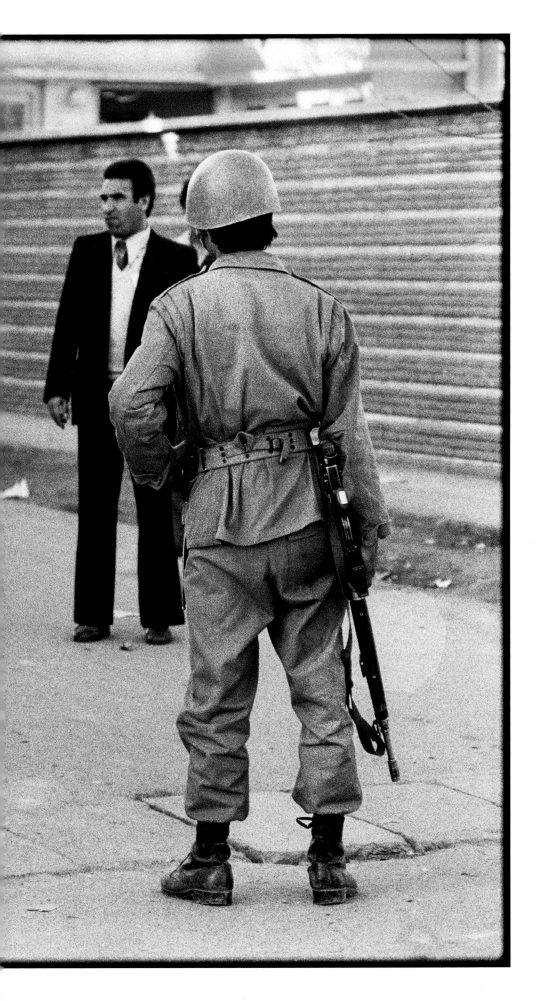

Soldiers on patrol after clashes killed scores.
Meshad, January 3, 1979

THE LAST PRIME MINISTER

Between August 1977 and the end of 1978, the shah appointed three different prime ministers in an ongoing attempt to quell growing opposition to his rule. After his last choice, Gen. Gholamreza Azhari, suffered a heart attack and stepped down that December, Iran was left effectively without a government.

In a desperate last attempt to appease the demonstrators, the shah turned to Shapour Bakhtiar. A French-educated leader who fought with the French Resistance during World War II, Bakhtiar served as the minister of labor in the government of Mohammed Mossadegh, which was overthrown in a CIA-inspired coup in October 1953. A vocal critic of the shah and a member of the illegal opposition group, the National Front, he was repeatedly jailed, spending a combined six years in prison.

With a promise that the shah would leave the country and appoint a Regency Council in his stead—a constitutional move designed to protect the monarchy—Bakhtiar accepted the task, fearful of a takeover by communists or the mullahs should he refuse. With his European manners and sensibility, he has often been associated with the tragic figure of the Russian prime minister Alexander Kerensky, who helped dethrone the czar but was soon swept from power by the Bolsheviks.

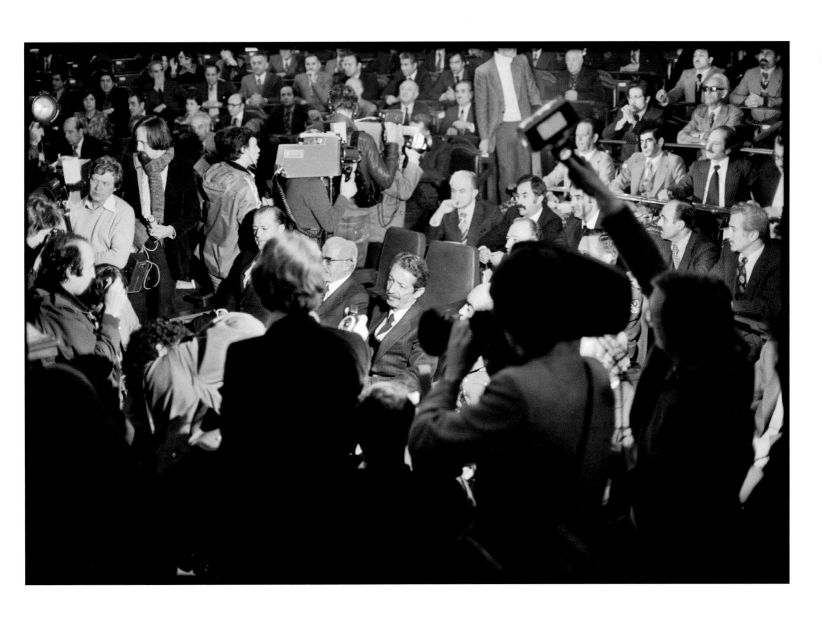

Shapour Bakhtiar, the new prime minister, at the Majles (Parliament). Tehran, January 4, 1979

ABOVE AND OPPOSITE: Shapour Bakhtiar, the new
prime minister, with the shah at Niavaran
Palace during the presentation of his cabinet.
Tehran, January 6, 1979

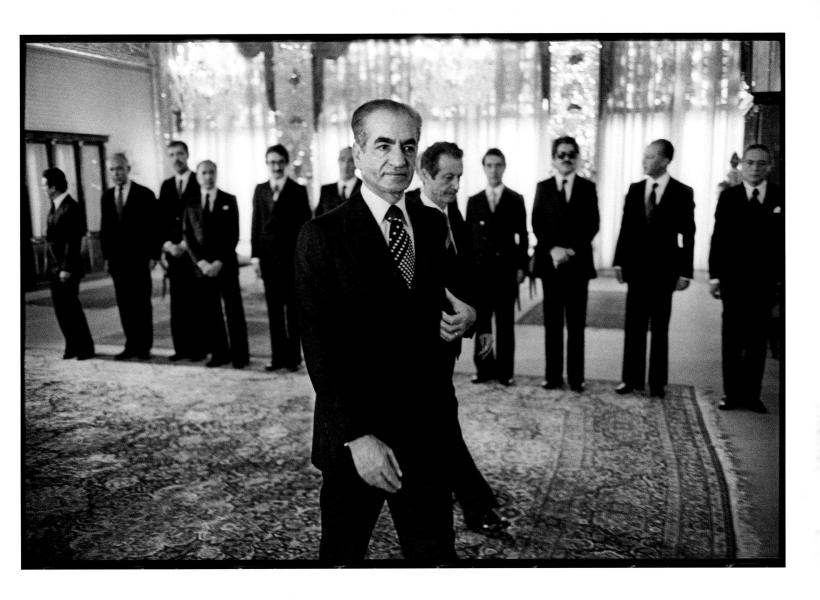

THE NOBLE RESOURCE

In 1901, for 20,000 pounds and 84 percent of net profits, a British citizen named William D'Arcy negotiated a 60-year contract granting himself mining concessions for nearly all of Iran. Seven years later, on May 26, 1908, Iran became the site of the first discovery of oil in the Middle East when explorers struck crude north of Ahwaz.

The following year, the Anglo-Persian Oil Company, in which the British government held a substantial stake, was formed. When, on the eve of World War I, the British Admiralty under the command of Winston Churchill switched from coal to oil to power its fleet, the world's appetite was whet.

But with the brief exception of the Mossadegh years (1951-53), Iran, the world's second largest exporter of crude oil after Saudi Arabia, remained in essentially a colonialist position vis-à-vis oil until the 1970s, with a "consortium" of the world's biggest oil companies sharing revenues on a 50/50 basis but charging Iran heavily for its refining expertise.

Empowered by the newfound power of OPEC, the Organization of Petroleum Exporting Countries, Iran finally wrested control from the consortium in 1973. The result was an astronomical rise in prices, revenues, and spending, as the shah embarked on an international shopping spree intended to modernize the country virtually overnight.

A natural gas production facility in southern Iran. Ahwaz, January 8, 1979

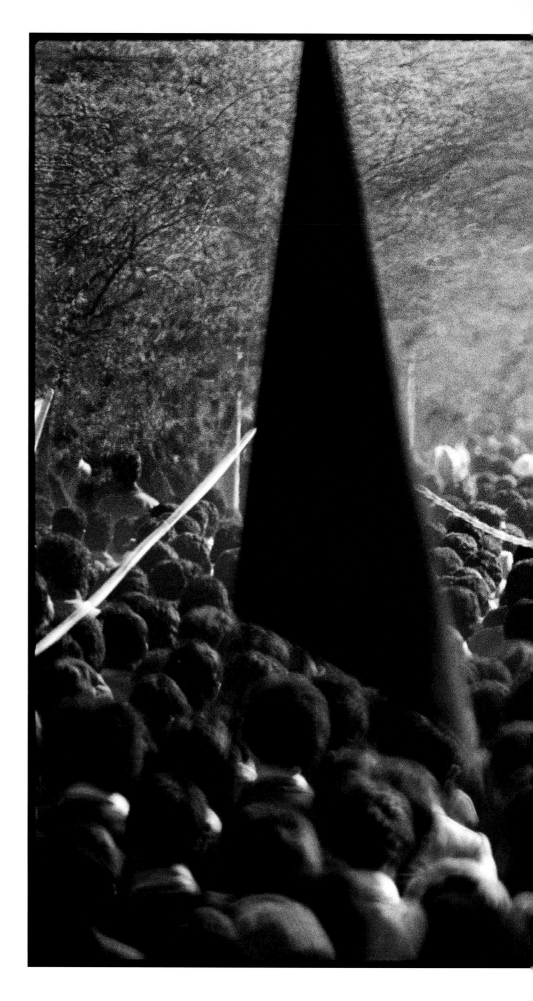

An anti-shah demonstration.
Ahwaz, January 8, 1979

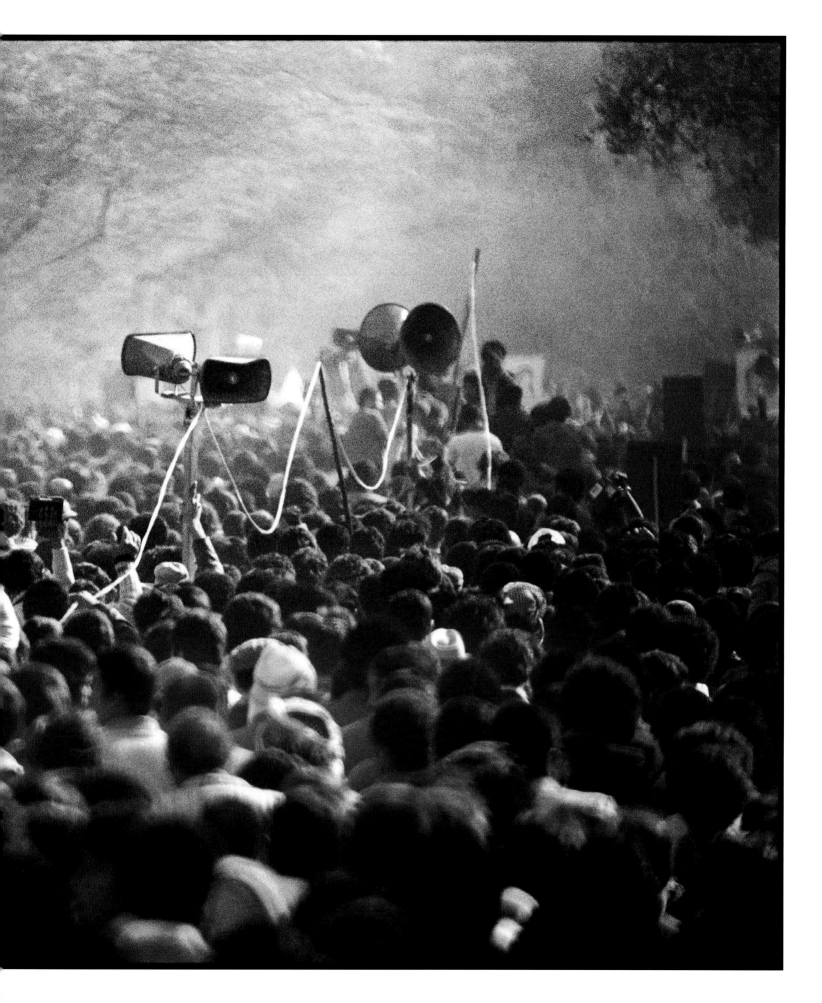

DAY 14

JANUARY 8, 1979 To force the shah's hand, much of the country is on strike: the banks, factories, and shops. But it's the closure of the oil spigot that really has the West on edge.

It's logical then to make a visit to Ahwaz, the big petrochemical town in southern Iran. I drive down with Dean Brelis, a senior *Time* correspondent. Dean, who lived in Athens, has rejoined the *Time* news service after more than a decade with CBS Television. We worked together two years earlier in Ethiopia, documenting the movements of the Eritrean Liberation Force Front in the western part of the country, near Sudan, and we get along well. There's something very bonding about 12-hour bus rides and picking sand off goat kebabs cooked over open desert fires. In his 50s, Dean calls me "junior."

When we reach Ahwaz, we drive slowly into town. Through the lowered window in the back seat, I notice some protesters gathering, preparing to march, and I squeeze off a few quick frames. But unlike the previous weeks in Tehran, this time when a small group of men in the crowd spot me, they run toward the car. I pop the exposed rolls out of the cameras into my socks and reload. Despite our attempts to explain who we are, they demand the film. I give them the fresh rolls and they leave, satisfied. But it's a reminder: In a volatile crowd, the less you're noticed the better.

As expected, almost everything in Ahwaz is closed. The oil company is very uptight about the press, and it takes hours of chatting up workers before I'm allowed to make a few shots of tanker trucks being gassed up at the docks. When the light starts to fade, we head back to Tehran, and I've got little to show for it.

Nearing the capital, many cars and trucks lie overturned in the winter's first snowfall. The storm has blanketed the city's outskirts, and light, powdery sugar flakes coat the trees, the stalled construction, half-dug metro tunnels, lifeless cranes, and the incomplete skeletal buildings, now cast in stark relief by the snow.

Near the central market after Friday prayers.
Tehran, January 12, 1979

TEHRAN UNIVERSITY DEMONSTRATION

On January 13, 1979, Prime Minister Shapour Bakhtiar announced the formation of a nine-member Regency Council, a constitutional move intended to preserve the monarchy after the shah's departure from the country. The council's establishment, and the "illegal" Bakhtiar government, were immediately denounced by Ayatollah Khomeini from exile in Neauphle-le-Château, outside Paris. Khomeini in turn announced the formation of an Islamic Council of Revolution to oversee the establishment of a provisional government.

The same day, Tehran University, closed by authorities the previous June as a hotbed of anti-shah dissent, finally reopened. Tellingly, the reopening of the country's largest and oldest educational establishment was undertaken not by the government, but by the professors themselves following a three-week sit-down strike. In an effort to avoid confrontation in the midst of the youth-driven revolution, Bakhtiar ordered all nearby military personnel to withdraw. The result was the largest demonstration Tehran had seen in a month. A crowd estimated by state radio at 400,000 spread peacefully over the football fields and chanted, "This is your last moment, American shah."

Two very different futures hovered before Iran. And neither included Mohammad Reza Pahlavi.

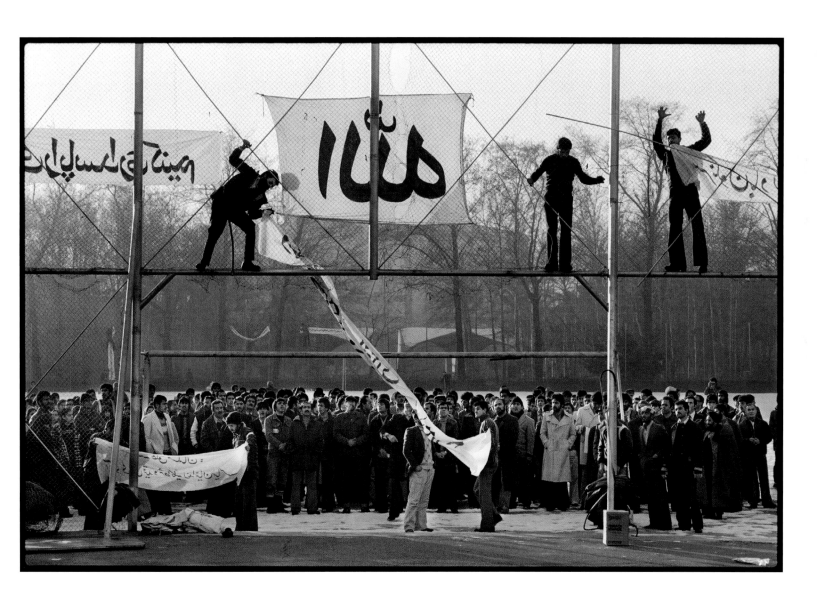

Demonstrators gather at the university, reopened for the first time in months. The large banner in the center says "Allah." Tehran, January 13, 1979

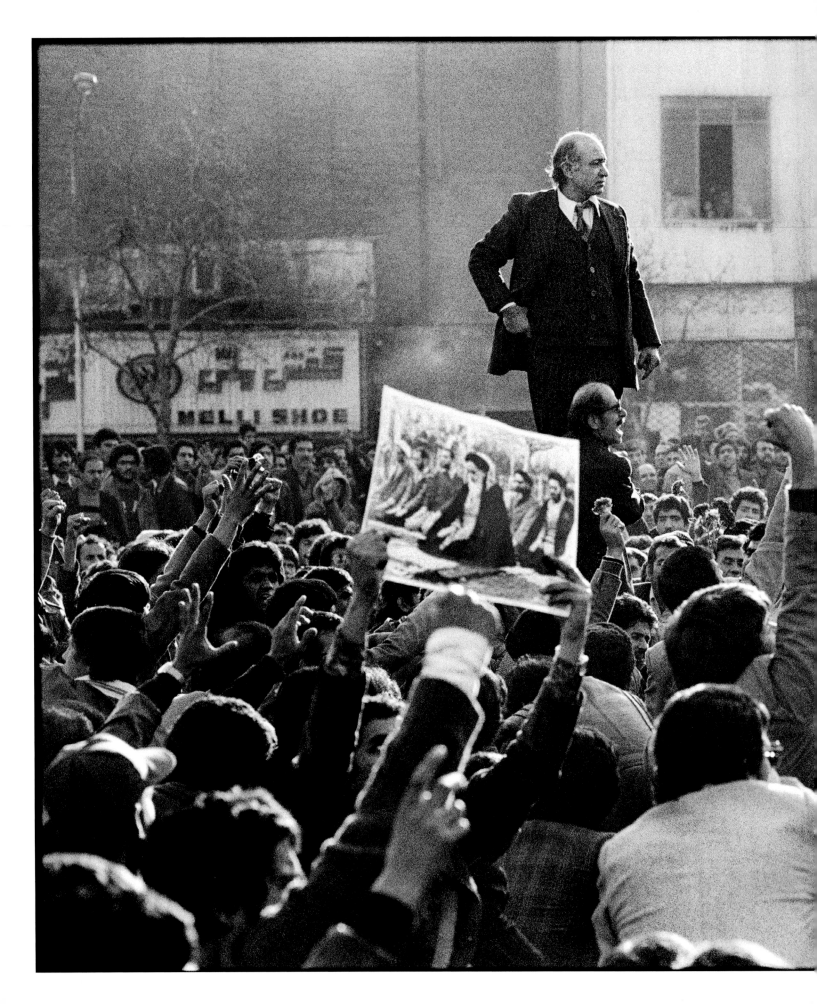

Anti-shah demonstration near the university.
Tehran, January 13, 1979

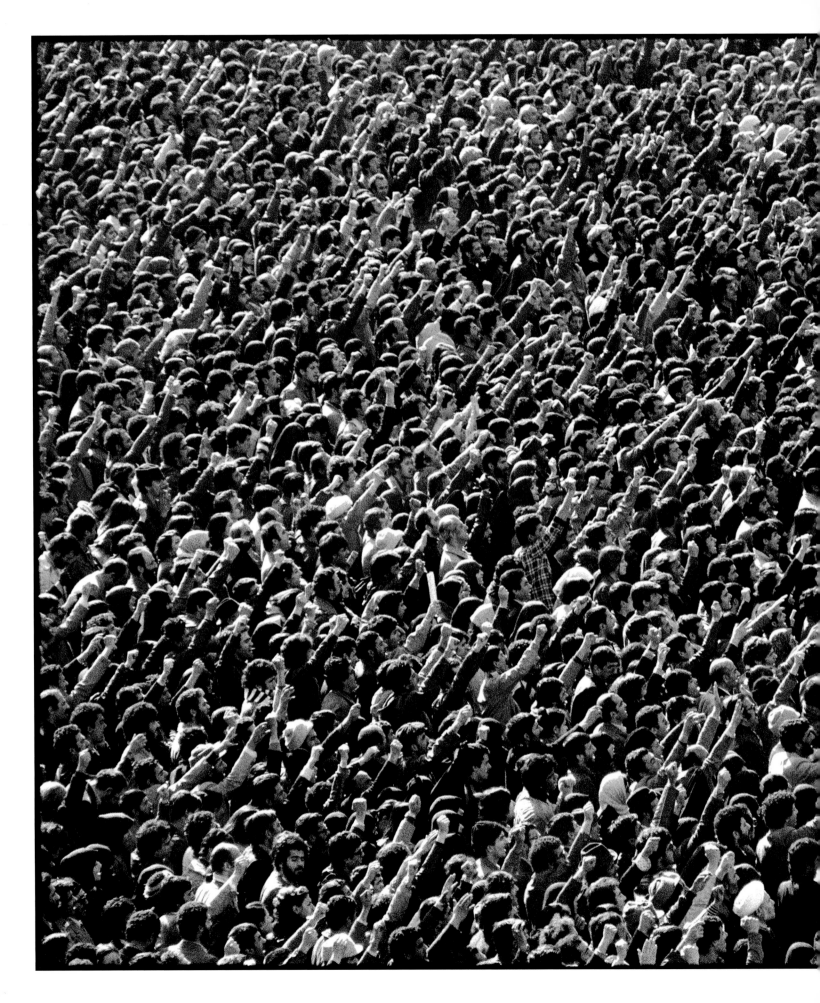

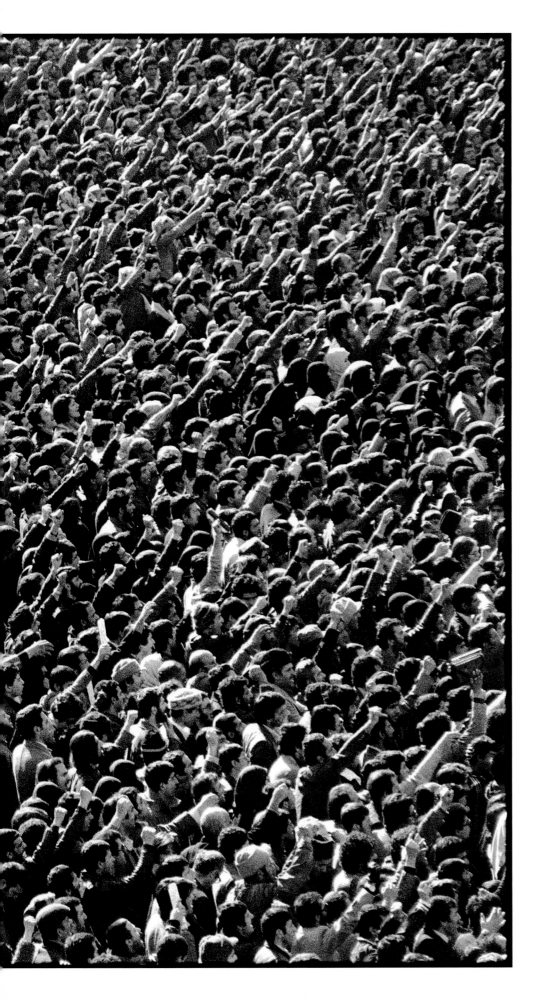

Anti-shah demonstrators at the university.
Tehran, January 13, 1979

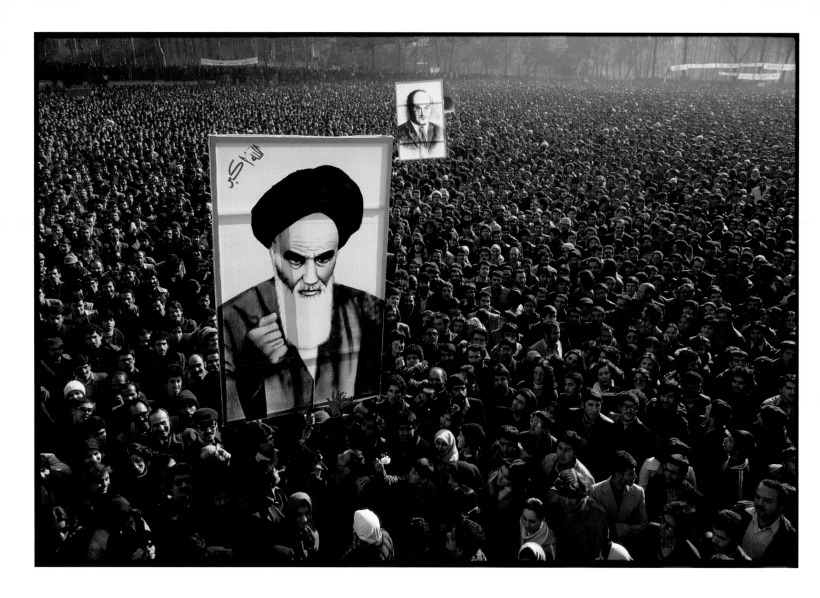

ABOVE: Anti-shah demonstrators at Tehran University
hold up hand-painted canvasses of Ayatollah Khomeini
and the late prime minister Mohammed Mossadegh.
OPPOSITE: The crowd listens to a speech by
Ayatollah Mahmoud Taleghani. Karim Sanjabi,
leader of the National Front, is to his right (in hat).
Tehran, January 13, 1979

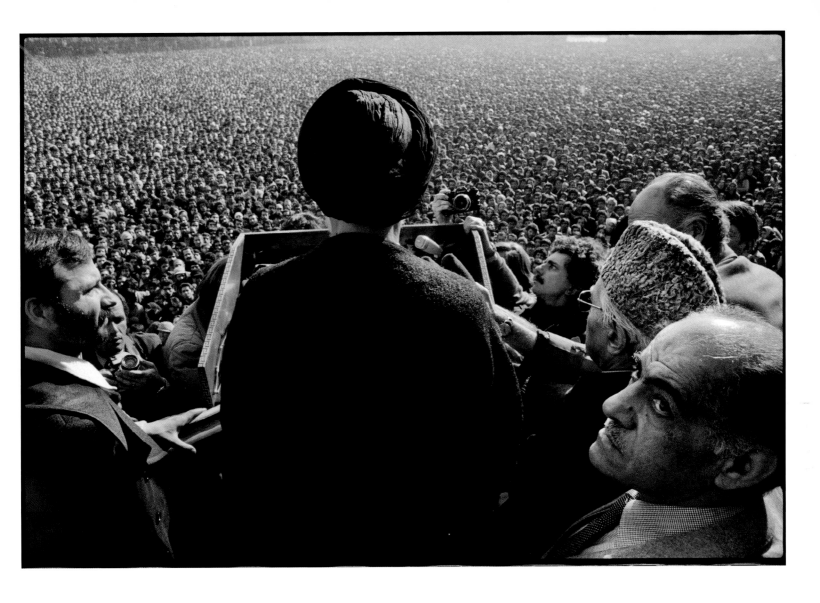

DAY 19

JANUARY 13, 1979 One night, Abbas invites me to a party. A few years older than I, Abbas is an Iranian-born photographer from Paris who is always helpful in trying to explain the intricacy of a situation. The details of insurrection are complex. It's not just a matter of trying to see it happening, but jumping on the merry-go-round and becoming a part of it.

The party is full of Iranian Parisian leftists trying to shape the revolution along the lines of May '68 or something similarly *moderne.* For a secular bunch, they seem strangely unperturbed by the rise of the clergy. One of Abbas' friends suggests they're merely an expedient political solution. I'm a little more doubtful: "It strikes me as odd that you'll be able to use the clergy as a crowbar to get rid of the shah and then somehow get them to relinquish power," I tell him.

Full of confidence and a little hubris, he sets me straight. "You know nothing about Iran," he says. "And you know nothing of Iranian politics."

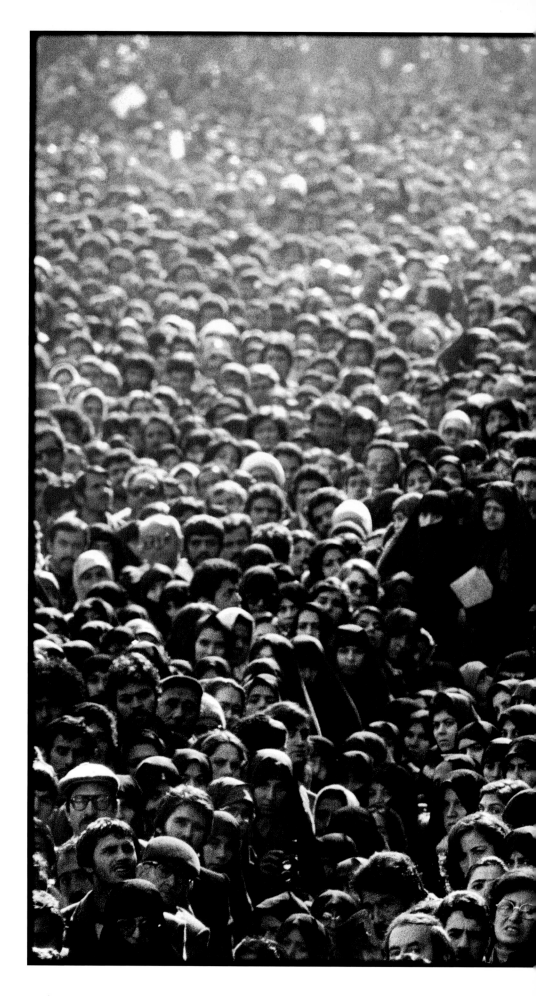

The crowd at the university listens to a
speech by Ayatollah Mahmoud Taleghani.
Tehran, January 13, 1979

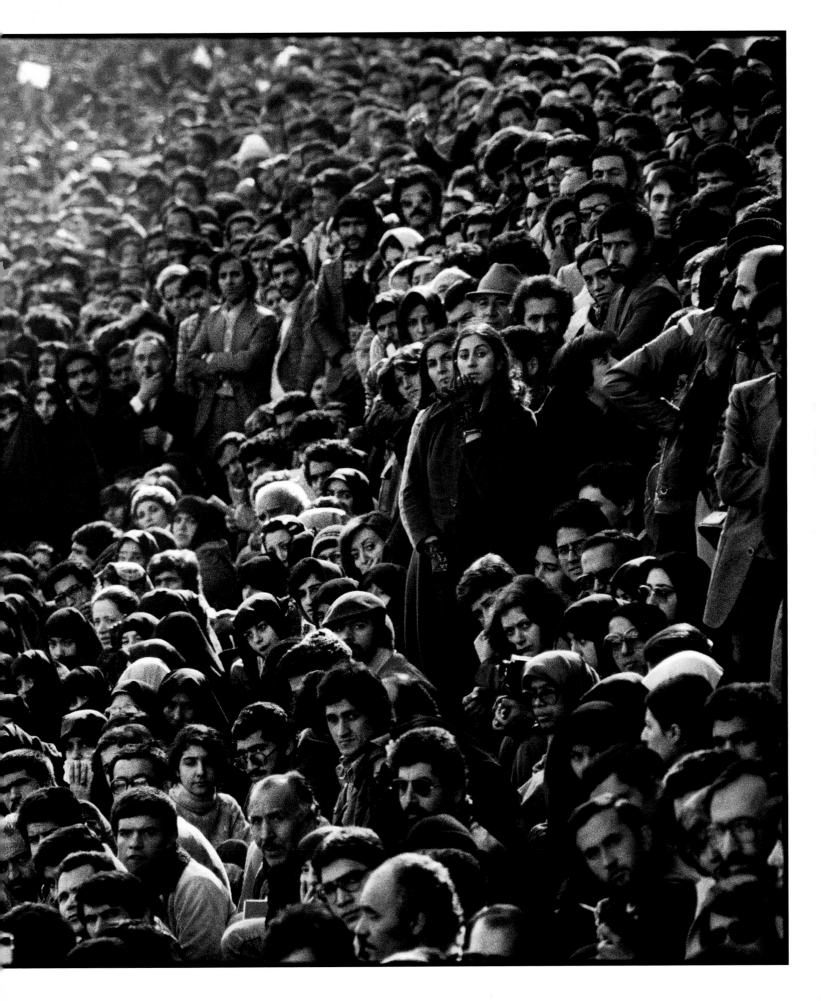

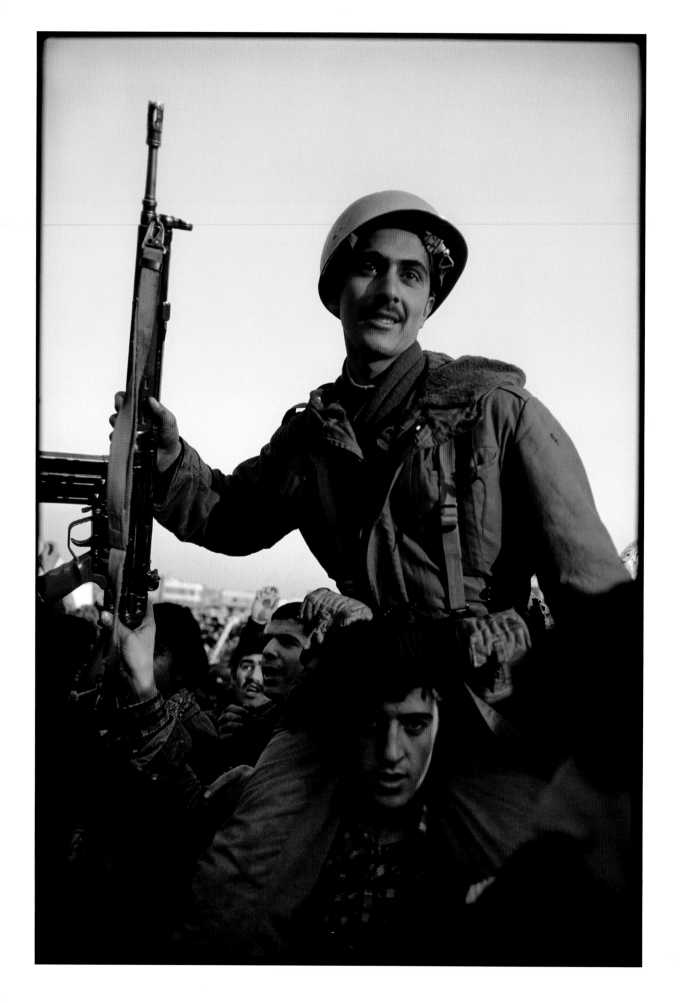

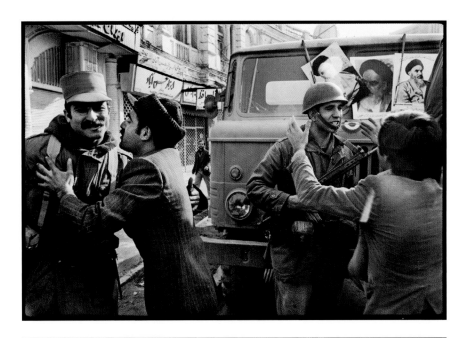

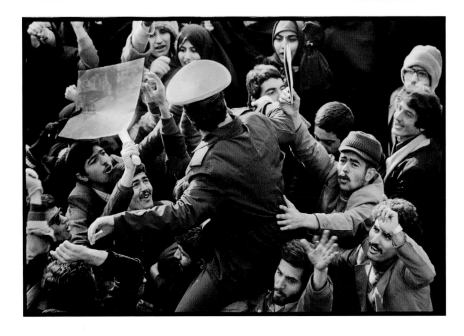

OPPOSITE AND TOP AND BOTTOM: Soldiers join the anti-shah protesters during the university demonstration.
MIDDLE: Security agents keep an eye on the crowd.
Tehran, January 13, 1979

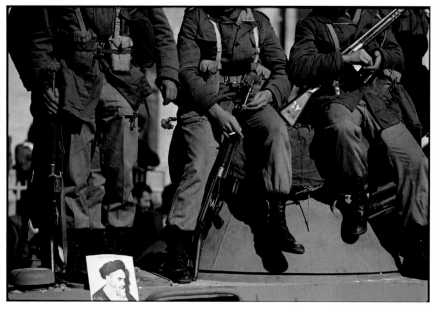

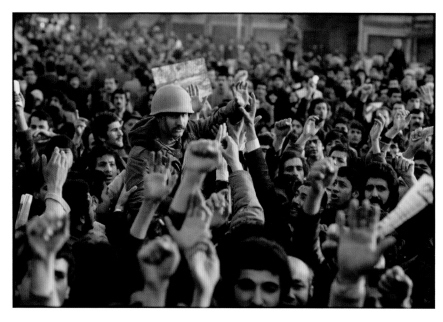

TOP: A woman at a unity march against the shah.
MIDDLE AND BOTTOM: Soldiers join the revolutionaries.
OPPOSITE: A reporter at the Intercontinental Hotel works by emergency light in the hallway during a power outage.
Tehran, January 15, 1979

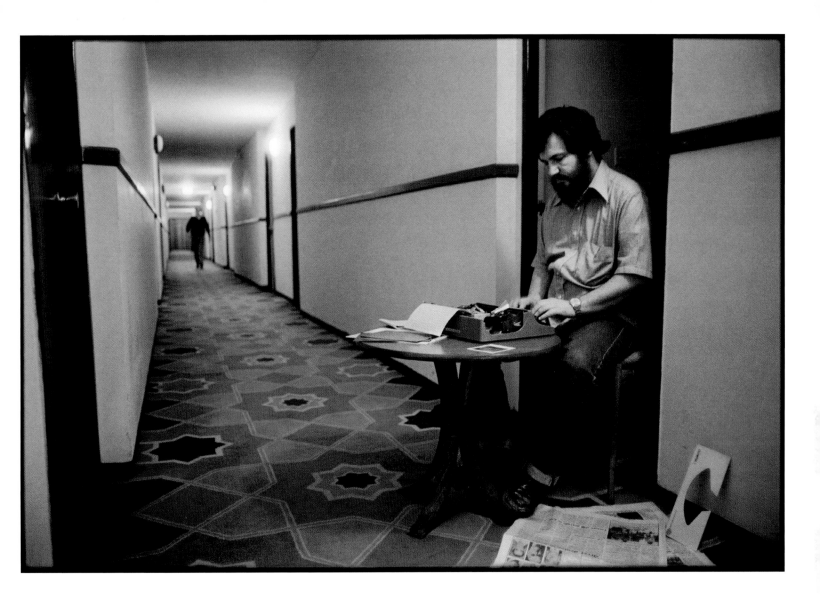

DAY 21 **JANUARY 15, 1979** The night before the shah's scheduled departure, a blackout hits the Intercontinental, forcing all the reporters out of their rooms and into the hallways and the lobby, which are lit with emergency lamps. Johnny Apple is there, and so are Michael Burns of the *Baltimore Sun* and Jon Randal and Bill Brannigan from the *Washington Post*. At another table sits Joe Alex Morris of the *Los Angeles Times*. Olivetti portables, the foreign correspondent's typewriter of choice, fill the corridors with an unmistakable metallic pecking sound; blue leather carrying cases lie on every table.

THE SHAH LEAVES

On January 16, 1979, at about 12:30 p.m., the shah and his wife, Farah Diba, left Niavaran Palace in northern Tehran and boarded one of the four waiting khaki-colored helicopters. Fifteen minutes later they landed near the Imperial Pavilion at Mehrabad Airport, where they had formerly greeted visiting heads of state.

The Iranian parliament, the Majles, had given its final approval to the government of Prime Minister Bakhtiar, fulfilling the embattled shah's last prerequisite before departure. During a brief farewell speech to a small group that included Bakhtiar and other government officials, the 59-year-old monarch grew teary-eyed. "I hope the government will make amends for the past and proceed in laying the foundation for the future." After kissing a Koran, he and Farah Diba boarded the royal jet, a silver-and-blue Boeing 707. At 1:24 p.m., after a year of revolutionary struggle, the shah took the controls and piloted the plane toward Egypt.

After word of the shah's departure was broadcast on the state radio at 2 p.m., ecstatic Iranians took to the streets, tearing down statues and rampaging over symbols of the ancien régime. In Paris, Ayatollah Khomeini, calling the shah's departure only the "preface to our victory," took aim at Bakhtiar and the Regency Council, calling on Iranians to stage a mass march on the coming Friday in protest of the "illegal" government. One million Iranians responded, setting in motion a contest between two parallel governments—Bakhtiar's, nominally backed by the military, and Khomeini's, nominally backed by the people.

A Huey helicopter carries the shah and the empress to the Imperial Pavilion at Mehrabad Airport for their flight into exile. Tehran, January 16, 1979

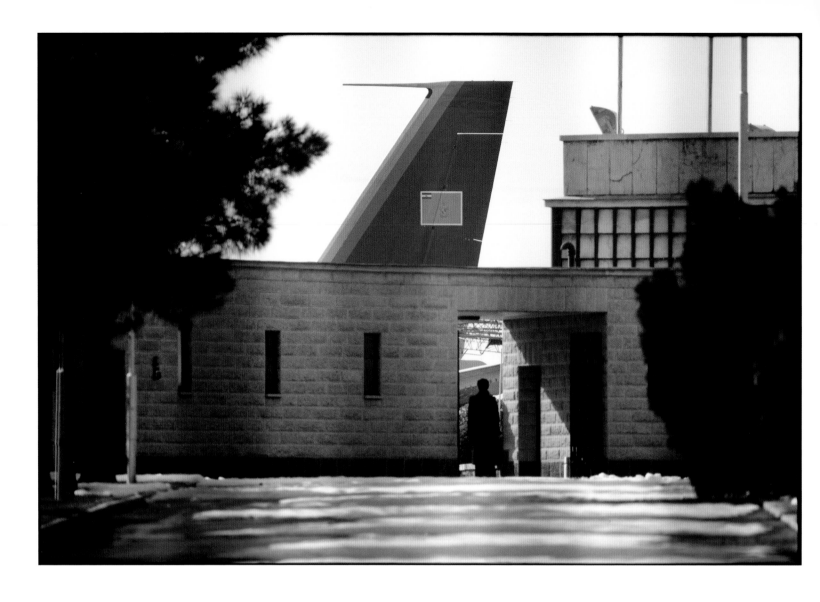

The tail of the shah's Boeing 707 is visible as
it taxis down the runway at Mehrabad Airport,
taking the monarch into exile.
Tehran, January 16, 1979

DAY 22 **JANUARY 16, 1979** In the morning we receive word that the shah's flight into exile is imminent. A bus is arranged to take the press to the airport, the "royal" terminal rather than the usual passenger terminal—but when we get there the guards don't let us through.

The grousing begins immediately. As usual, a sympathetic and powerless official from the government press office makes excuses. A road goes up to the building and that's as close as we get, parked behind the fence and standing around hoping.

I'm next to Bert Quint, the longtime CBS correspondent. The "fireman" of the Walter Cronkite team, Bert is a 30-year veteran who has covered Vietnam, the Congo, and a dozen other wars. If anyone gets in, I think, it's going to be him. But this time the gates remain shut. After about an hour we hear a jet start to taxi and glimpse the blue tail of the royal Boeing slide past the terminal building. I shoot a few quick frames. Then the roar of jet noise slowly diminishes and it's gone. He's gone.

AFTER THE FALL

JANUARY 16, 1979 – JANUARY 31, 1979

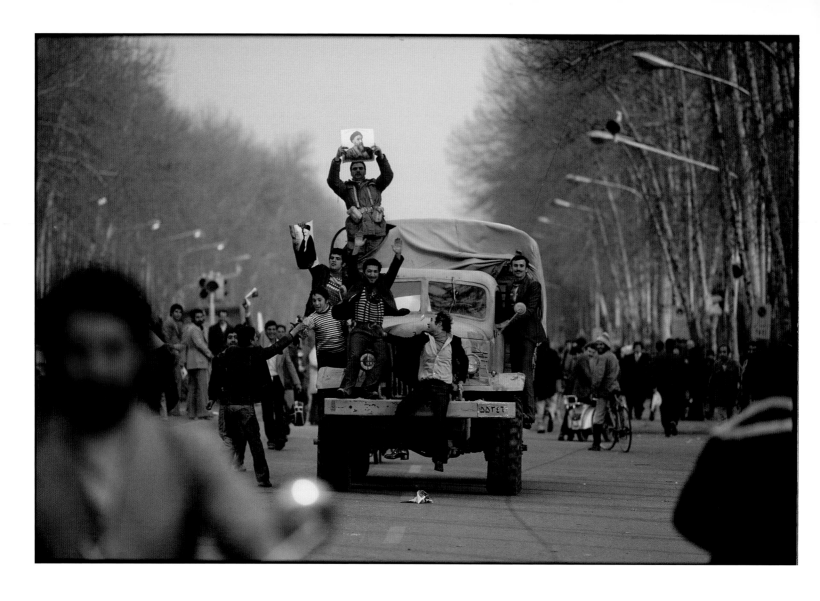

ABOVE: Jubilant men ride on an army truck after the announcement of the shah's departure.
OPPOSITE: Men hold up a 100-rial banknote with the shah's face cut out and replaced by that of Ayatollah Khomeini.
Tehran, January 16, 1979

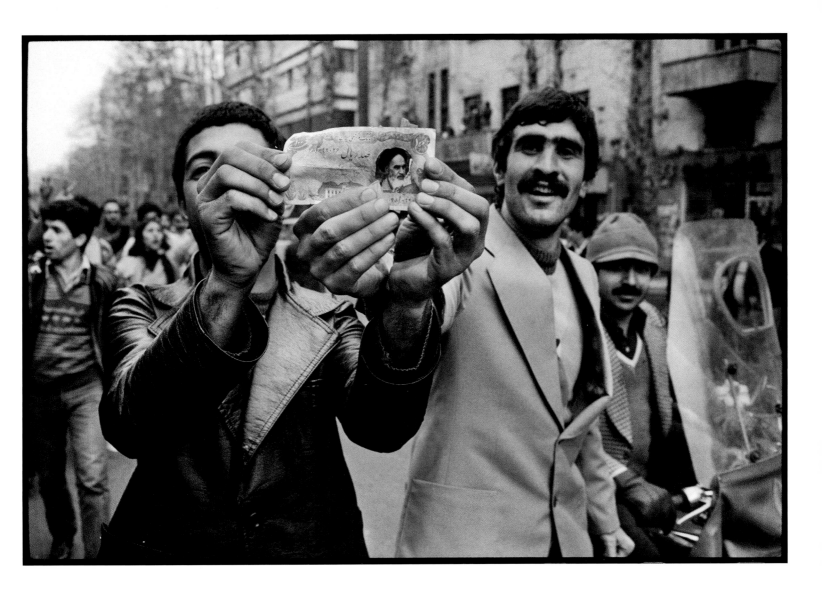

DAY 22

JANUARY 16, 1979 Word that the shah has left spreads quickly. Within an hour, the same people who have been rallying against him are out in the street, cheering and surging and waving and mugging for the camera. Many hold up rials, the Iranian currency, with the shah's picture torn out. A traffic jam of cars and buses blare their horns and jubilant crowds run through the street with their posters of Khomeini. For the first time in days, many of the faces in the crowds are smiling.

In Mordad Square, a statue of a farmer and workers put up by the shah is toppled. In Shahyad Square, another statue, of the shah's father, Reza Pahlavi, is pulled down and dragged through the streets. The crowd tries to pull it up to a highway overpass using a shovel, but it doesn't work, and the statue lies there, lifeless.

As night falls, waves of marauders, suddenly unrestrained by curfews, roam around in groups, burning posters and effigies of the shah and jumping on the downed statues. Because of the curfew, it's probably the first time I've shot at night since I got to Iran, and there is a furtive, electric feeling to it—fleeting moments when the revelers are suddenly frozen in the light of my strobe or the headlights of passing cars.

Downtown celebrations after the
announcement of Shah Mohammad
Reza Pahlavi's departure.
Tehran, January 16, 1979

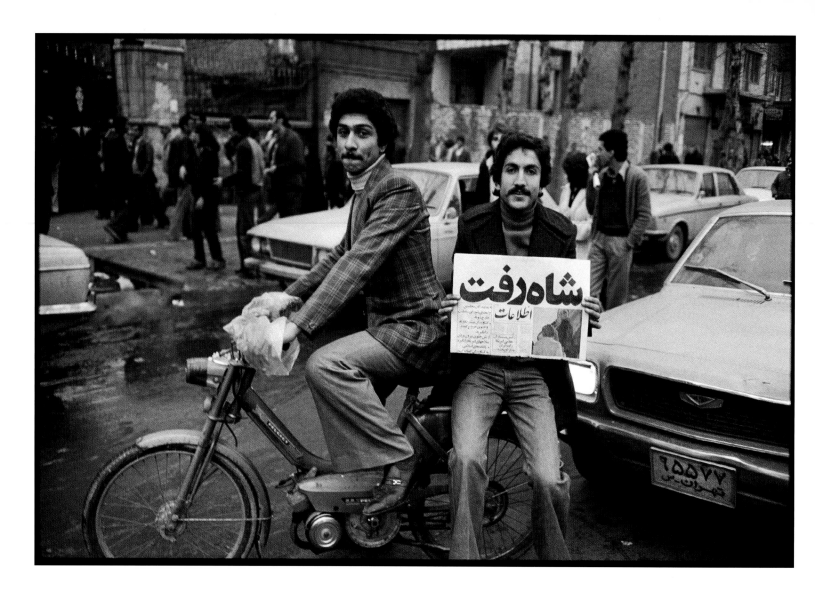

ABOVE: A newspaper announces, "Shah is Gone."
OPPOSITE: Iranians celebrate the shah's departure.
Tehran, January 16, 1979

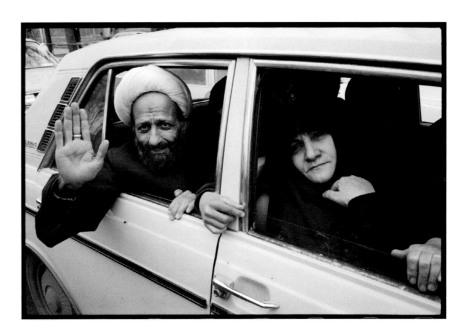

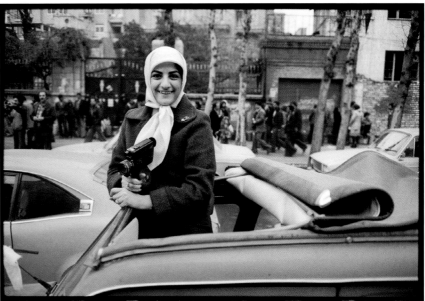

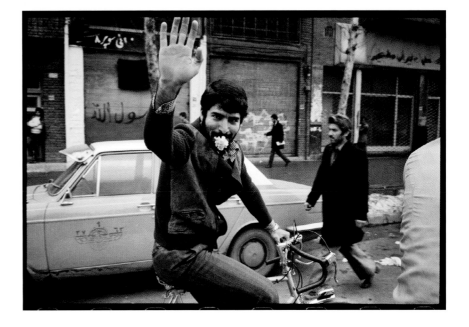

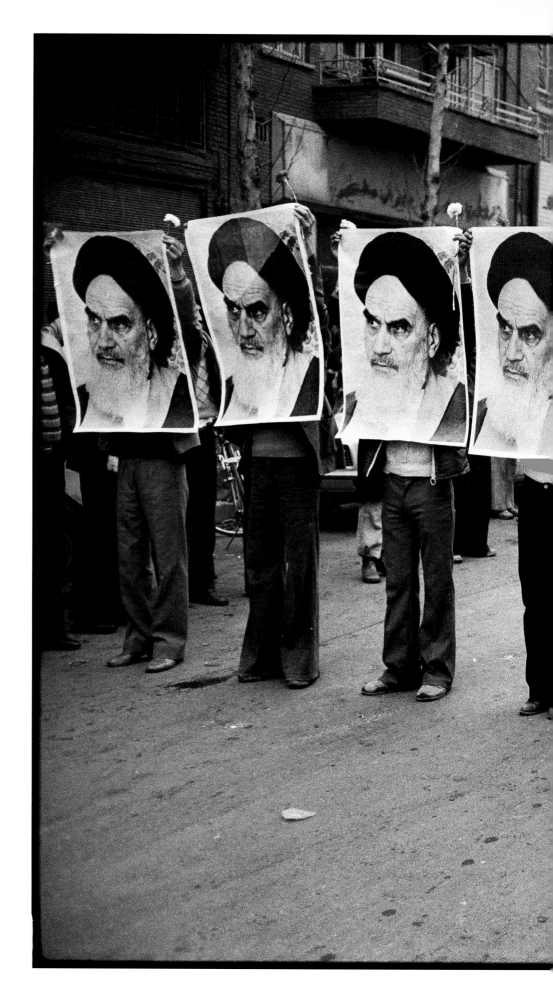

Marchers hold aloft posters of Ayatollah
Khomeini after the shah's departure.
Tehran, January 16, 1979

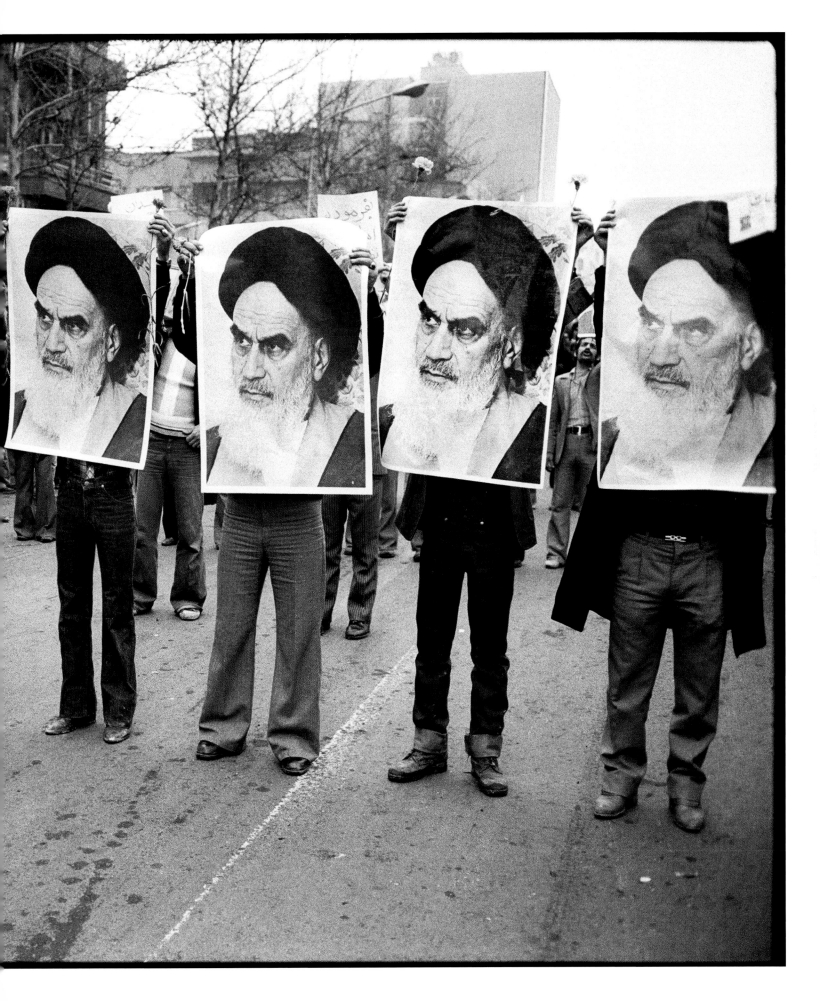

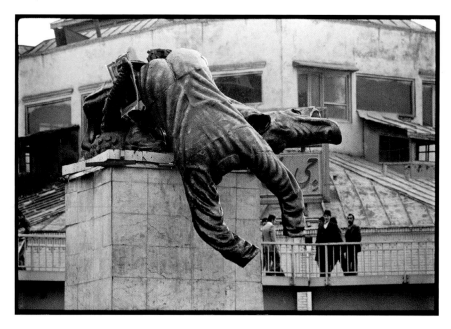

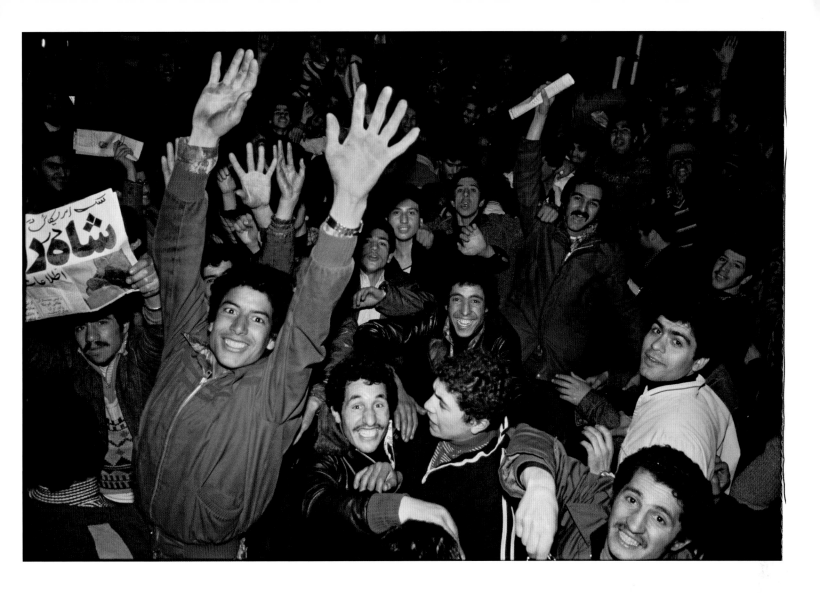

ABOVE: Celebrations continue all night in the capital.
OPPOSITE TOP: A statue of the shah's father is smashed.
OPPOSITE MIDDLE AND BOTTOM: Scenes of celebration after the
departure of the shah. The shah is depicted as a cat
because the French for "cat" *(chat)* sounds like "shah."
Tehran, January 16, 1979.

ABOVE: A statue of the shah's father, Reza Shah, is toppled.
Tehran, January 16, 1979
OPPOSITE: Foreign journalists in the shah's
private office at Niavaran Palace.
Tehran, January 17, 1979

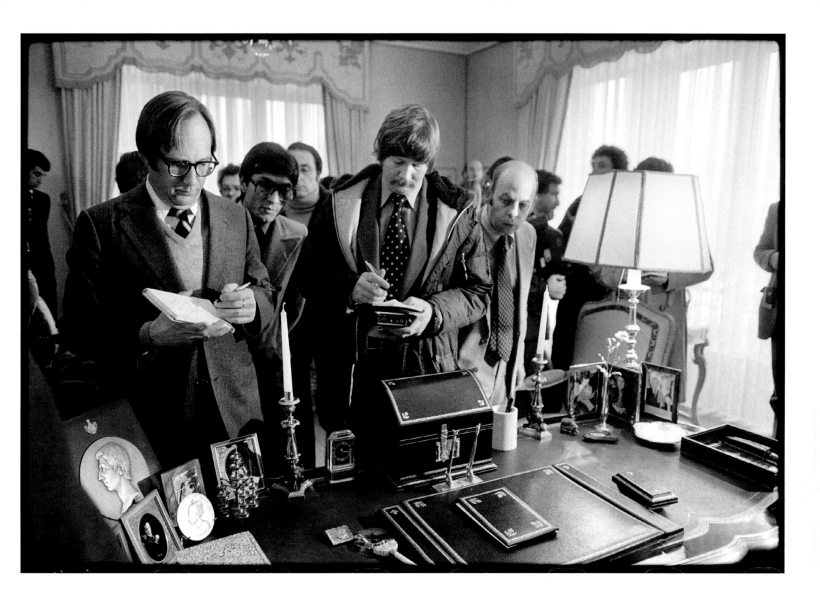

DAY 23

JANUARY 17, 1979 Most of the photographers I know covering the revolution are French. There's Olivier Rebbot, freelancing for *Newsweek;* Alain Keler, Alain Dejean, and Patrick Chauvel with the agency Sygma; Alain Mingam with Sipa; the Franco-Iranian Abbas with Magnum; and Catherine Leroy, the only woman on the scene. Like me, she is shooting for *Time.*

Besides that, there's Englishman Bob Dear with AP, and Tom Cargas, an American staffer with UPI. There's also a coterie of Iranians, including Hatami, who had lived in Paris for 20 years, and Kaveh Golestan, an intense young photographer who's returned to his country from abroad just in time.

These are the main people I see every day—maybe a dozen photographers for the entire story.

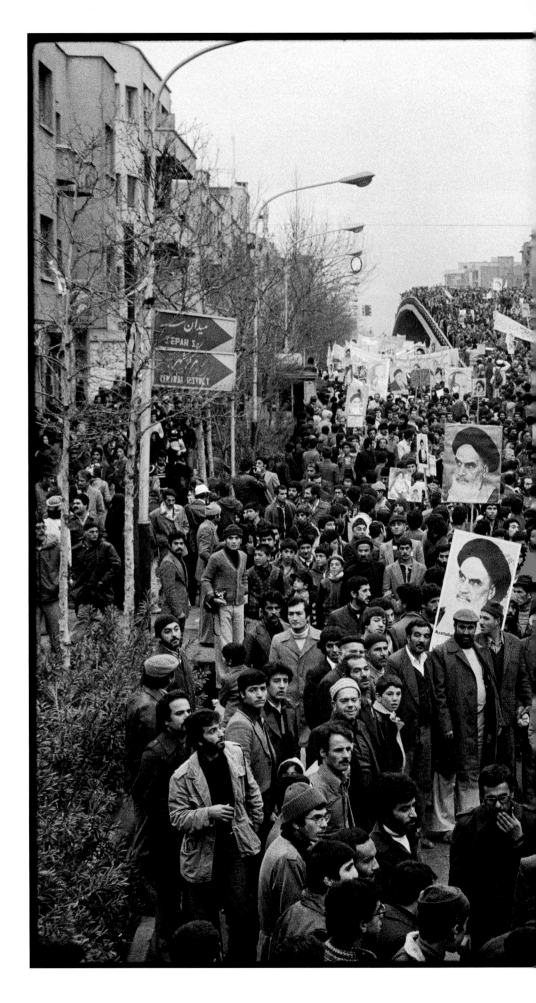

A crowd estimated at one million
en route to Shahyad Square in
support of Ayatollah Khomeini's return.
Tehran, January 24, 1979

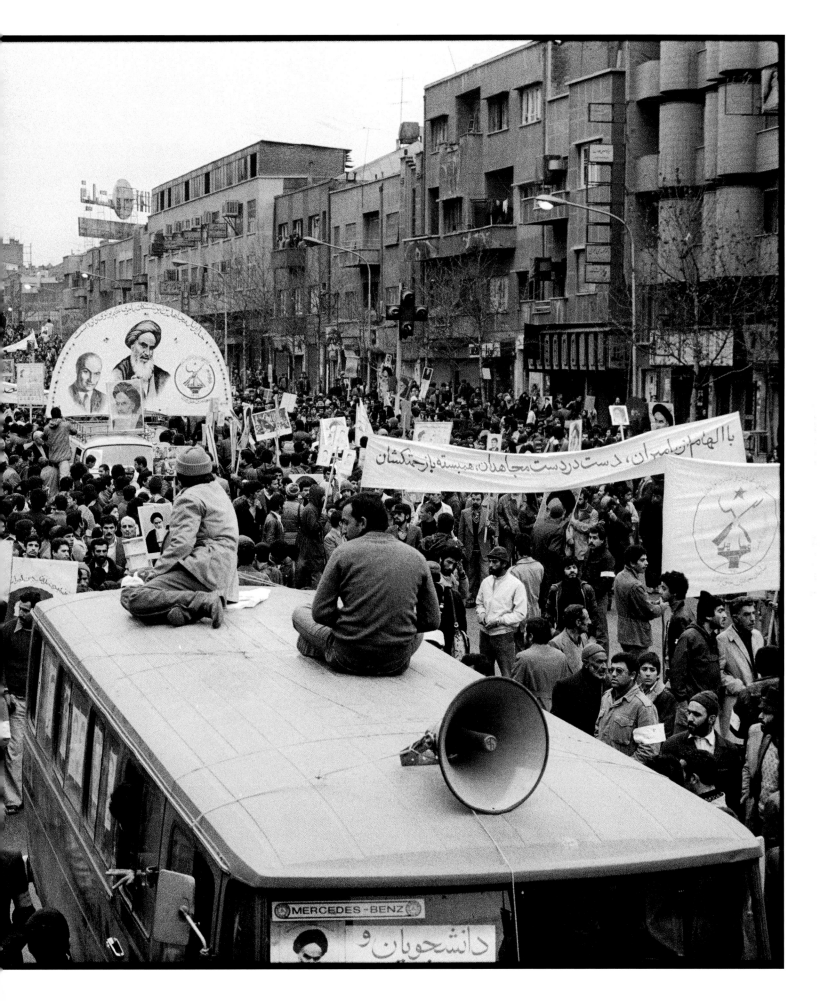

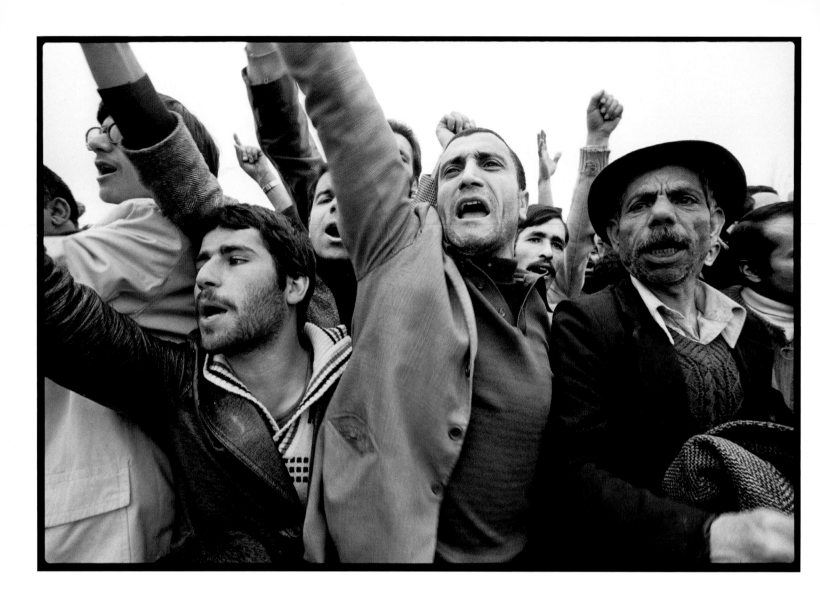

ABOVE AND OPPOSITE: Surging pro-Khomeini
demonstrators at Shahyad Square.
Tehran, January 19, 1979

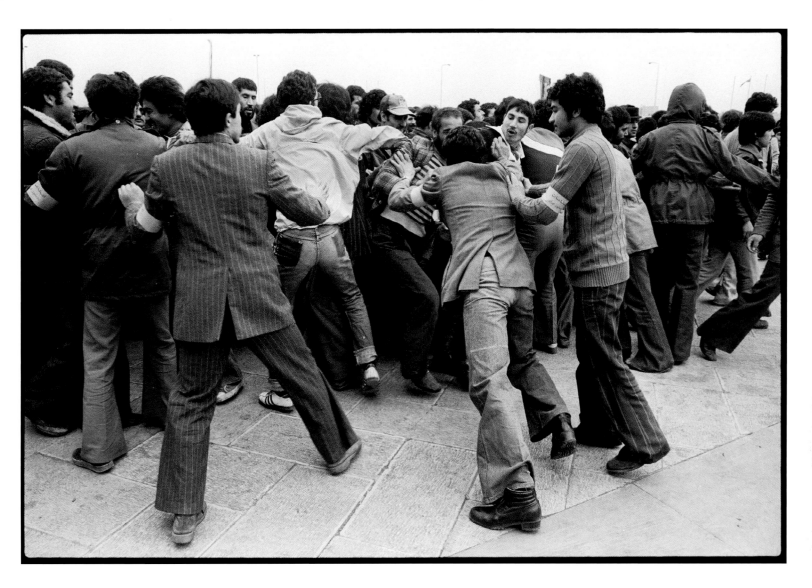

DAY 25 **JANUARY 19, 1979** On one of my first days in the country an Iranian man asked me where I was from. I told him New York: big mistake. "Why did the Americans do this? Why did they do that?" All of a sudden it was as if I were Jimmy Carter's official representative, personally accountable for each one of the shah's crimes. I thought to myself, "It's going to take me an hour to get out of this—this is stupid."

Since then I've told people I'm Canadian, or French. The shah was really cozy with the last four U.S. Presidents, so there's a pretty high level of mistrust and anger toward anything American. At the same time, when I go to a demonstration at the Shahyad and a million people are chanting, "Death to America," I don't really feel that they're talking about me.

I've had a couple of very heated conversations with people who live in Isfahan, where Bell Helicopter's employees have their own little village. You can just see it; these well-paid Americans creating their own version of Fort Worth wherever they go, just like in Vietnam, and treating Iranians like second-class citizens. For them it's a good job. But a lot of Iranians take umbrage at how they act. Money and attitude—that's what's out in front.

No one ever talks about this, these bad ambassadors. Sure, plenty of students I've met would like to go to UCLA, but it's not that they have a warm fuzzy feeling about America. They're really pissed off.

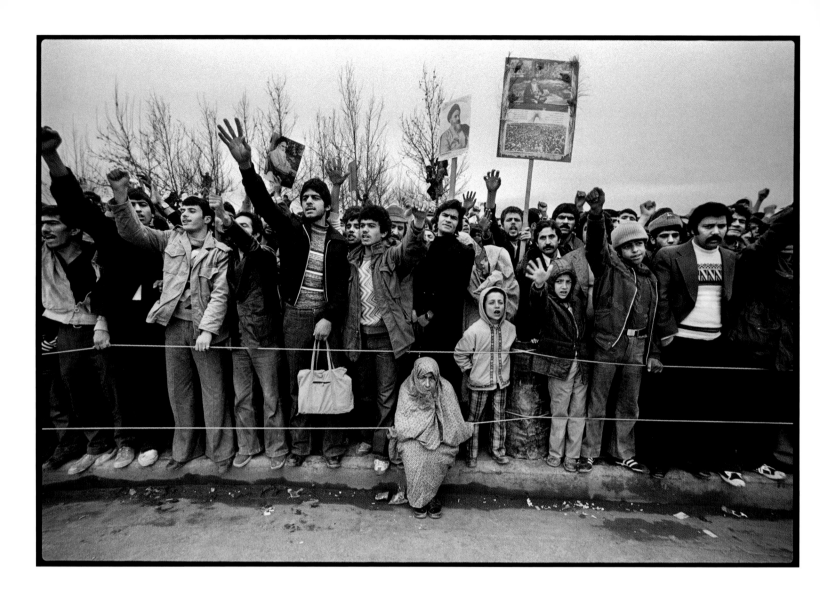

ABOVE: Ayatollah Khomeini supporters at Shahyad Square.
OPPOSITE: A pro-Khomeini demonstrator dons a jacket
decorated with photographs of victims of the shah's
repression and a hat that reads "crown of the martyrs."

FOLLOWING PAGES:
ABOVE: Clerics march toward Shahyad Square
in support of Ayatollah Khomeini.
BELOW: Ayatollah Khomeini supporters at Shahyad Square.
OPPOSITE: A demonstrator's jacket is decorated with
photographs of the shah's victims.
Tehran, January 19, 1979

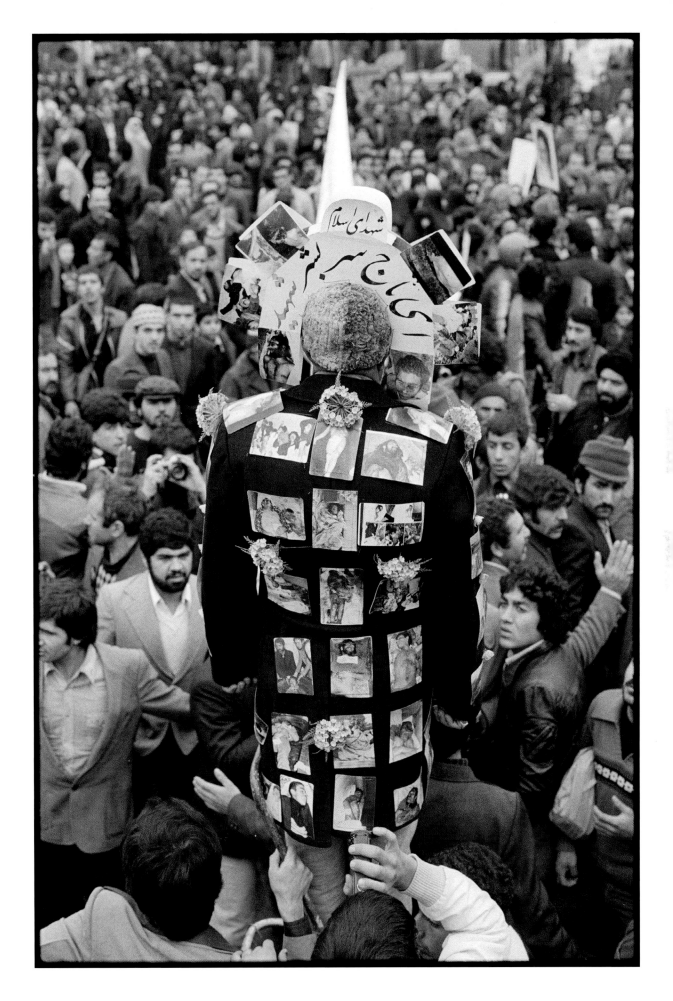

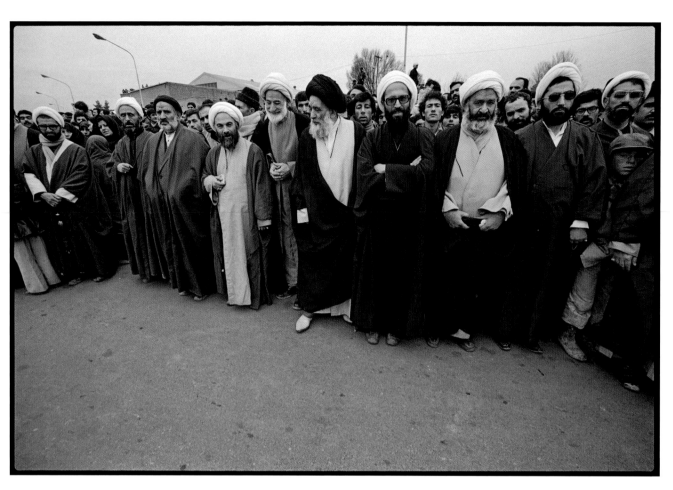

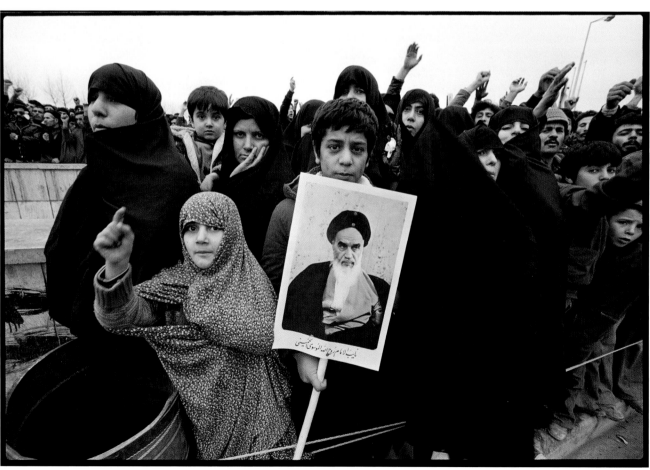

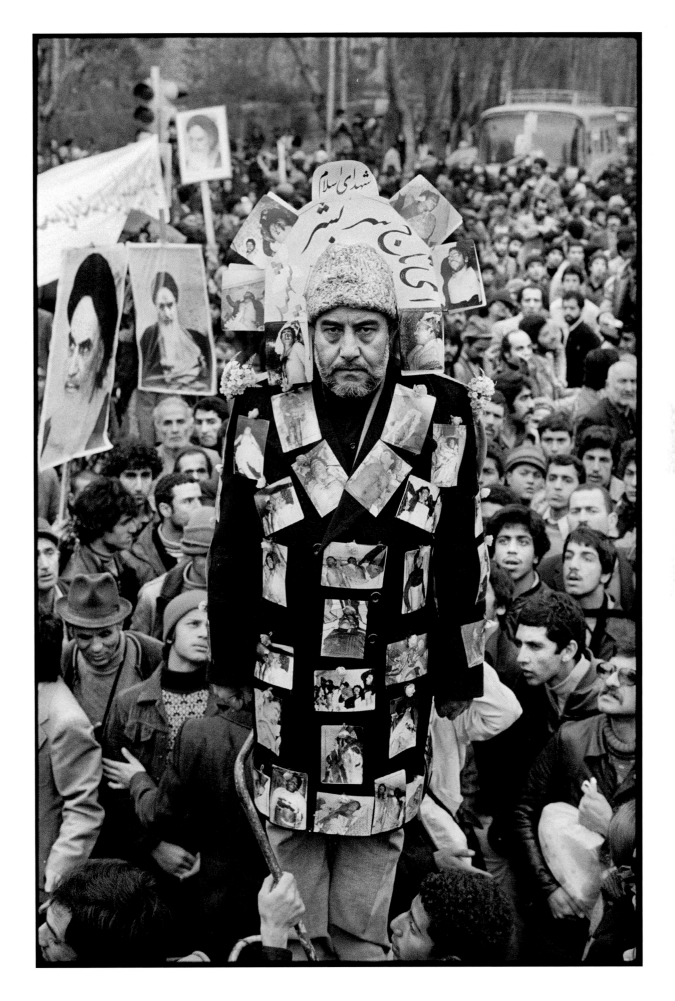

THE HOLY CITY

Qom, the religious heart of Iran and the antithesis to western-ized Tehran, is a hundred miles south of the capital. One of the holiest places and the most prominent research center in Shi-ite Islam, this is where a year earlier, after a slanderous attack on Ayatollah Khomeini in *Kayhan,* the government-controlled newspaper, enraged mullahs took to the streets and were met by bullets. Forty days later, at the end of the traditional mourning period, there were more killings, and more funerals. The 40-day cycle, begun in Qom, was the vicious circle that spiraled into the cyclone of revolution.

It was to Qom that the future ayatollah Ruhollah Khomeini, born in 1902, came to study in 1921. He would stay for the next 43 years, writing, lecturing, and assuming the absolutist line that ultimately led to his condemnation of the shah and his subsequent arrest in 1963. He was exiled to Najaf, Iraq, a year later.

At Ayatollah Khomeini's home, his housekeeper, who has kept up the house for 15 years, awaits his return. Qom, January 23, 1979

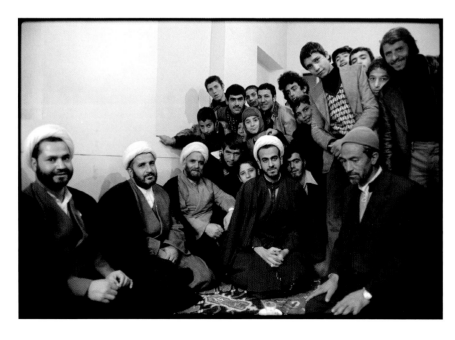

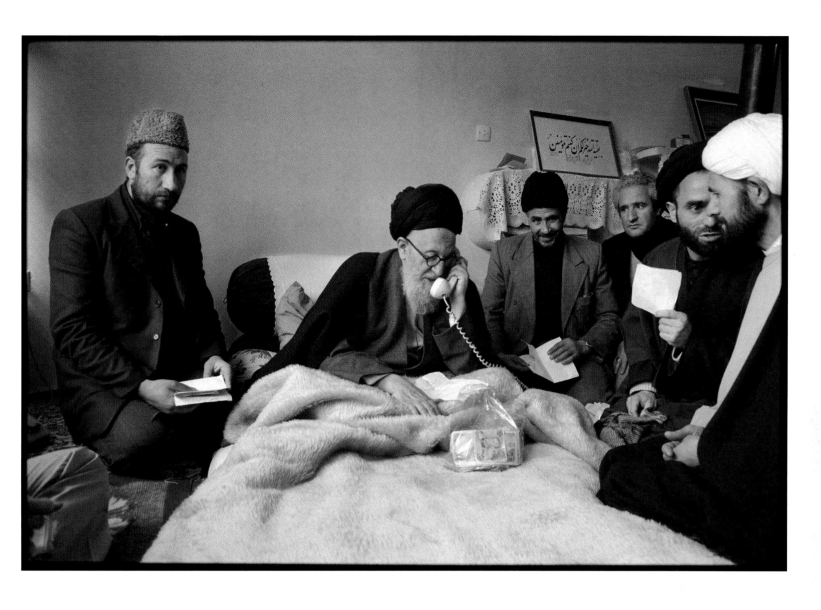

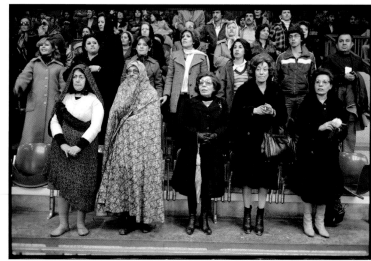

ABOVE LEFT AND RIGHT: Followers of the shah and Prime
Minister Bakhtiar hold a "pro-Constitution" rally. The sign
held by the man above reads, "We respect the law."

FOLLOWING PAGES: Clashes between pro-Khomeini followers
and supporters of Prime Minister Bakhtiar. The banner
reads, "independence, freedom, constitution."
Tehran, January 24, 1979

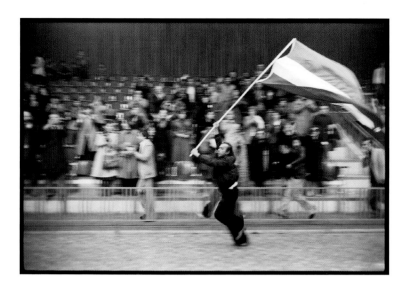

DAY 30

JANUARY 24, 1979 Before Khomeini's planned return, I attend an indoor rally held by the "pro-Constitution" forces. These are the people who still support the shah, support Bakhtiar, and are against turning Iran into an Islamic republic. In contrast to the opposition demonstrations in the street, the pro-shah event, held inside a sports hall, has the feeling of a pep rally, with people kissing Iranian flags and shouting "Freedom, Democracy, Constitution!" There are women in chadors, and women in furs. Some are crying with emotion, and a few are so worked up they start gasping and screaming.

When the rally ends, the "constitutionalists" exit into the snowy streets and begin to march. They pass several army trucks and the soldiers cheer them on, but a few minutes later they come close to a group of Khomeini supporters just down the road. The Khomeinites begin pelting them with rocks. I climb up a highway overpass and watch the pro-shah people below dodging projectiles and throwing some back.

At first the soldiers try to restrain the larger contingent of Khomeinites, but soon the two groups are hugging each other. Then the soldiers back off and head down the street. The jubilant Khomeinites cheer, and the pro-shah people beat a retreat.

To me this small clash, with the pro-shah forces on one side, pro-Khomeini forces on the other, and the army in between, exactly sums up what's happening in a much larger way all over the city and the country. In literally a matter of minutes I've watched the turn of the screw—how the army, when confronted with a choice between throwing its support behind its dwindling traditional base or to a much larger group of rebels, quickly swings its allegiance from the king to Khomeini.

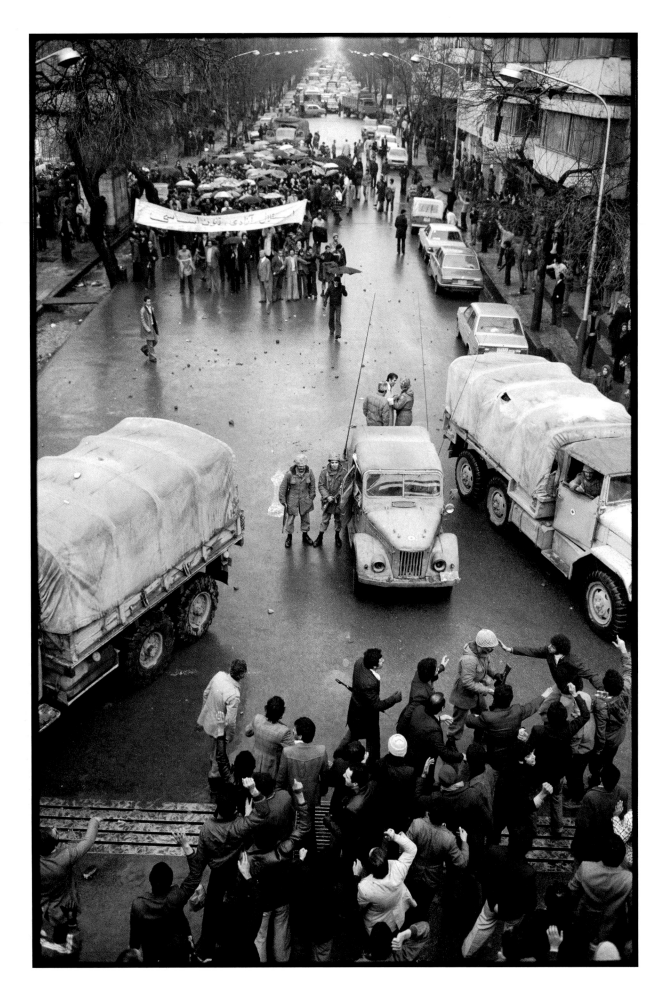

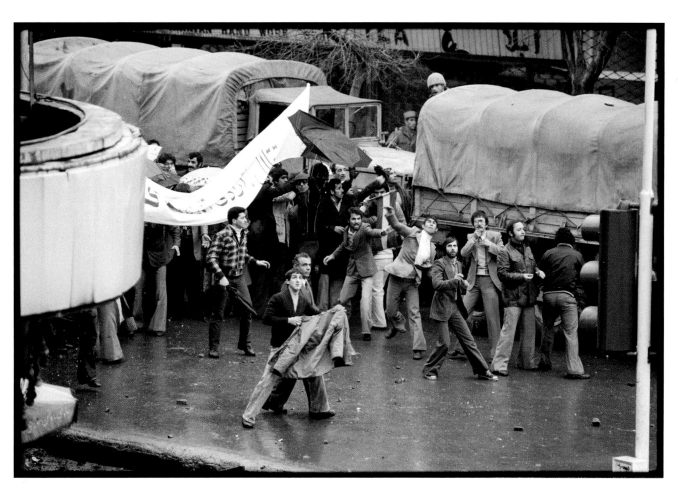

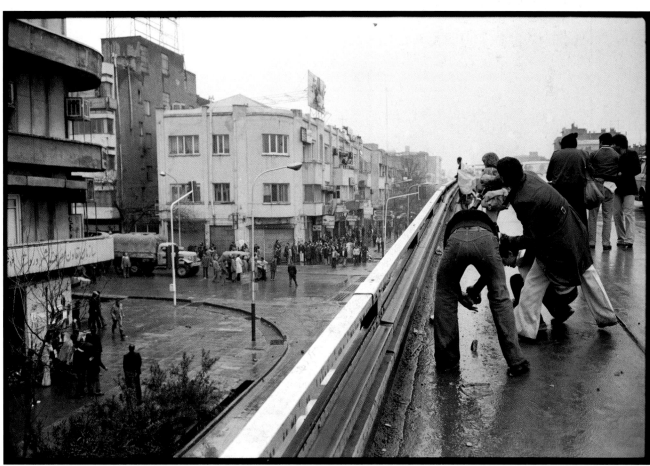

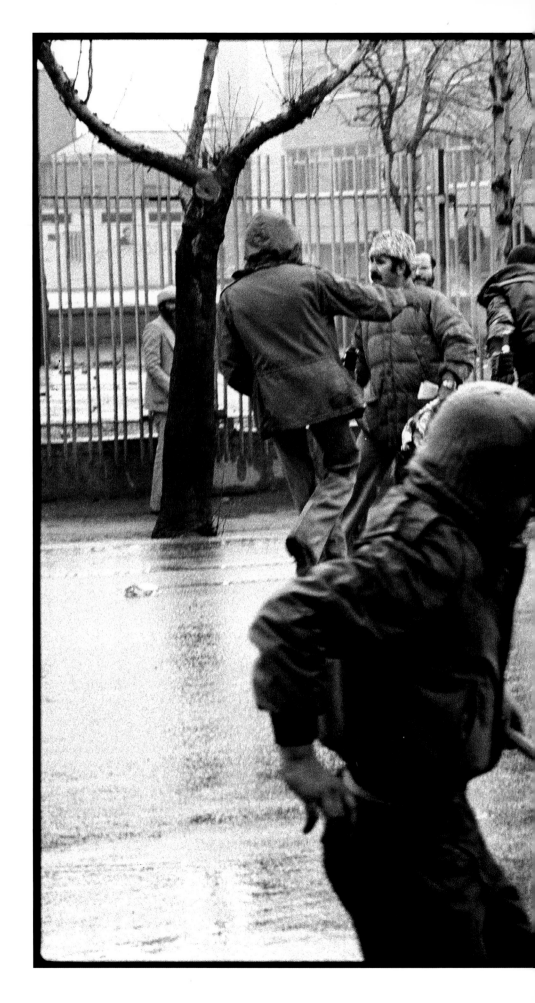

Pro-Khomeini supporters attack
"pro-Constitutionalists"—shah supporters.
Tehran, January 24, 1979

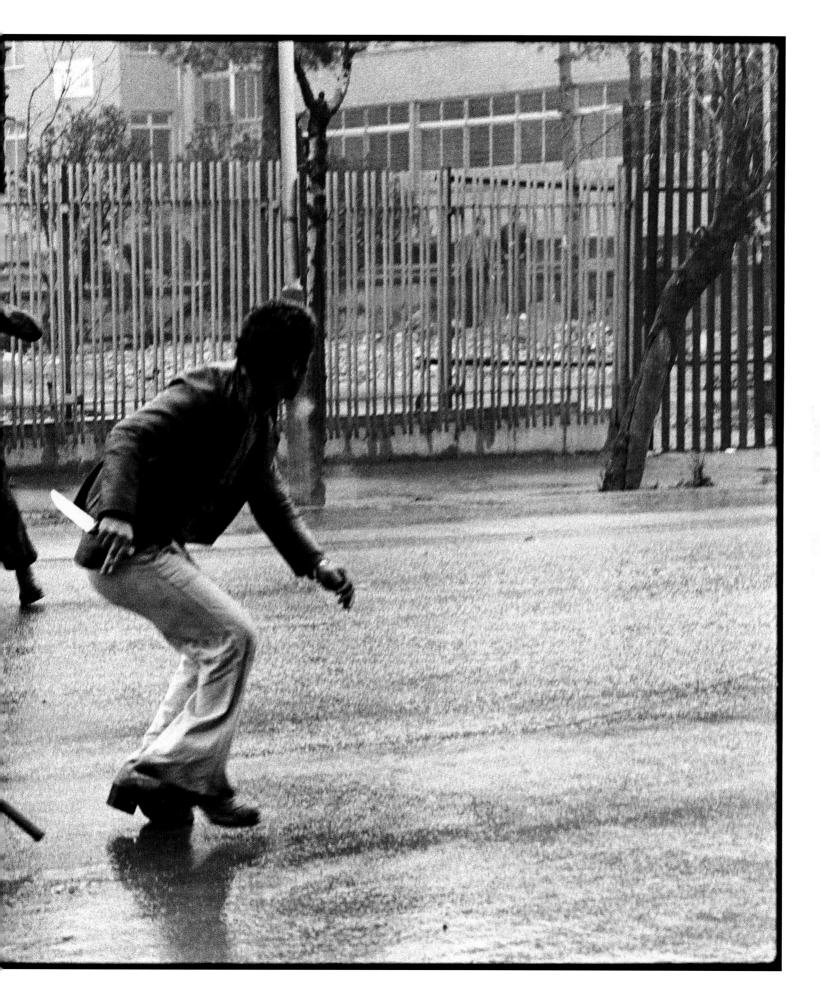

A woman at the Shahyad Monument
awaits the return of Ayatollah Khomeini.
Tehran, January 26, 1979

DAY 32

JANUARY 26, 1979 The local reaction to the press is an up-and-down affair. At first it isn't uncommon to be harangued by the crowds who feel that, as a Westerner, I'm as much to blame for things as the shah himself. But at some point in early January, one of the wire service reporters sends a note to his Paris bureau, asking if they can put in a good word for the press with Khomeini. The ayatollah owes much of his new power to being able to get his words out by radio, and following the wire service request he announces that the international press in Iran should be treated as "our friends."

The situation changes overnight. Just how much becomes apparent on Friday at Shahyad Square. Finding myself caught in a giant eddy of people, unable to see over the hundreds of thousands of heads, I am straining to look around when several smiling and enthusiastic young men ask if they can help. "I want to get UP," I say, "so I can see the crowds." Without a moment's hesitation, four of them then reach down, grab my ankles and legs, and hoist me aloft like a Hungarian circus act. I float above the crowd for the next five minutes atop a human tripod, able to see in all directions.

A few minutes later, I clamber onto the roof of a truck. The demonstrators have ringed the square with buses, and in the distance one of them slowly circles through the crowd. On the roof is Patrick Chauvel, a French war photographer I'd worked with in Portugal and other hot spots. Over the sea of people, he kind of looks at me and holds up his camera, doing the "I don't have any film" shoulder shrug. I reach in my pocket and get a roll. By now there's about a hundred feet between us. I'm stationary and he's moving, and I take this roll of film and heave it as hard as I can. It sails over hundreds of heads—but not far enough. After flying about 80 feet, it goes down into the mass of people.

All of sudden a hand in the crowd pops up, fingers wrapped around the film. Then people start passing it hand over hand. After a few seconds, another hand emerges right next to Patrick's bus and holds the roll aloft. Chauvel swoops down and gets it, and a small cheer goes up from the few hundred people who've been watching.

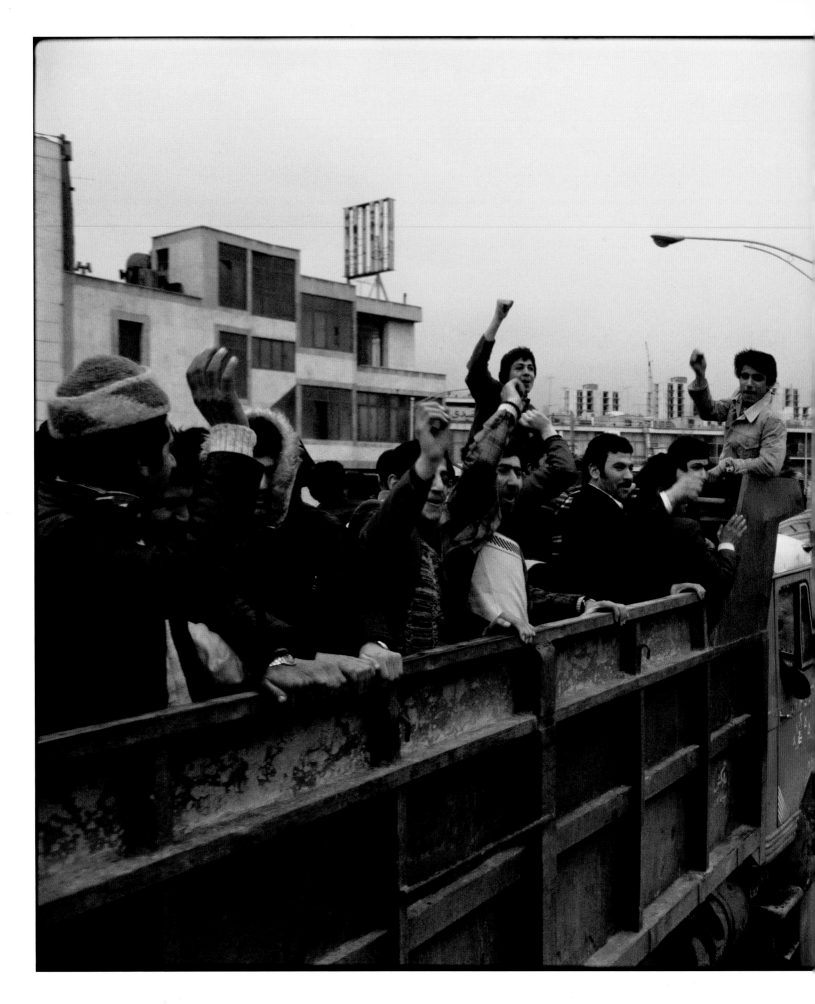

Supporters of Ayatollah Khomeini make
their way toward Shahyad Square
from the outskirts of the capital.
Tehran, January 26, 1979

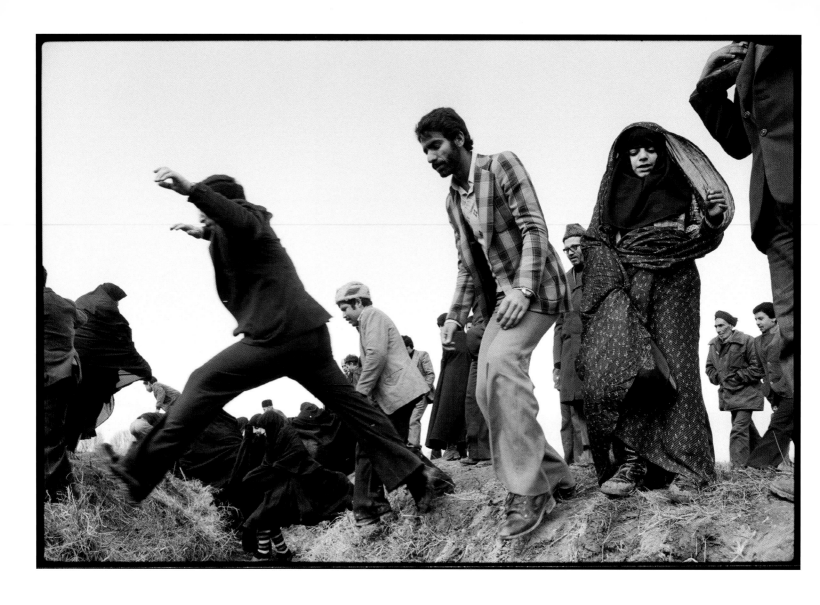

ABOVE AND OPPOSITE: Before Khomeini's return, crowds march
through "Martyr" Square, where those killed in the revolu-
tion are buried, to greet Ayatollah Khomeini.
Tehran, January 26, 1979

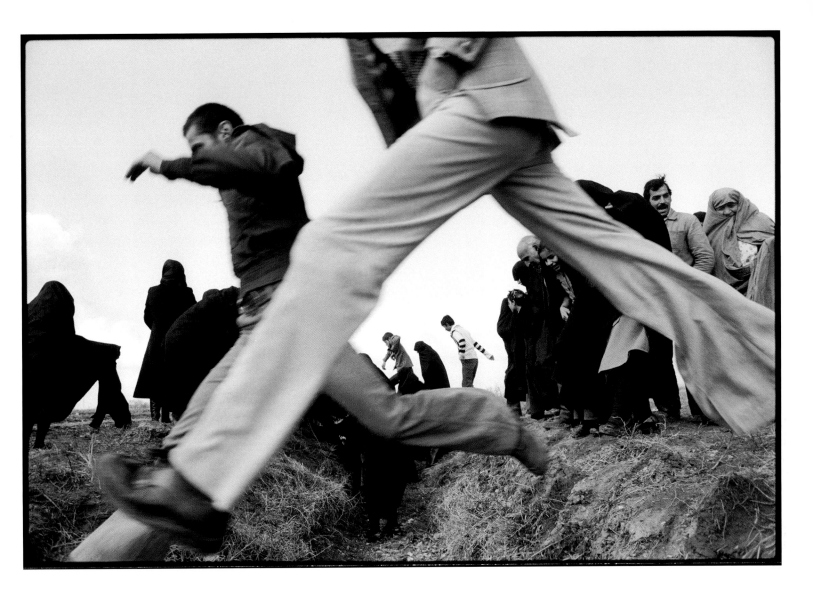

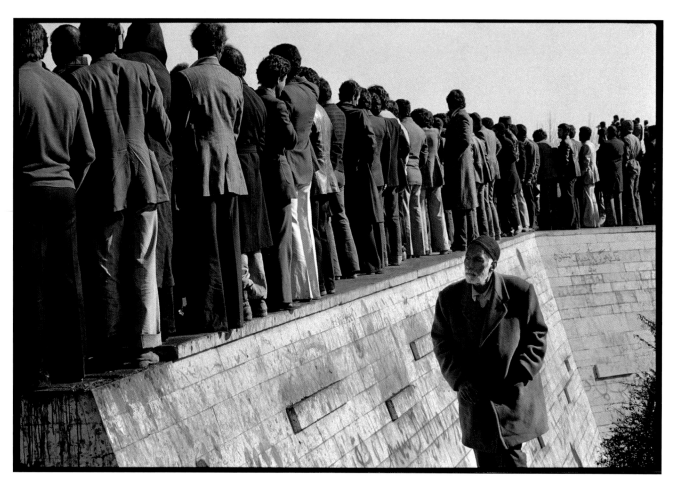

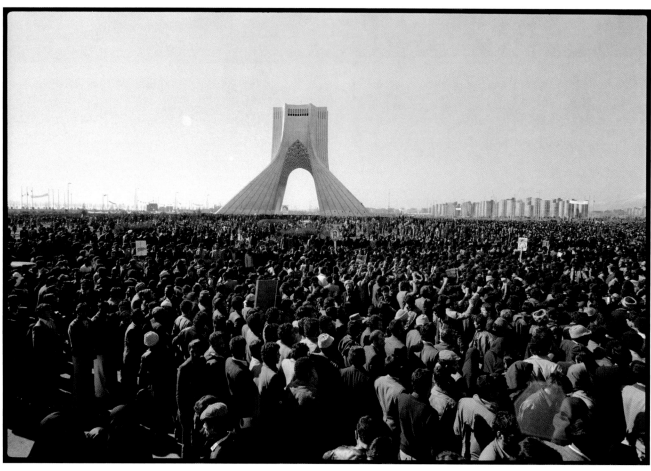

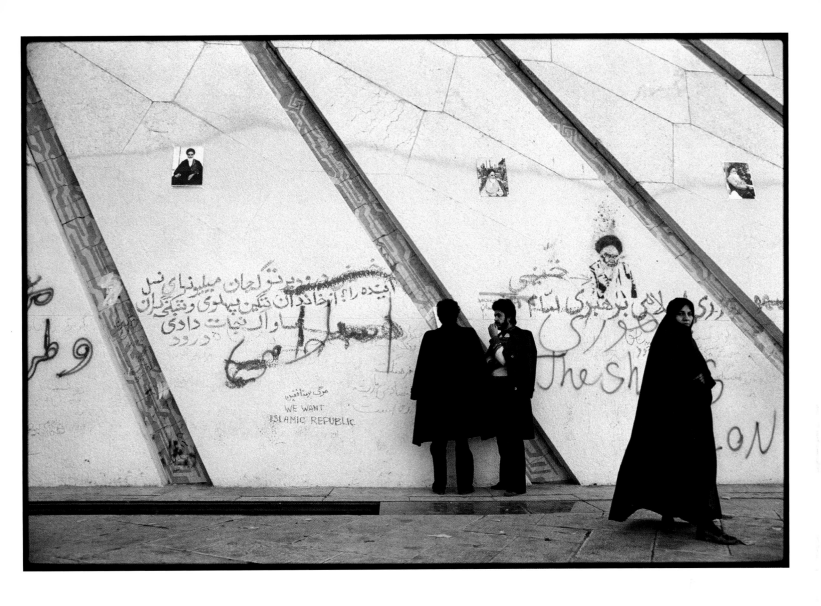

OPPOSITE AND ABOVE: Crowds at Shahyad Monument
await Ayatollah Khomeini, whose return was
delayed by the closing of the airport.
Tehran, January 26, 1979

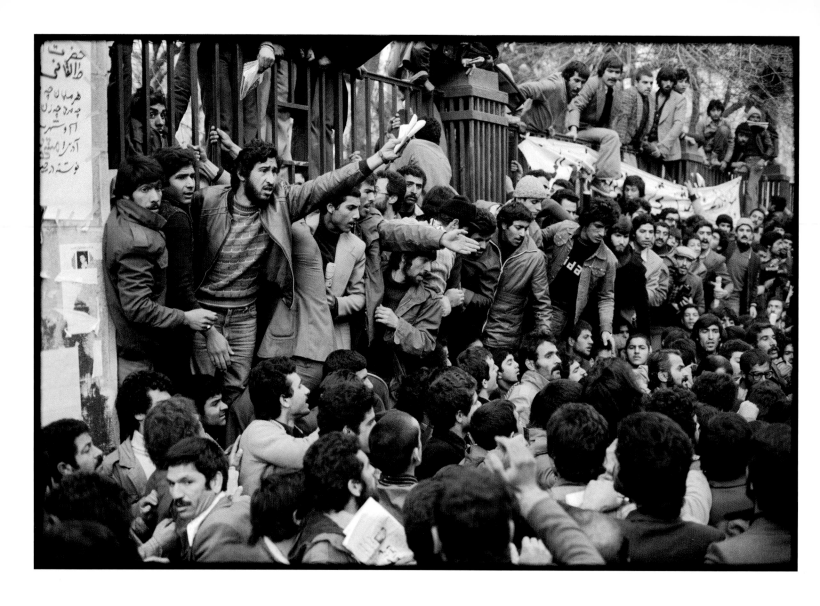

ABOVE: Pro-Khomeini demonstrators at the university
march down Shah Reza Boulevard.
OPPOSITE: A spectator watches the demonstration
head toward Shahyad Square.
Tehran, January 27, 1979

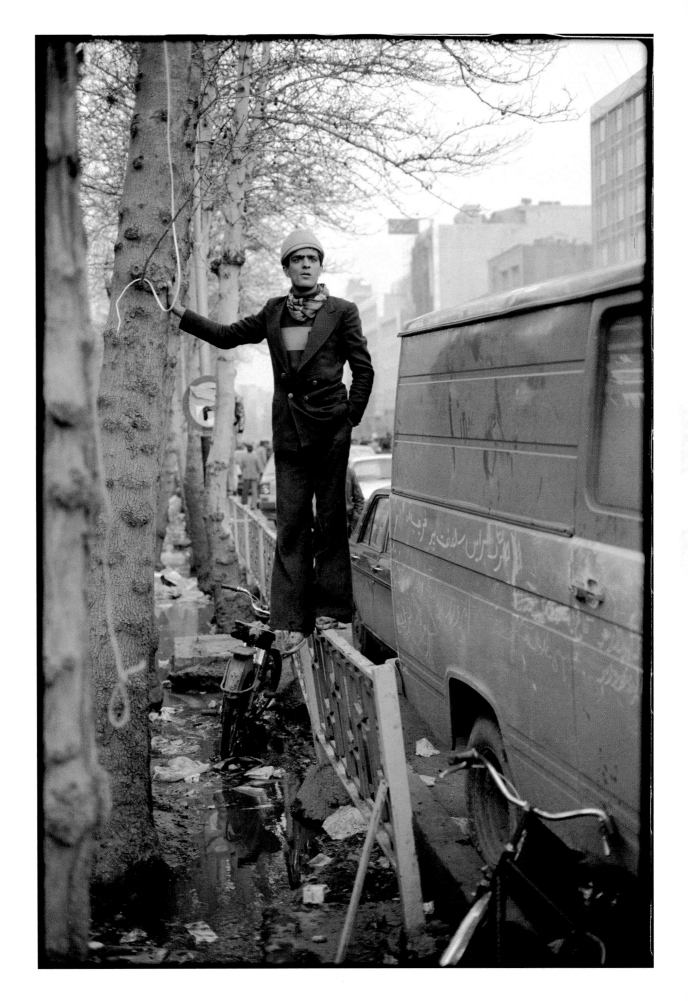

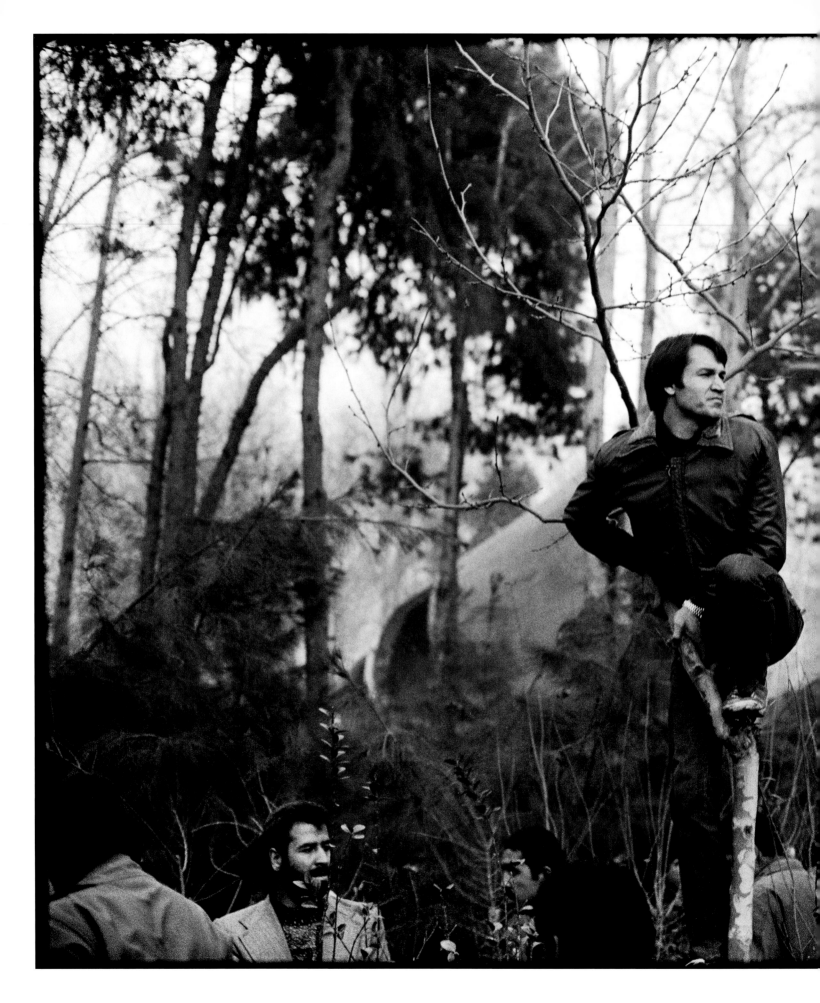

Spectators on Shah Reza
Boulevard near the university watch
a pro-Khomeini demonstration head
toward Shahyad Square.
Tehran, January 27, 1979

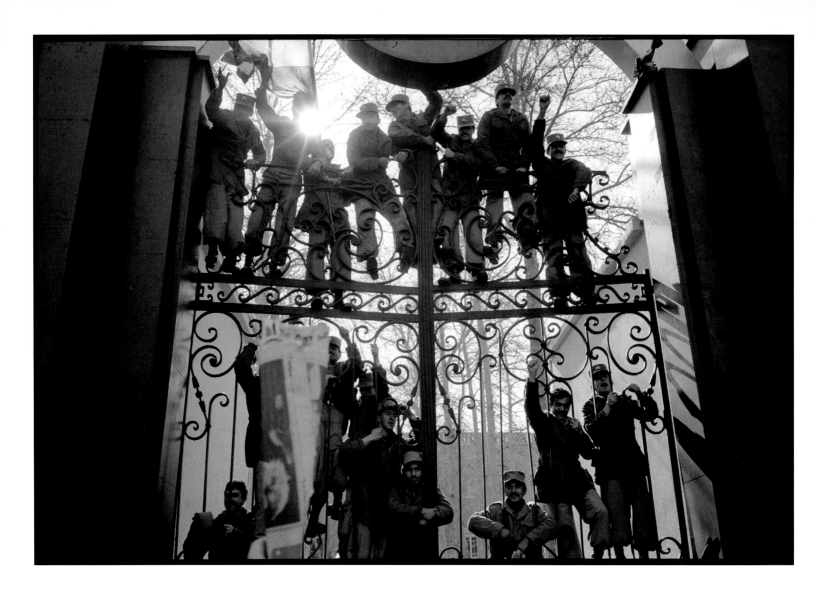

ABOVE: Iranian military guarding the prime minister's office
express support to pro-Bakhtiar demonstrators outside.
OPPOSITE: Pro-Bakhtiar supporters stage a rally
before Khomeini's return.
Tehran, January 28, 1979

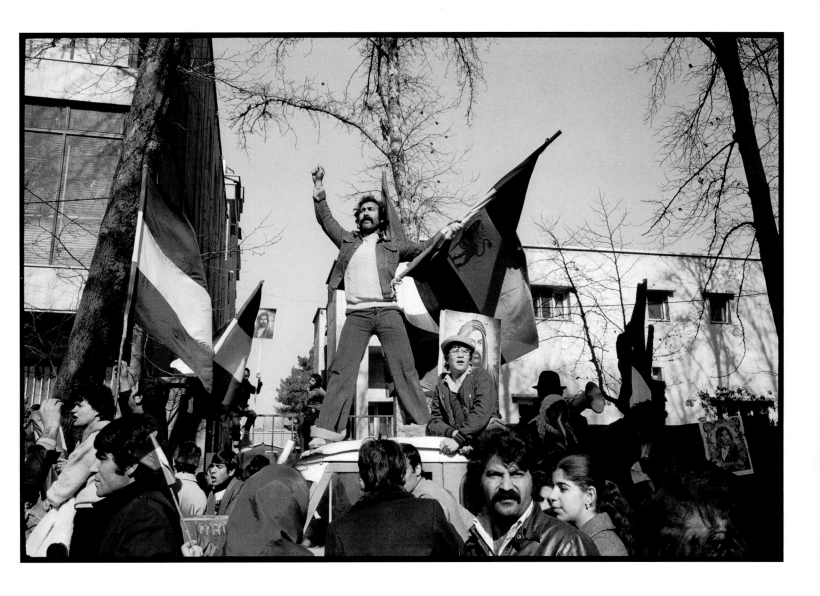

DAY 33

JANUARY 27, 1979 One day while Olivier Rebbot, Alain Mingam — a French photographer shooting for Sipa, one of the French picture agencies — and I are prowling the streets together, we manage to find two former students with motorbikes who are happy to earn a few dollars as chauffeurs. Even with gas lines stretching around the block, Tehran traffic is often impassable. A motorcycle is a great solution, letting you snake through the traffic, often with only inches separating cars and elbows.

Olivier and I, the two smallest, crowd behind the driver on the back of a single Yamaha. Balancing three people, with all our cameras, lenses, film, and bags, is no small feat. We fly east to the university, into the center of the city past the souk, all the while keeping our eyes open for the unusual, the surprise.

French photographers are generally more comfortable getting around on motorbikes than Americans — they do it all the time in Paris — but after a few minutes in the streaming air, so much more in touch with the surroundings, the smells, sights, and sounds, it's hard for me to go back to cars.

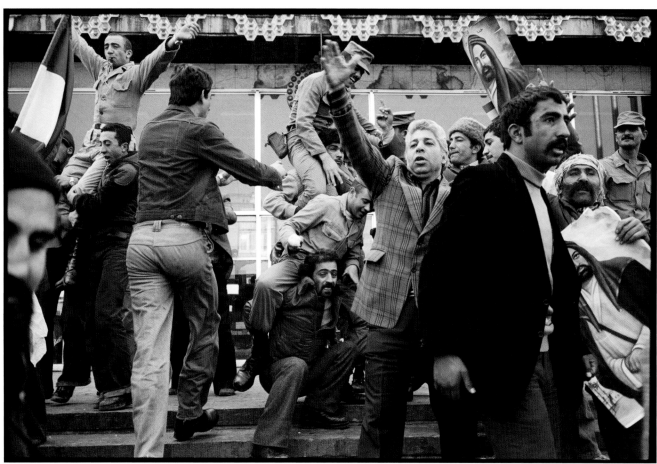

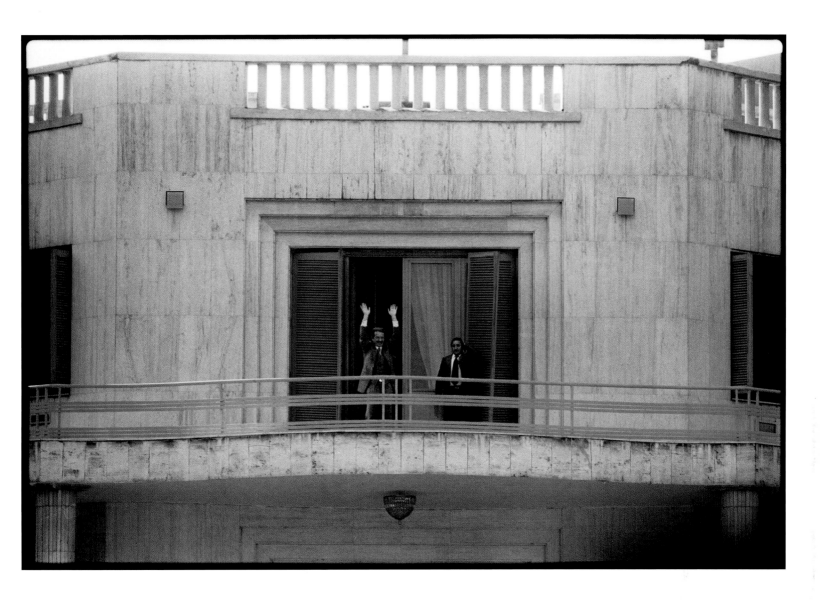

OPPOSITE TOP: Spectators at the pro-Bakhtiar rally.
OPPOSITE BOTTOM: Pro-Bakhtiar supporters and military personnel at the rally. ABOVE: Prime Minister Bakhtiar greets the crowds from his upper-floor office.

PAGE 148: David Burnett is held aloft by the crowd near 24 of Esfand Square.
PAGE 149: Demonstrators with a sign written in blood that reads "150 wounded, 150 killed in 24 of Esfand Square. The killing continues."
Tehran, January 28, 1979

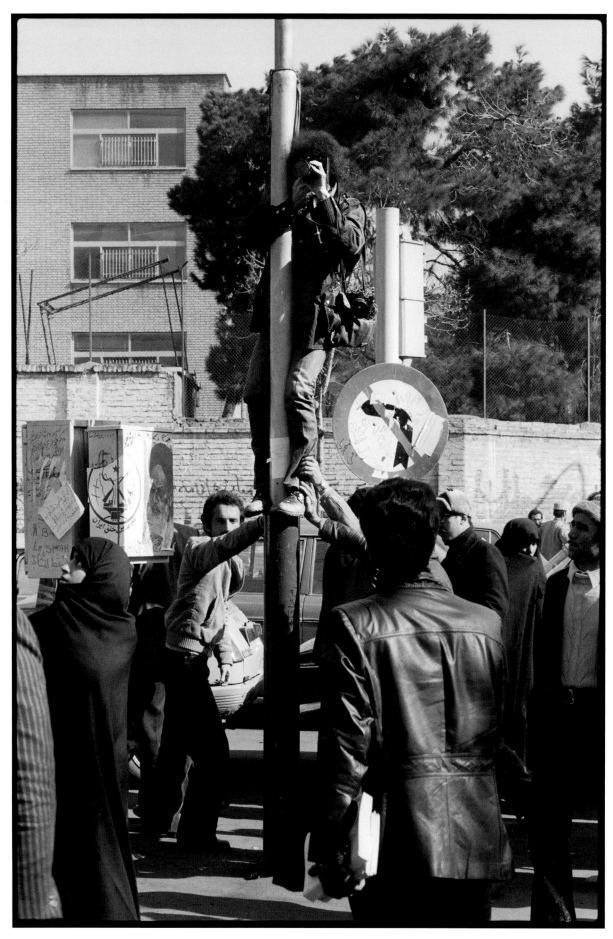

Photograph by Olivier Rebbot

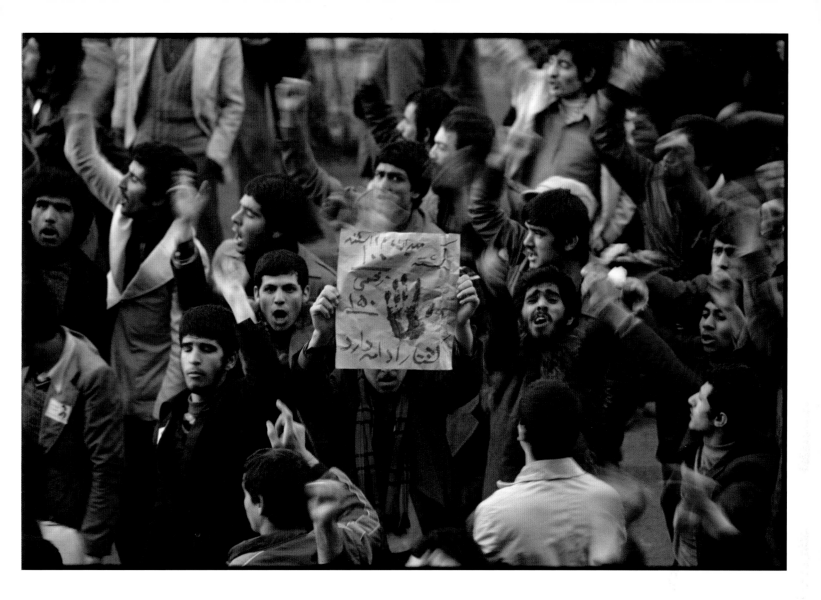

DAY 34

JANUARY 28, 1979 24 of Esfand Square. It's already late afternoon, and as I arrive, I hear shooting. People start diving for cover, dodging behind trees and cars, and jumping over barricades. I see one guy crouched in a telephone booth. A car is set afire. An ambulance races by. A wounded Italian journalist is carried through the crowd. I'm with Olivier Rebbot and Alain Mingam. We race to a residential building across the street, climb to the third floor, and knock on the door of an apartment overlooking the square. An older man answers. With the three of us standing there with our cameras, we don't have to explain what we want, and he waves us in. We walk past his family, past the small framed family photos, and out to the balcony. It's starting to get dark, but from there I can see how each gunshot scatters the crowd and sends people darting back and forth like silverfish. Then it quiets down, and the movement of the crowd slows down, too, until the next gunshot.

When I run out of film, I hustle back into the apartment to rewind. I can still hear what is going on. At one point Alain cries out, "Dave, *viens, un type a été descendu!*" But by the time I get back to the balcony, the wounded man has already been carried off.

The shooting and rushing goes on for about 45 minutes, until it is completely dark. The crowd finally disperses and we go home—back to that bit of tranquility known as the hotel.

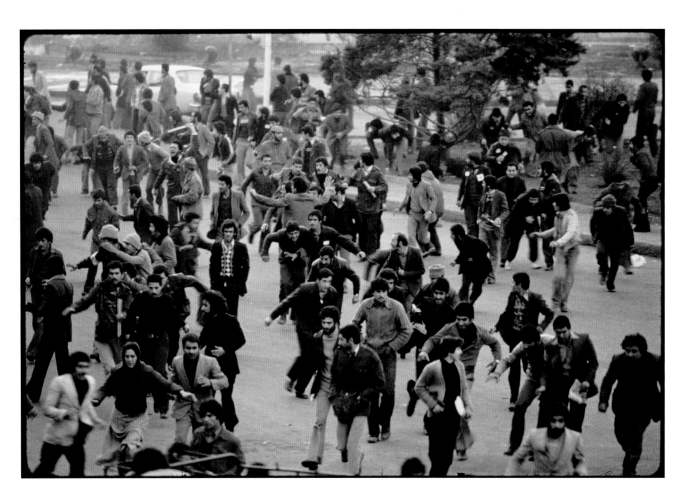

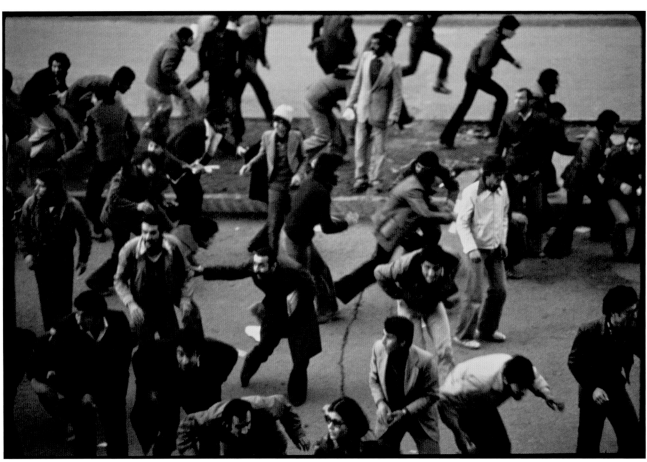

The army opens fire on pro-Khomeini
demonstrators at 24 of Esfand Square.
Tehran, January 28, 1979

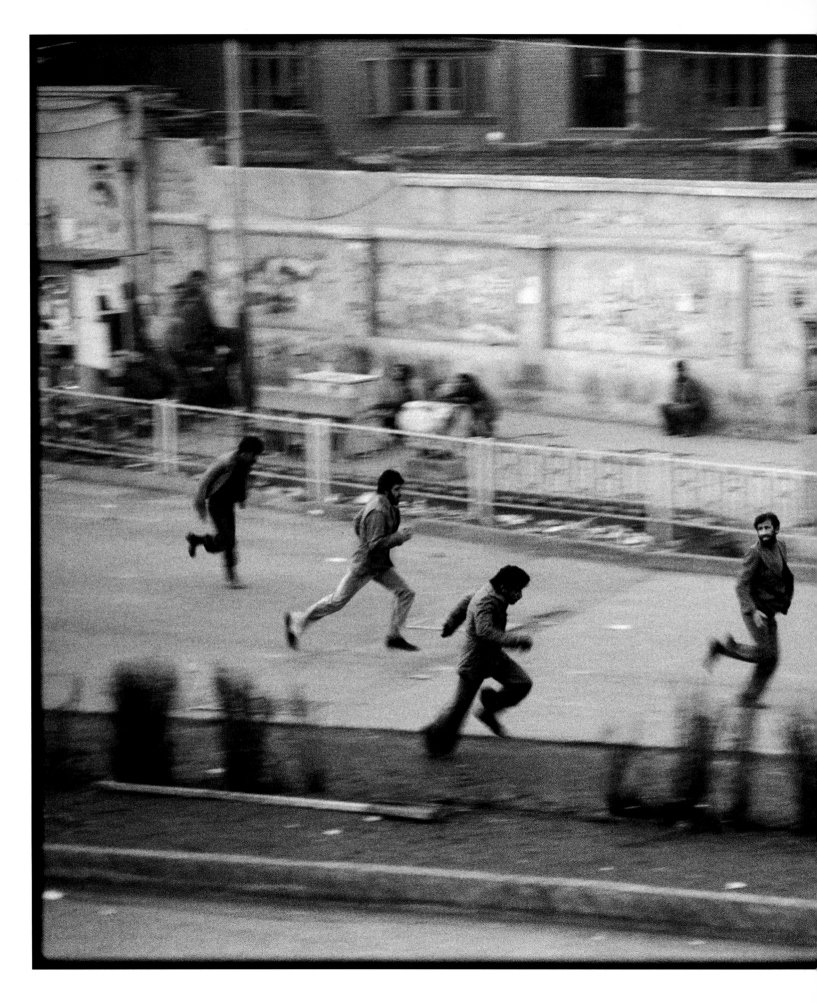

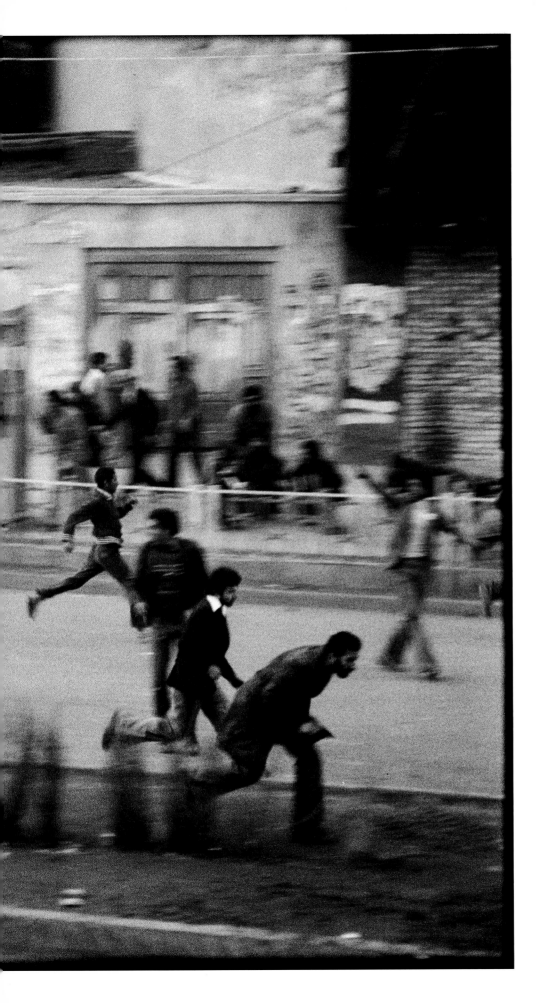

Pro-Khomeini demonstrators at 24 of Esfand
Square on the run after the army opens fire.
Tehran, January 28, 1979

ABOVE AND OPPOSITE: Skirmishes between pro-Khomeini
supporters and the army around 24 of Esfand Square.
Tehran, January 28, 1979

 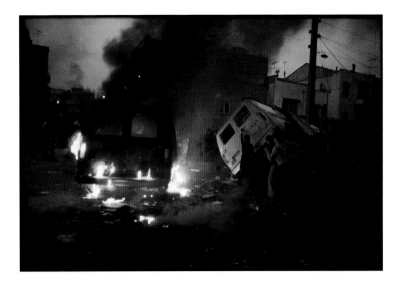

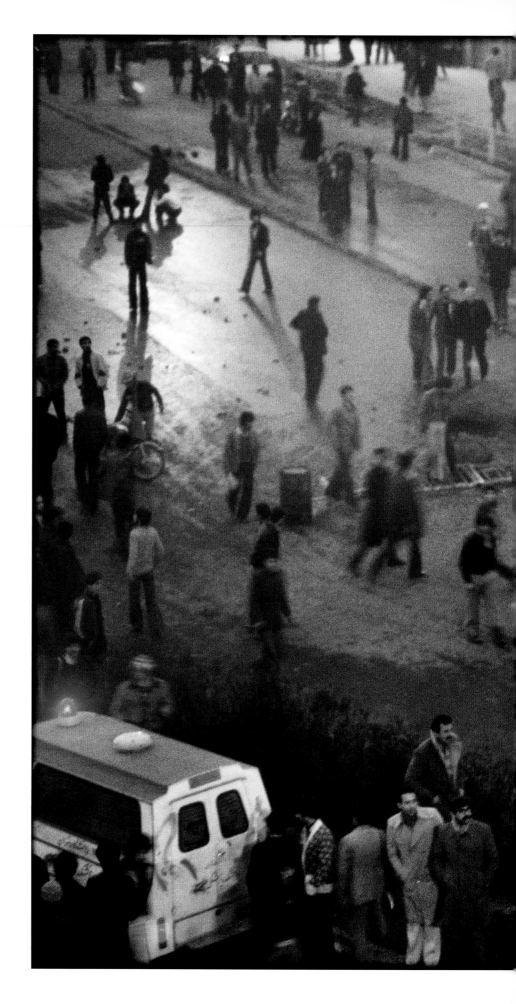

Pro-Khomeini demonstrators set fire to vans
and motorcycles around 24 of Esfand Square.

FOLLOWING PAGES: The bodies of five people killed
in the street fighting lie at the morgue.
Tehran, January 28, 1979

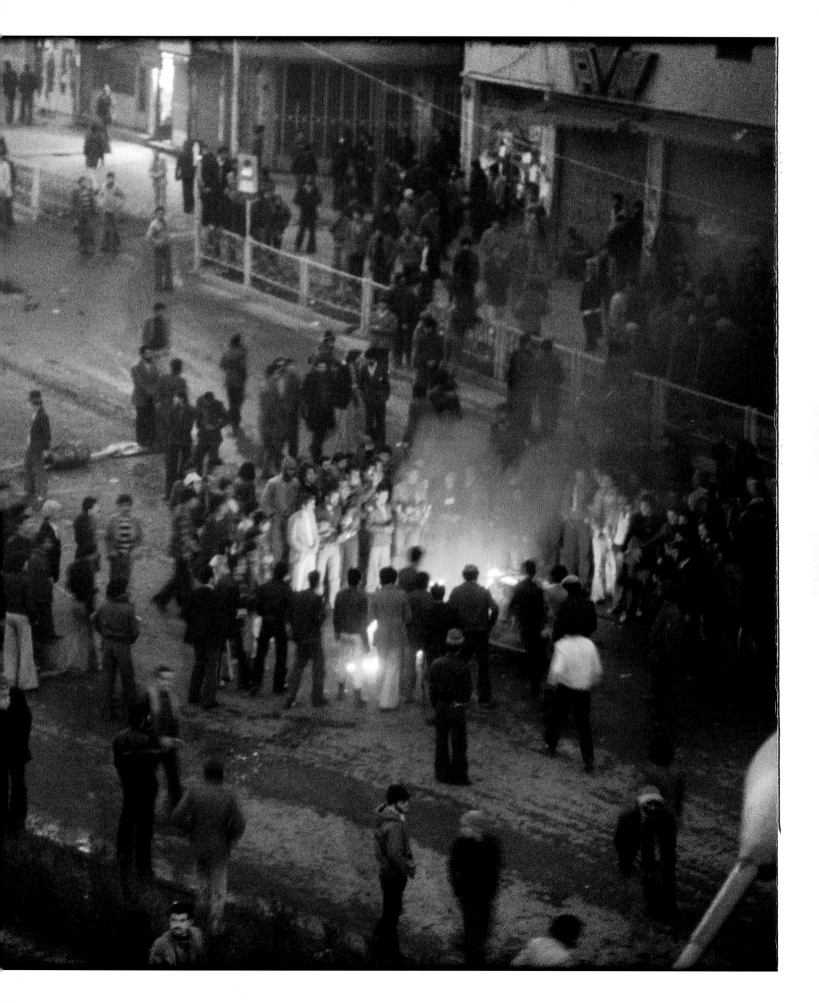

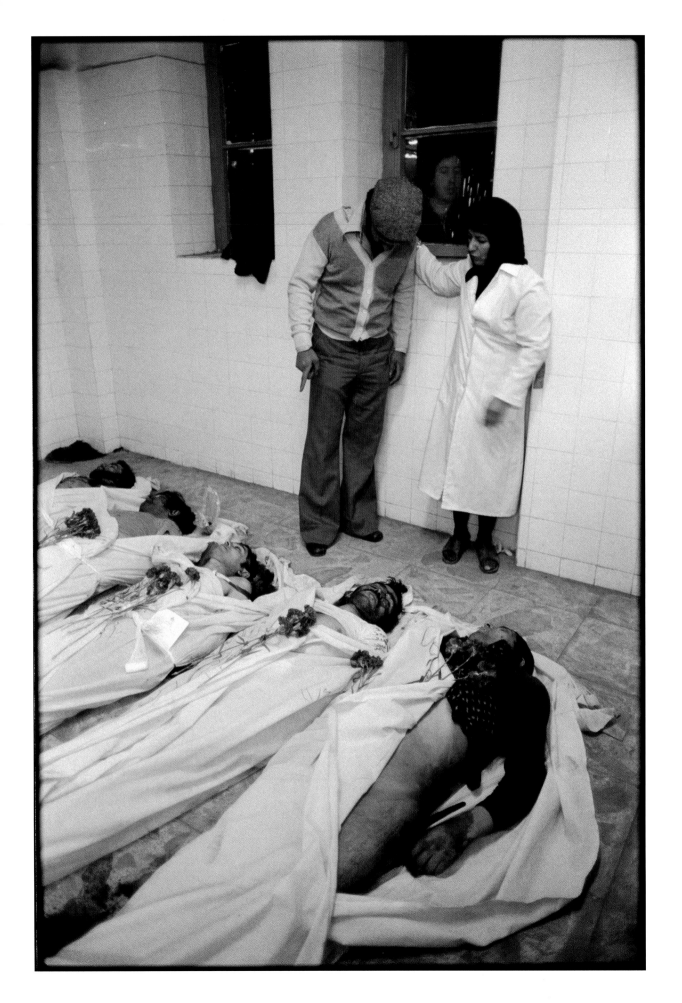

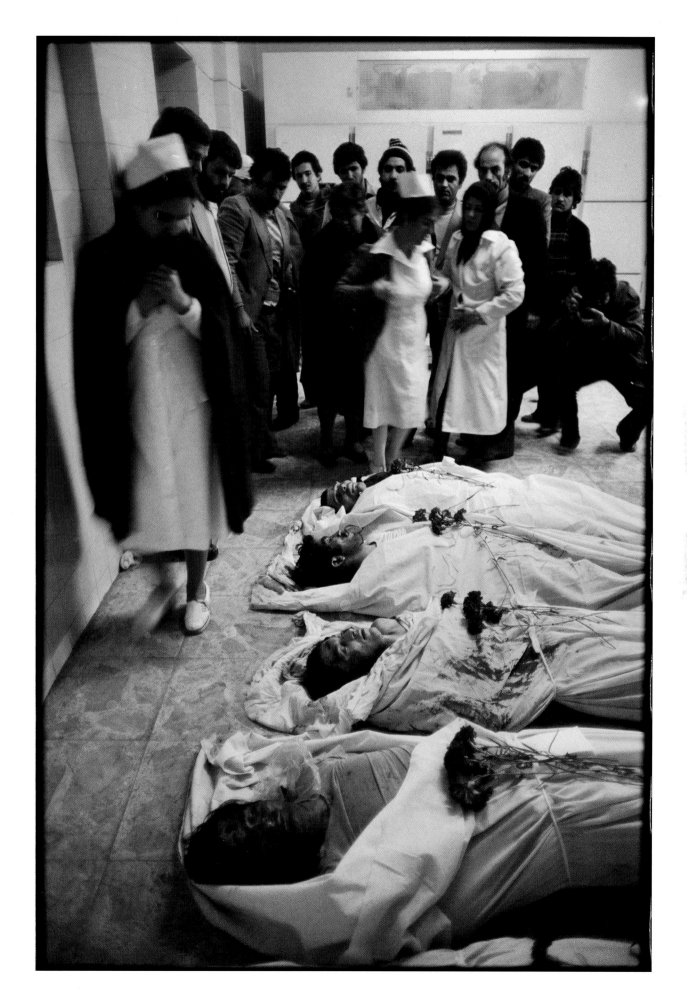

THE GENERAL AND THE MOB

From the time of Shah Mohammed Reza Pahlavi's departure until the return of Khomeini, Iranian politics was a slow and dangerous pas de deux. The new Bakhtiar cabinet attempted to take control, but revolutionaries, in response to damning pronouncements by Khomeini in France, prevented officials from entering their offices. The prime minister retaliated by placing tanks on the runways of Tehran's Mehrabad Airport, preventing the ayatollah's return. Between the two sides, the army, whose allegiance remained unclear, loomed as a smoldering threat that might at any moment pitch the country into all-out civil war.

The immediate result of the stalemate was further bloodshed. On January 28, 1979, nearly 50 people were killed by the army near Tehran University, and throughout the capital, cinemas, nightclubs, restaurants, liquor stores, brothels, and other symbols of "decadence" were sacked by revolutionaries.

It was against this backdrop that, on the following day, Maj. Gen. Taghi Latifi, the chief adjutant of the 78,000-member paramilitary police, was sighted by a crowd leaving police headquarters in his blue Mercedes near 24 of Esfand Square. After the car was struck by a Molotov cocktail, the driver fled, and Latifi was dragged out by the mob and repeatedly punched and stabbed. Some news outlets reported that he had been killed, others that he survived and was last seen in a coma at Pahlavi Hospital.

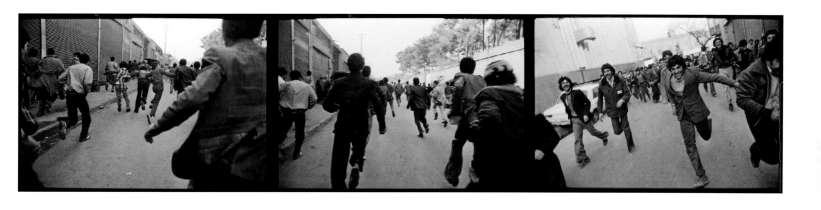

Crowds flee the renewed violence at 24 of Esfand Square. Tehran, January 29, 1979

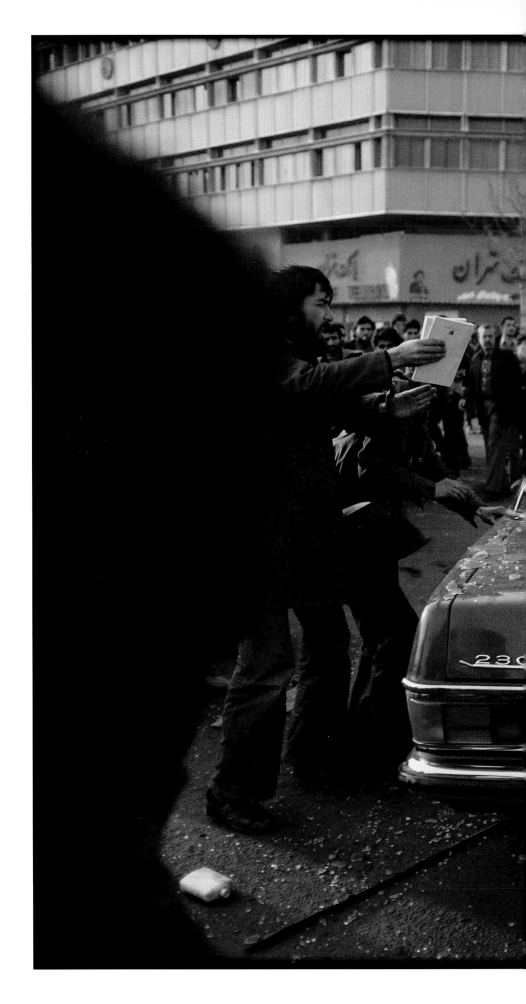

General Latifi is pulled from his car after it is hit
by a Molotov cocktail in 24 of Esfand Square.
Tehran, January 29, 1979

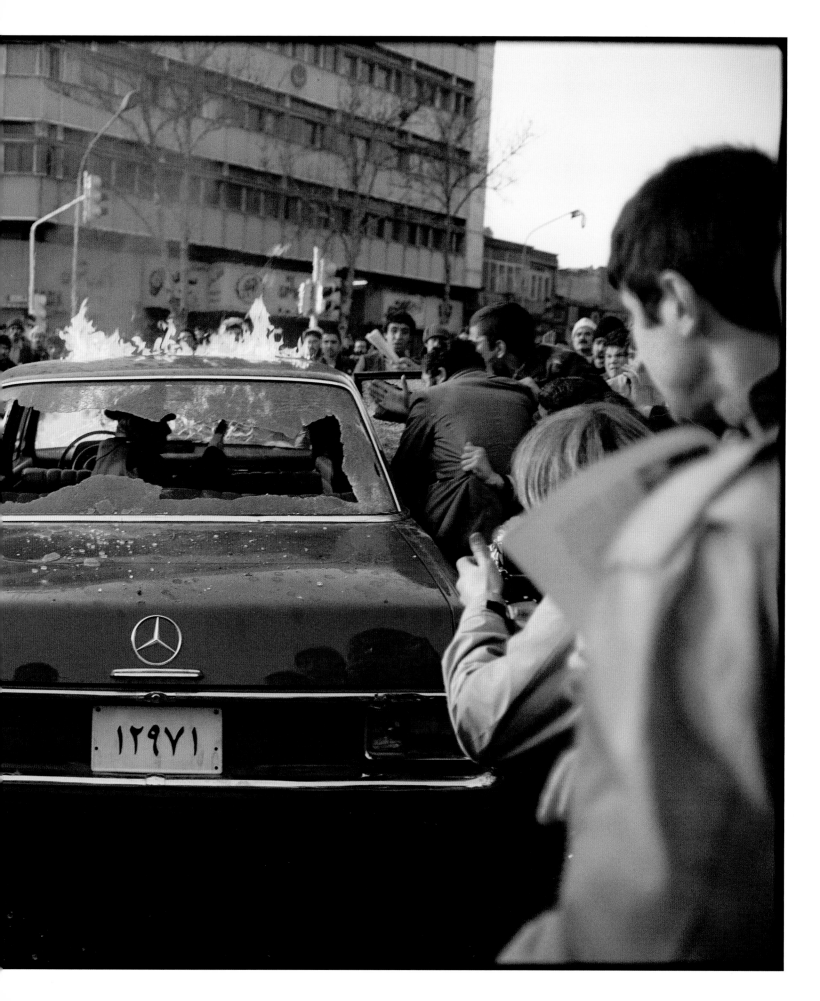

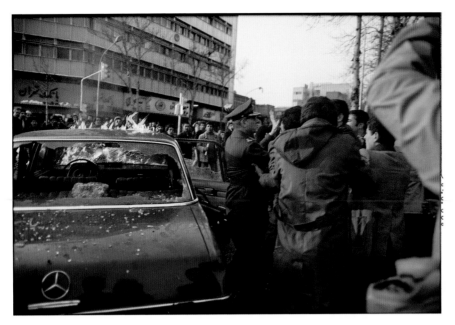

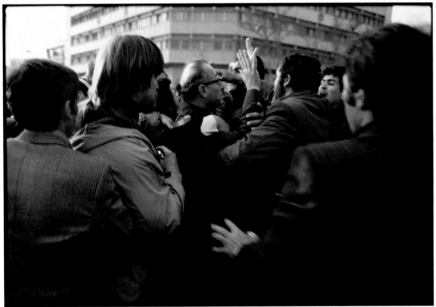

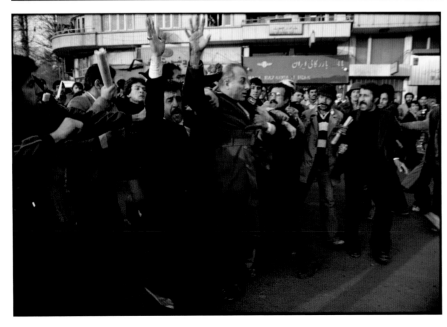

DAY 35

JANUARY 29, 1979 Of all the people I know in Iran, I'm closest to Olivier Rebbot. I first met him in the summer of 1973 at Louis Armstrong Stadium in Queens, New York, where we had both gone to photograph the 15-year-old Indian guru Maharaj Ji during his Millennium tour. Though we don't cross paths very often, when we do we get along great. He's a charismatic person, Olivier, with an impish sense of humor, the type to walk into a restaurant and ask the chef, "How bad is your food?"

As a photographer, he's a bit more daring than I. He isn't reckless about it, but he never hesitates to jump into the fray either. No matter what it is, he gets right in there.

The day after the shooting at 24 of Esfand Square the two of us go back. It's late afternoon, about 5 p.m., very calm, with quiet afternoon traffic cruising slowly around the square. It's the hour when people just want to get home at the end of a long day. I figure nothing much more is going to happen, and we're about to go back to the hotel when out of nowhere there's a deafening explosion of noise and shattering glass. Just in front of us, a Molotov cocktail has hit the front of a blue Mercedes, 20 or 30 feet away.

The car belongs to General Latifi, alleged to be working for SAVAK. As the flames begin to consume the car, a crowd surrounds it. The driver escapes, but some of the protesters reach into the back seat and drag Latifi out. Fists begin flying, and in a frenzy of anger a dozen or more people begin beating him. Then they start dragging him through the crowd in my direction.

I raise up my Leica, shoot a few from the viewfinder and a half dozen more by holding the camera over my head and aiming it toward the spot, a few steps in front of me, where Latifi is being beaten. Now and then, I briefly catch sight of Olivier in the crush of the crowd. He's got his elbows up high, trying to maneuver with his cameras through the throng.

I have no real idea who Latifi is, but how he looks by the time they get to me, 20 or 30 feet out of the car—punching him, jerking him around, dragging—is horrible. He's smeared with blood, his face pale, the crowd shouting, more and more crazed, possessed.

I guess there may be contingents of attackers, people in chadors, some more Western looking—but it isn't obvious. It's a mob, is all, a few hundred people by now, and everybody is screaming.

As they pull the general along, the crowd moves, too, with people leaping on and off of parked cars, buckling the roofs, scurrying down the avenue to keep up. All the while, the beating continues. I don't know if Latifi is dead by the time they arrive in front of the university, but he looks pretty lifeless.

Olivier and I leave them at the entrance gates. We've had enough. Disgusted, we turn back toward the hotel. Neither of us says a word. Words seem somehow out of place. Witnesses—and voyeurs also—we hardly look at each other, and don't speak again until we're back at the hotel.

"Terrible," Olivier mumbles.

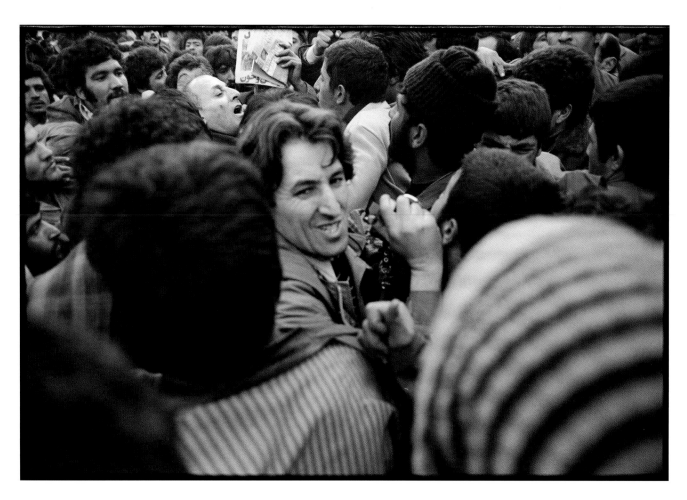

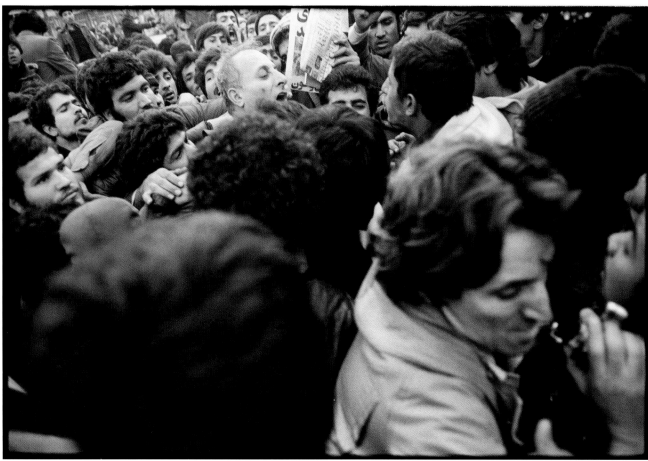

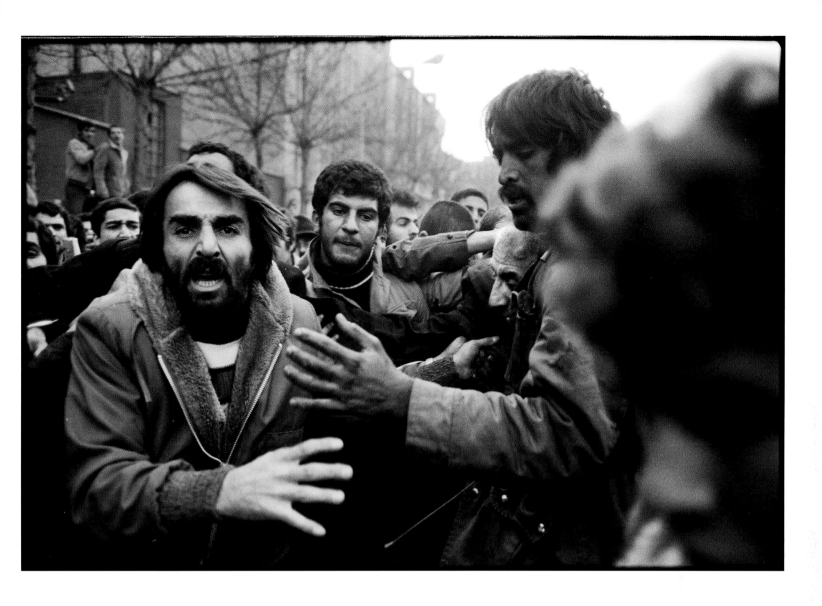

OPPOSITE AND ABOVE: General Latifi is attacked by the mob.
In the center and foreground of the images
opposite is photographer Olivier Rebbot.
Tehran, January 29, 1979

General Latifi is dragged away by the mob.
Tehran, January 29, 1979

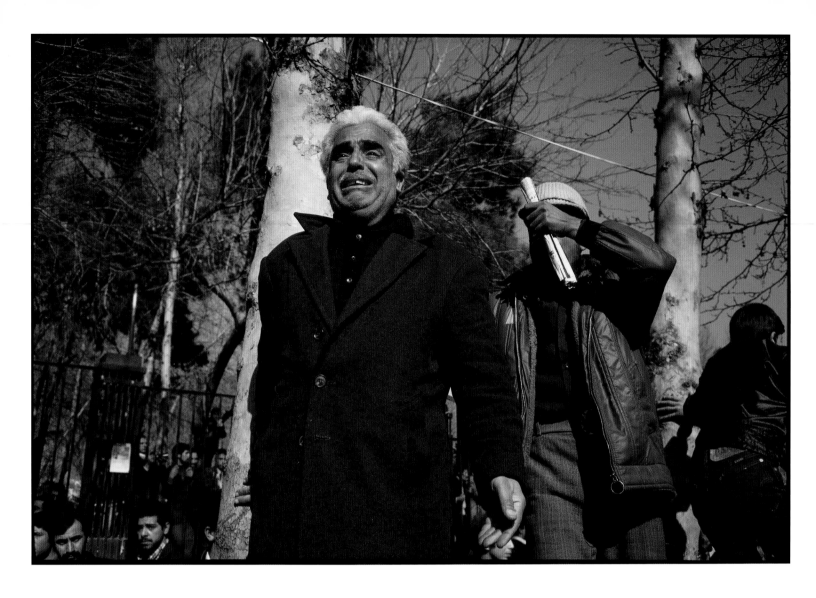

The crowd reacts after a young man is shot
and killed by the army near the university.
Tehran, January 31, 1979

DAY 36

JANUARY 30, 1979 The day before Khomeini's return, a Sunday, I take the day off. It's sunny outside and Tehran seems to be enjoying an almost carefree respite from the violence. I'm starting to feel worn down and I need to recharge, so I leave my gear in the room and head out for a leisurely walk with just a Leica and a couple rolls of Kodachrome in my pocket. People are meandering around, having picnics. The atmosphere is as relaxed as I've seen it since my arrival.

But things change quickly. Near Tehran University, some Palace Guards in a military truck decide they should make one final show of force before the ayatollah lands. They drive menacingly through the crowds, where they are immediately assailed by taunts and insults. They answer with bullets, firing blindly into the group. One kid goes down.

After the shooting, the soldiers drive off, parting the crowd and leaving a trail of grief in their wake. Men are crying. Friends of the young victim run over to his body and dip their hands in his blood, the revolution's newest martyr. Then they come down the street in my direction, chanting, with their hands in the air. The fresh, wet blood glistens on their outstretched palms. In the harsh sunshine, it's as red as anything I've ever seen.

Behind the marchers, an older man stands on a lamppost, his eyes filled with tears. Coming on the heels of such a peaceful and serene day, the carnage is a shock to everyone.

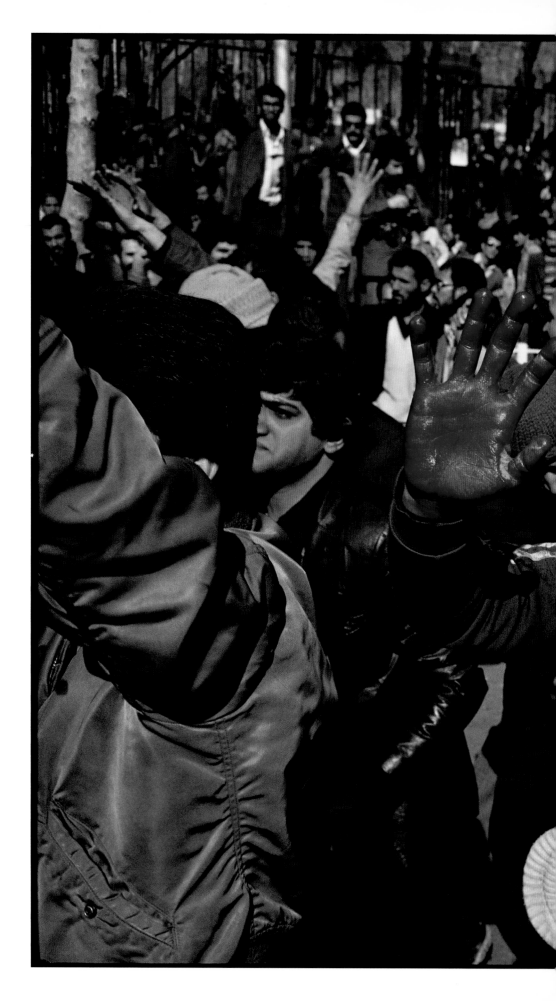

A protester near the university displays
the blood of the latest "martyr."
Tehran, January 31, 1979

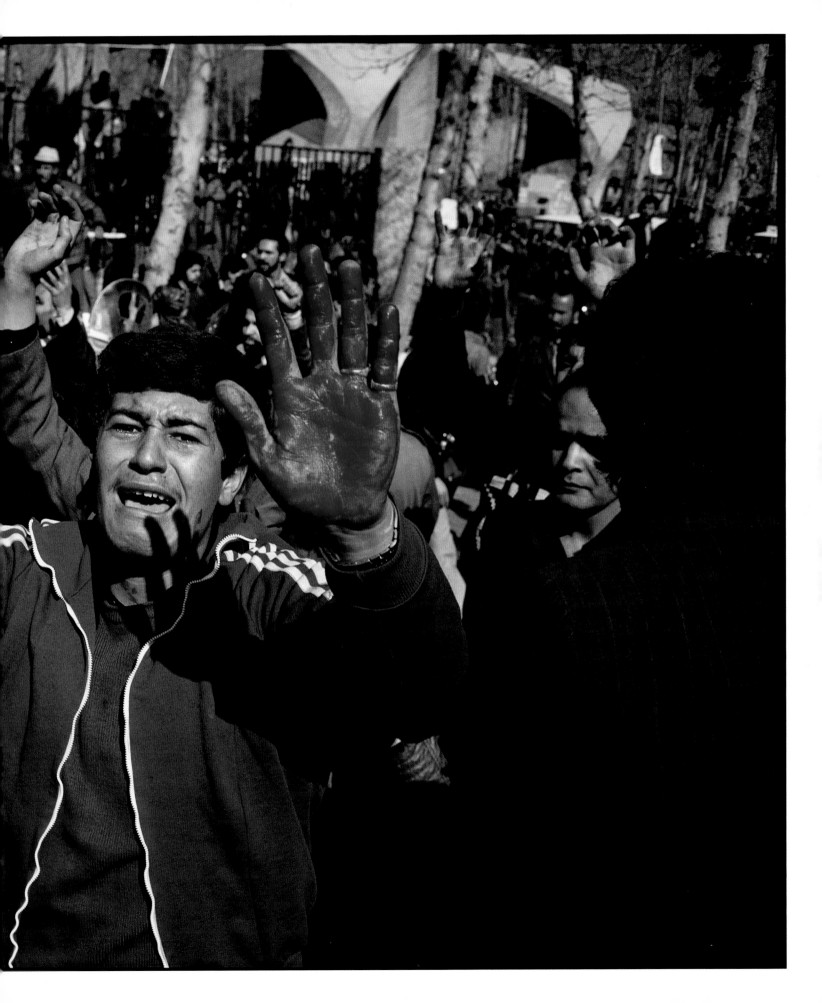

PART THREE

THE NEW ORDER

FEBRUARY 1, 1979 – FEBRUARY 7, 1979

KHOMEINI RETURNS

Even after the shah's departure, Ayatollah Khomeini never wavered from his position that the Bakhtiar government was the heir of an illegitimate and criminal regime. When the prime minister offered to meet him in France, Khomeini demanded he resign first. Nonetheless, after a four-day closure of the Mehrabad International Airport—a period of serious violence and destruction in Tehran—Bakhtiar relented. On January 29, 1979, he announced that the airport would reopen, paving the way for the ayatollah's return.

Days later, on February 1, 1979, Khomeini boarded a chartered Air France 747 in Paris for the trip home. Sixteen days had passed since the departure of the shah, 15 years since the ayatollah's exile, and a year since the revolution began in Khomeini's hometown of Qom.

Khomeini's plane touched down in Tehran at 9:30 a.m. No one from the Bakhtiar government was at the airport to greet him, but millions of Iranians flooded the streets of Tehran along the ayatollah's motorcade. Asked by ABC's Peter Jennings what he felt about his historic return to Iran, the 78-year-old Khomeini replied, "Nothing!"

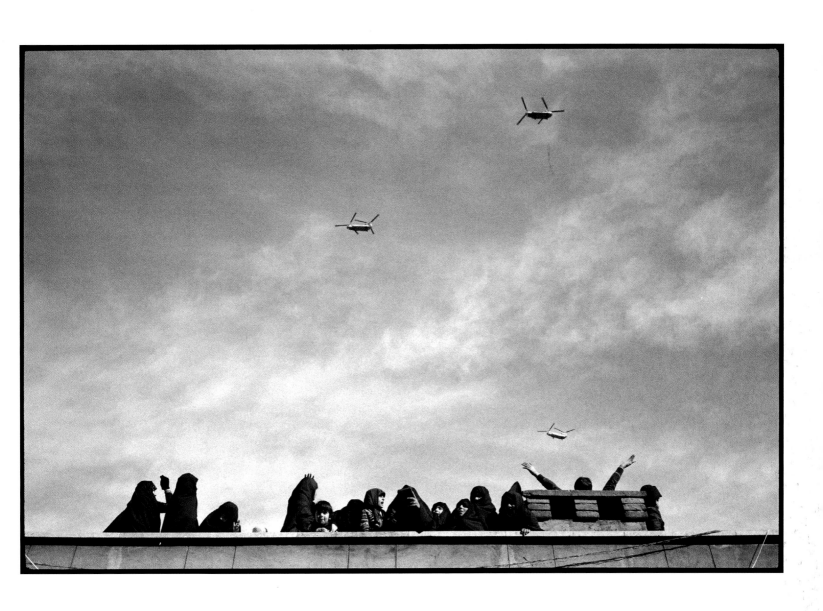

Armed forces helicopters fly over the capital as crowds await the return of Ayatollah Khomeini. Tehran, February 1, 1979

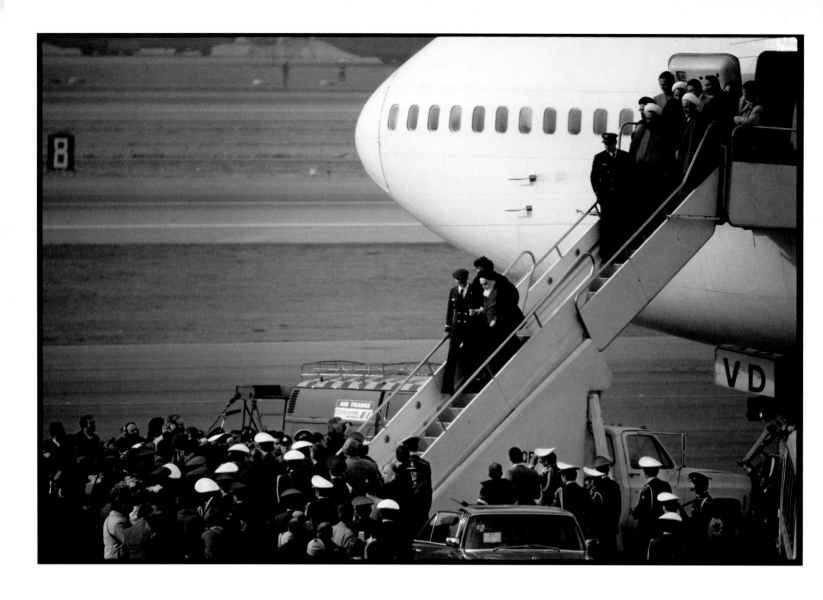

Ayatollah Khomeini disembarks from a char-
tered Air France 747 jet at Mehrabad Airport.
Tehran, February 1, 1979

DAY 38

FEBRUARY 1, 1979 I think it's Dean Brelis who breaks the news that there's only a single accreditation for a *Time* photographer to meet Khomeini's plane on the tarmac. "We're gonna let Kaveh take this one," he tells me.

Kaveh Golestan is an Iranian who's just come back from living in London to document the revolution, and the feeling is that since this is his country, and in a sense *his* revolution, he should get the spot.

What can I say? Like a good soldier, I take my 500-mm lens and perch up somewhere out at the edge of the terminal. When Khomeini arrives and walks unhurriedly down the steps of the plane onto the tarmac, he's a distant silhouette. But even at 500 feet, unmistakable.

The stern, implacable face of the ayatollah is startling. There's an undeniable force, a presence, and the Iranian crowd gathered at Mehrabad Airport goes wild. They're cheering and chanting and moving and running. This is what they've been dreaming about, what we've all been talking about and waiting for. Now it's actually happening and here he is.

Khomeini is led into the terminal. I manage to get inside the overhead mezzanine. Amid the tumult and fervor, the ayatollah is a study in calm. He walks through the terminal slowly and with purpose. He doesn't look like someone who feels he'll have to answer to anyone. He looks as if he's already in charge.

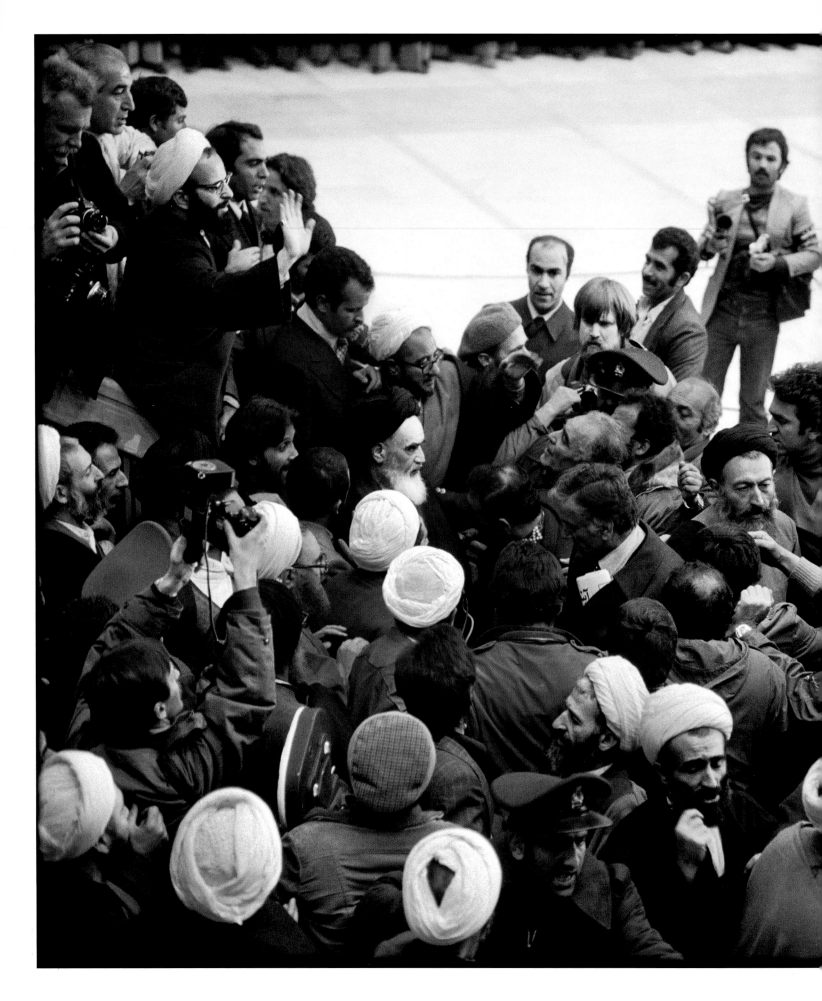

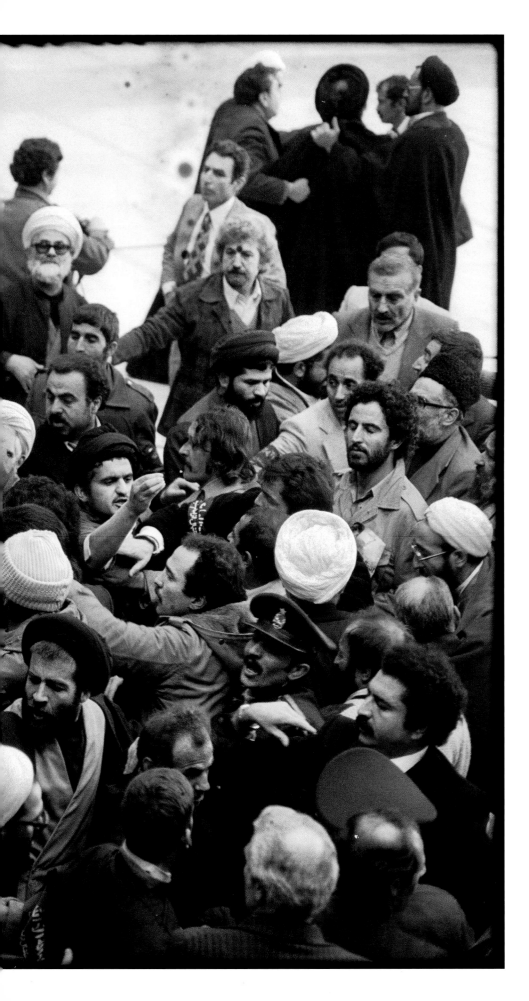

Ayatollah Khomeini is surrounded by
supporters and the media at the airport.

FOLLOWING PAGES: Crowds of supporters near
the Shahyad Monument hope to see the
Ayatollah Khomeini, who did not show up.
Tehran, February 1, 1979

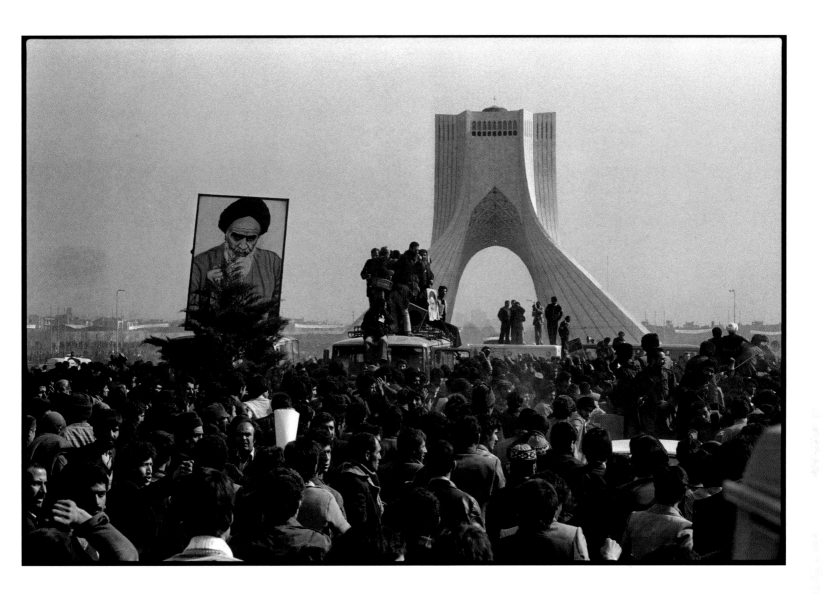

DAY 39

FEBRUARY 2, 1979 Khomeini and his staff have moved into the Refah School, a grade school for girls in southern Tehran. Every half hour or so the guards open the gates at one end and let a couple thousand people, men alternating with women, into the courtyard, actually the playground, which measures approximately 50 by 60 meters. The crowd cheers and chants. Khomeini eventually comes to the window, waves a solemn greeting, and everyone outside goes berserk. Two minutes later he disappears and the guards open the gates at the other end of the yard to let everyone out and usher in a new group.

The day after his return, I attempt to make my way through the crowd up to the window. It's hell squeezing through, supertight, everybody pushing, kicking, and shoving, and I'm dragging a big camera bag. I try to anticipate the forward flow of the crowd, and at the right moment let myself be borne along. It takes about 20 minutes to get myself right under Khomeini this way, but it's well worth it. I find a position and stay there for several groups, watching as one woman, overcome with emotion, reaches up to grab Khomeini's hand and nearly pulls him out of the window.

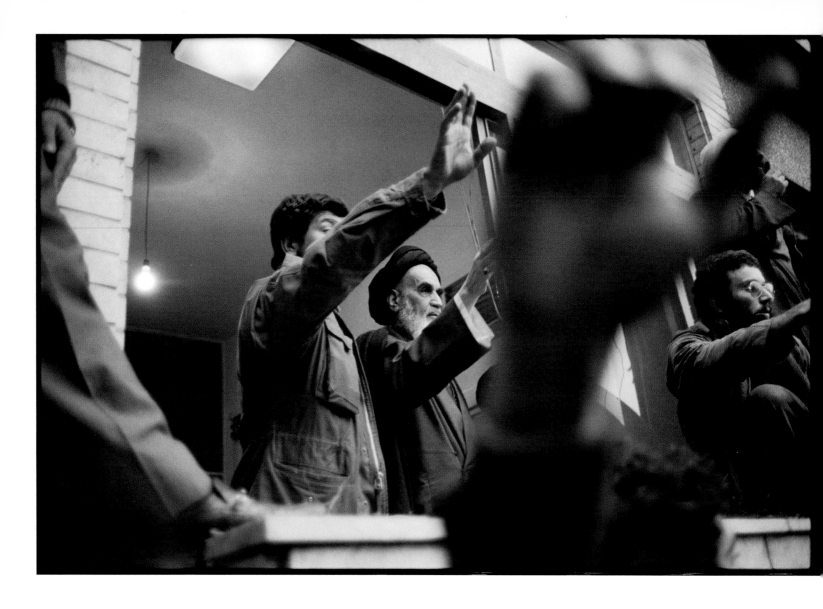

Ayatollah Khomeini greets female followers at the
Refah School for girls, his provisional headquarters.
Tehran, February 2, 1979

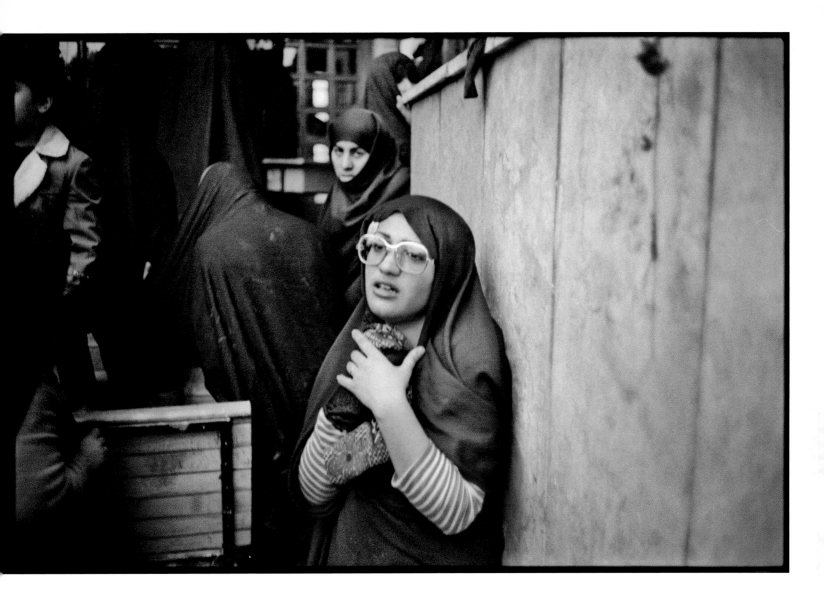

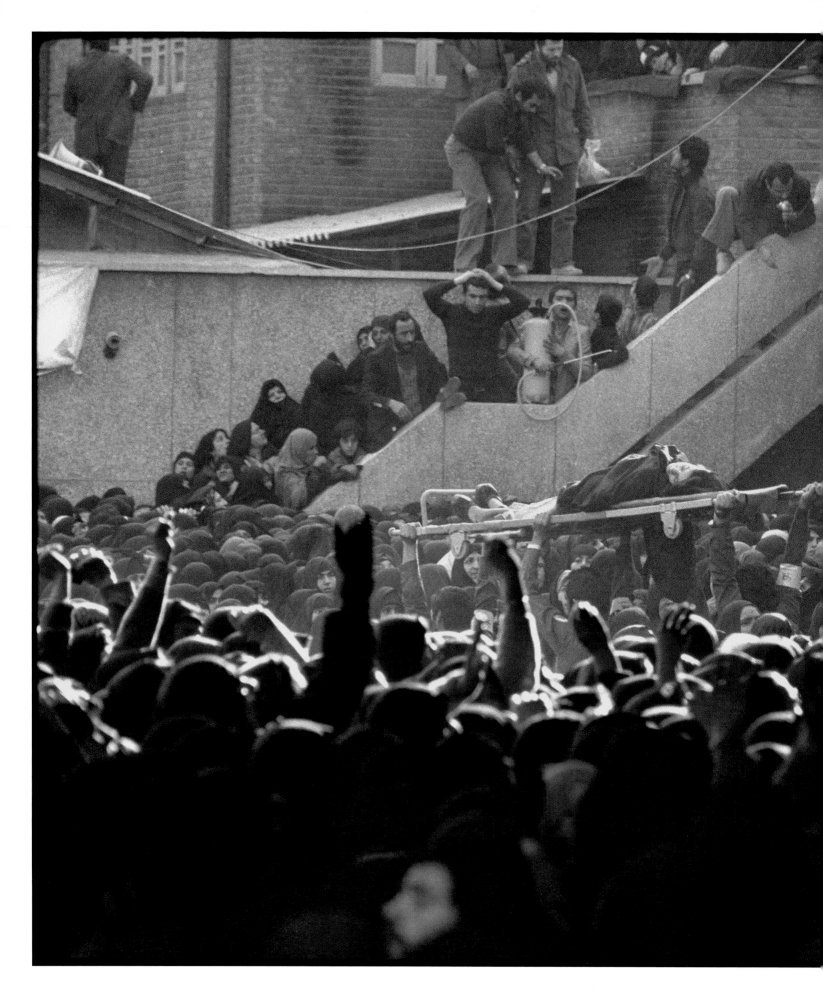

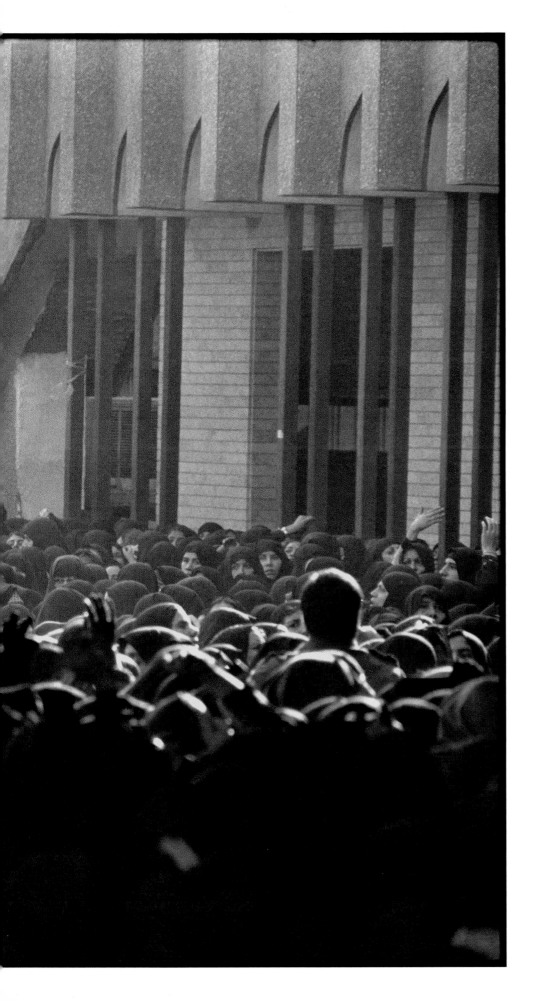

A Khomeini follower is borne away by stretcher
after collapsing at the Refah School.
Tehran, February 2, 1979

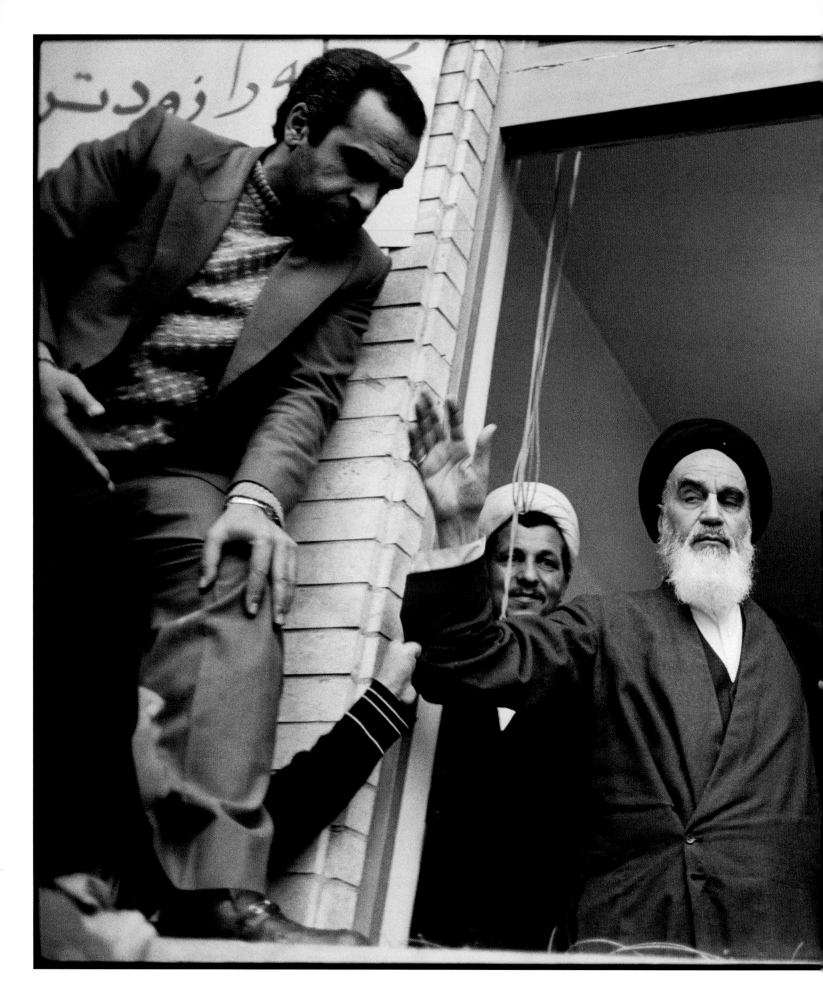

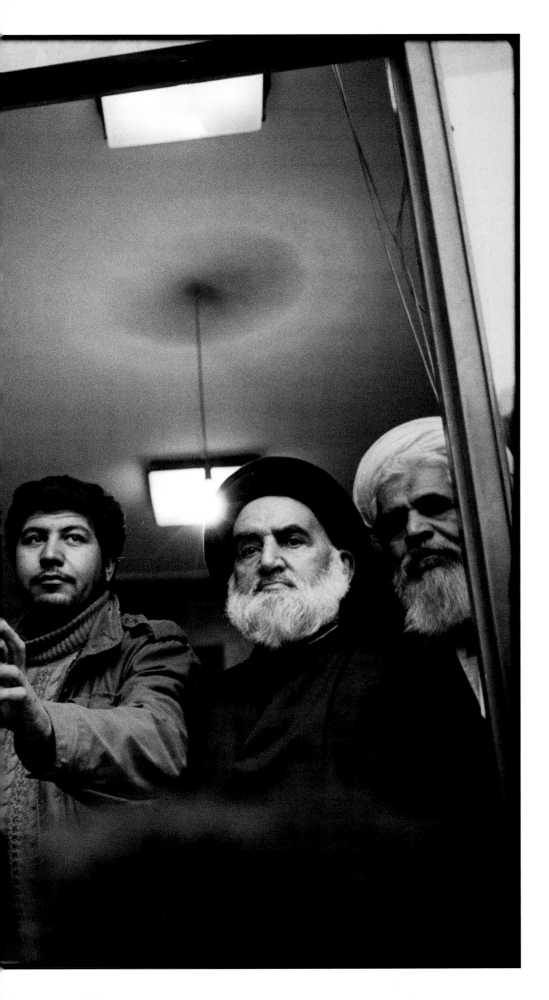

Ayatollah Khomeini greets supporters
at the Refah School. To his right is his
aide Akbar Hashemi Rafsanjani.
Tehran, February 2, 1979

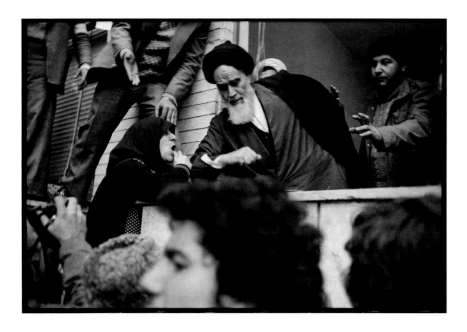

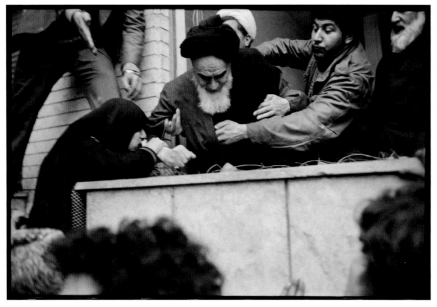

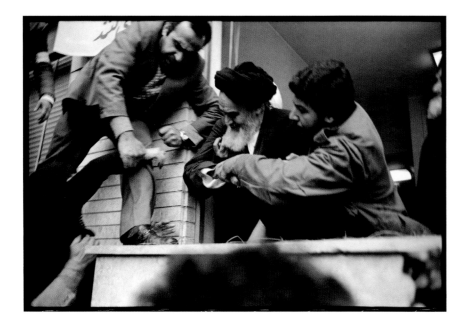

An overzealous woman nearly pulls Ayatollah Khomeini out of the window at the Refah School.

OPPOSITE: Ayatollah Khomeini speaks into a microphone held by his aide-de-camp Ebrahim Yazdi during a press conference at the Refah School. Another close aide, Sadegh Ghotbzadeh, is to the right.

Tehran, February 2, 1979

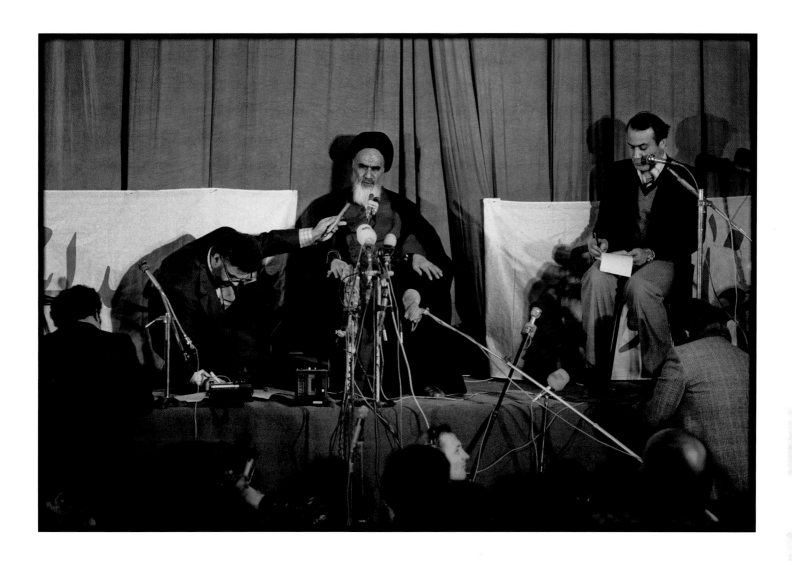

DAY 39
FEBRUARY 2, 1979 The press conference is held in a big room at the Refah School. Khomeini arrives with a small coterie and takes a seat on the short stage, looking as if this is the last place he wants to be. On the stage with him are his advisers, Ebrahim Yazdi and Sadegh Ghotbzadeh. The ayatollah appears completely uninterested in the event.

Questions flow from the press, and answers, carefully translated into English, follow. There is a similar attitude among all speakers while they await the translation. They become bored, and their thoughts seem to turn to other things. Watching Khomeini with my 280mm lens, (a 200 with a 1.4x extender), the arced lights create strong shadows over his face as his piercing eyes scan the room like tiny lasers.

I move about trying to catch views of his face from several different angles. Then he rises and slowly walks to the edge of the stage. The curtains part, and he's gone.

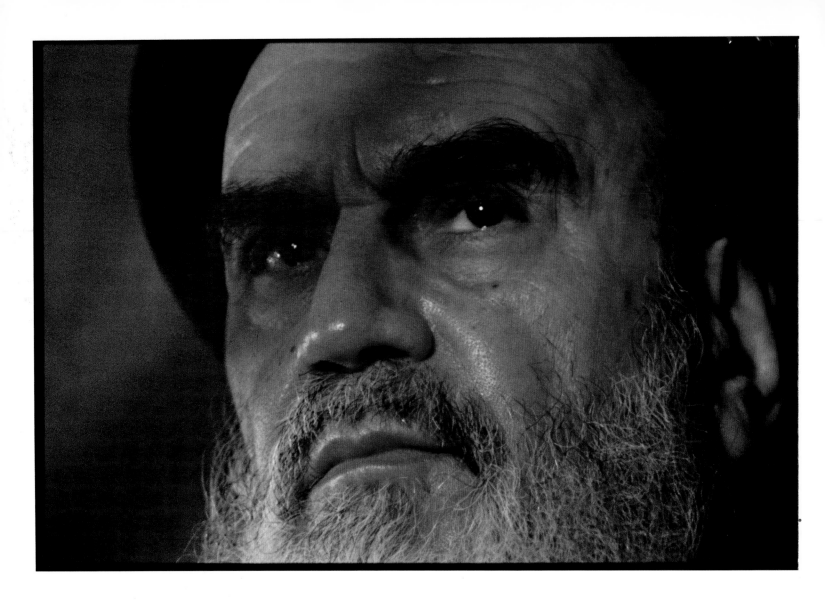

ABOVE: Ayatollah Khomeini during a press
conference at the Refah School.
OPPOSITE: Supporters strain to catch a glimpse
of Ayatollah Khomeini at the Refah School.
Tehran, February 2, 1979

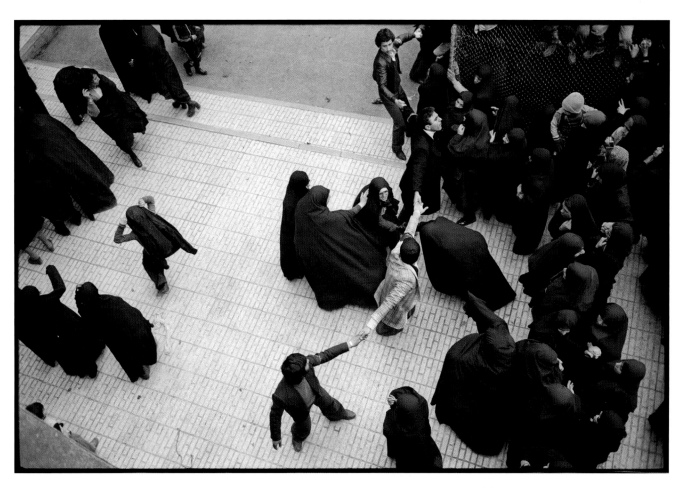

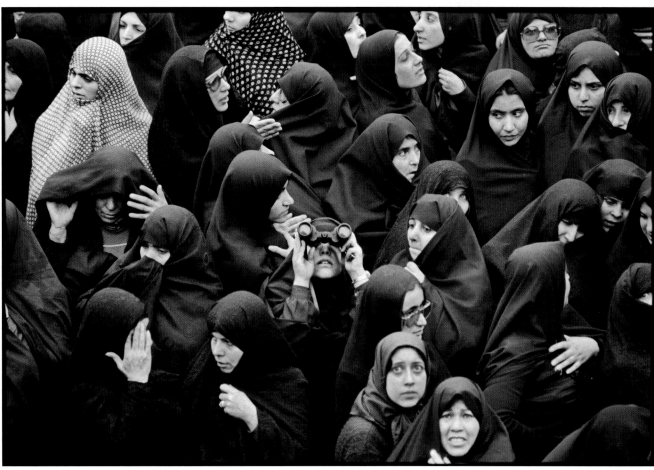

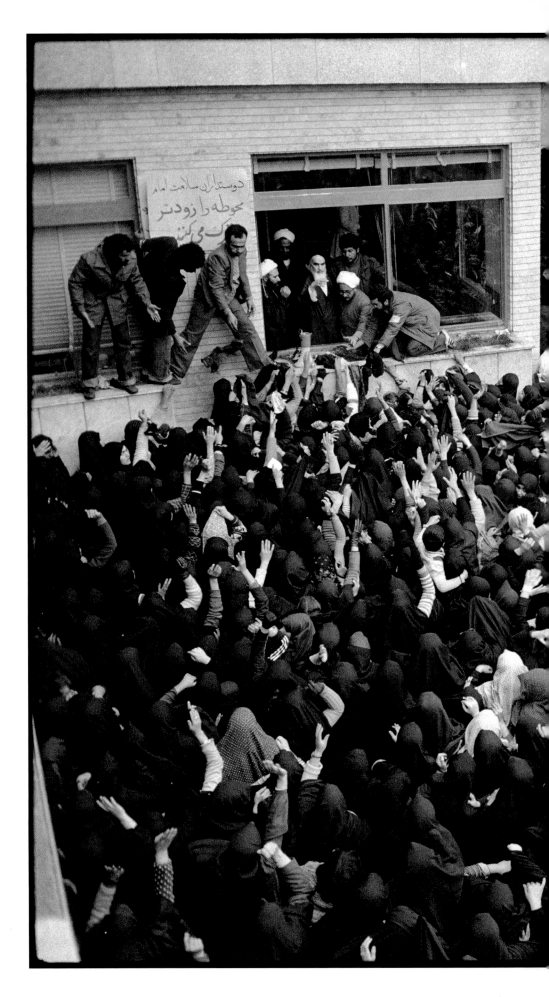

Ayatollah Khomeini greets supporters at the
Refah School. The sign on the building reads,
"Those who cherish the health of the Imam
Khomeni will leave the premises promptly."
Tehran, February 3, 1979

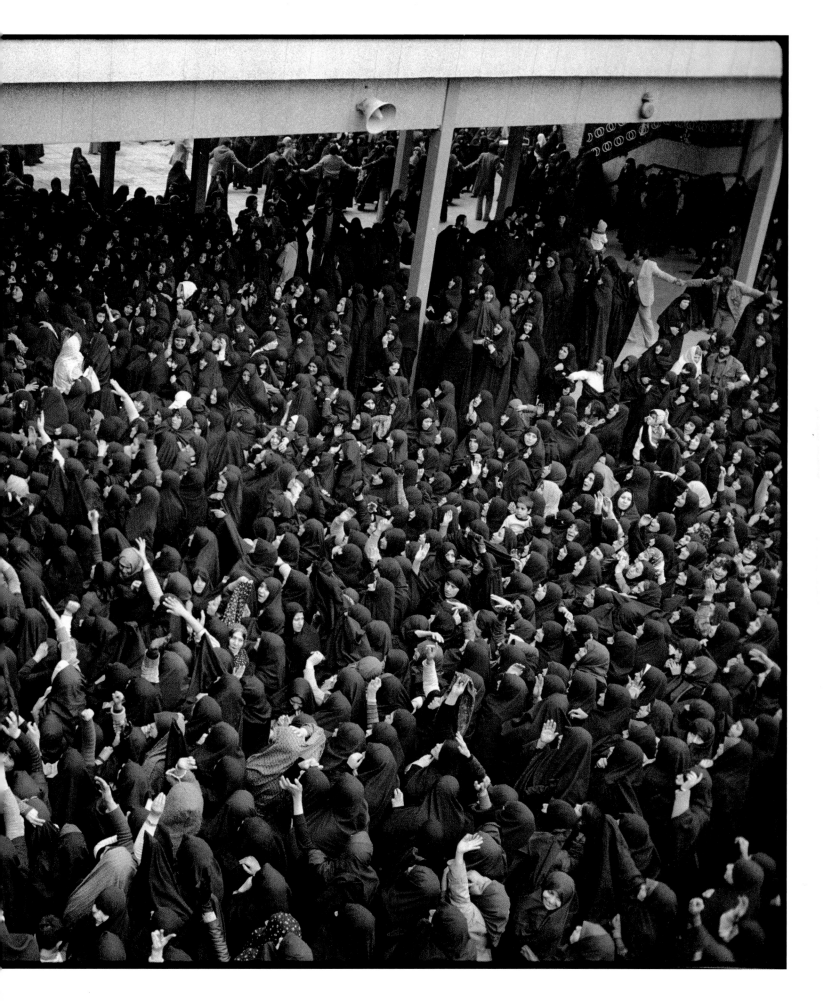

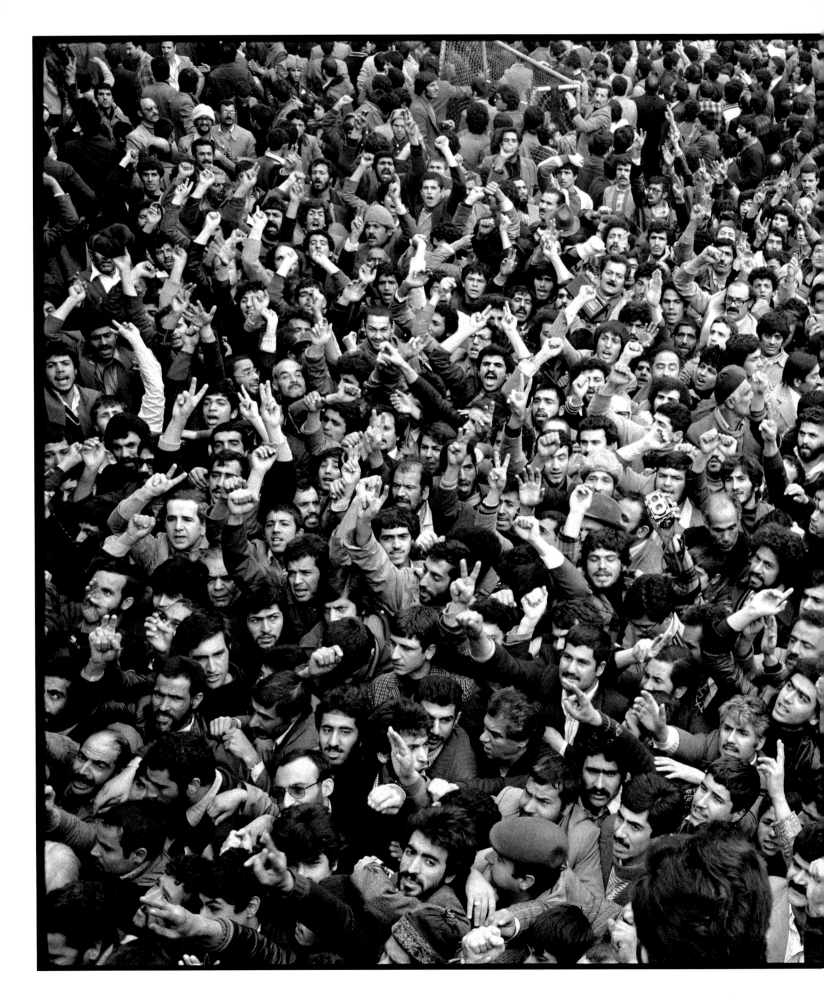

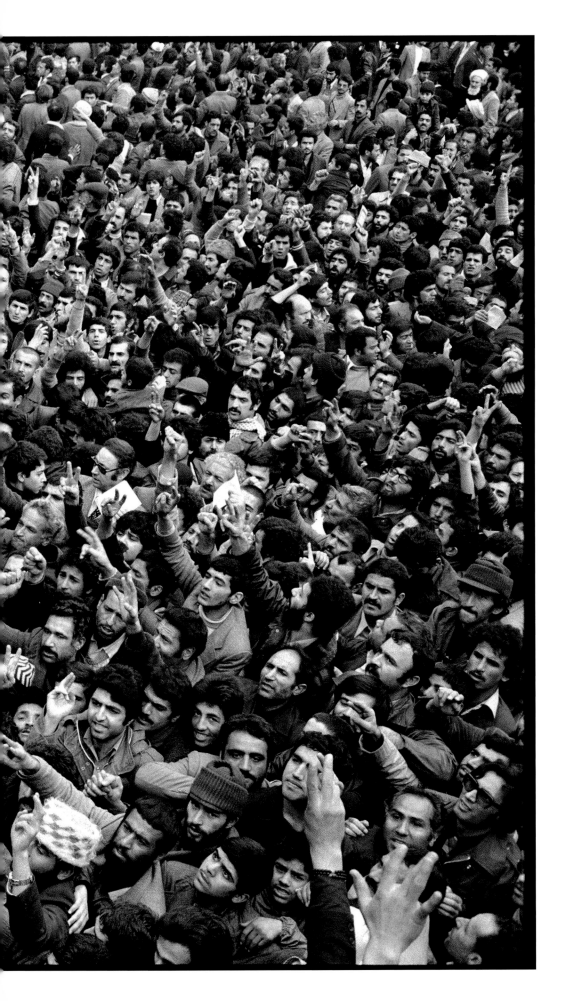

Ayatollah Khomeini greets male
followers at the Refah School.
Tehran, February 4, 1979

FOLLOWING PAGE, TOP: Akbar Hashemi Rafsanjani
and Ayatollah Khomeini appear at a press
conference at the Refah School.
FOLOWING PAGE, BOTTOM: (l to r): Akbar Hashemi
Rafsanjani, Ayatollah Khomeini, Mehdi
Bazargan, and an interpreter at a press
conference at the Refah School announcing
Bazargan's appointment as prime minister.
FOLLOWING PAGES, RIGHT: A mullah speaks to a
female Khomeini follower at the back of the
Refah School. Tehran, February 5, 1979

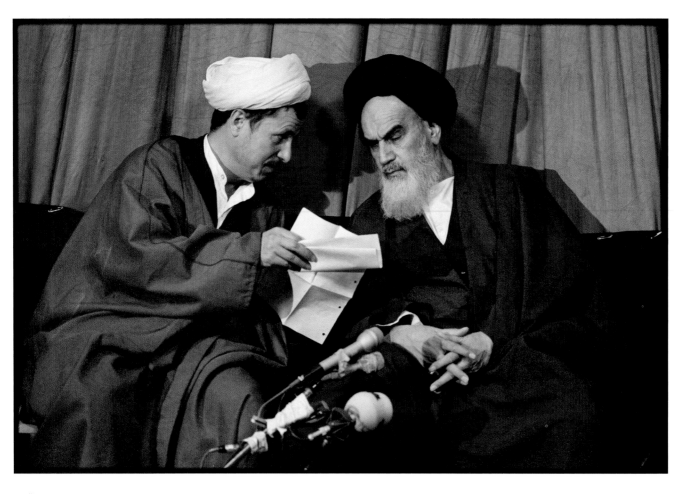

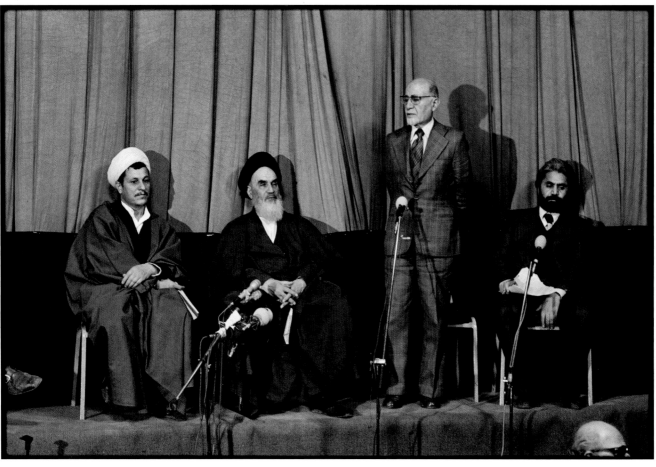

DAY 42

FEBRUARY 5, 1979 Khomeini's people select a professor to take care of the foreign press. His name is Javad. Trained as an economist, he doesn't really know what he is supposed to do. He holds daily briefings in one of the classrooms at the school, and we all go and sit at little school desks. But the briefings bear no resemblance to anything at 10 Downing Street or the White House. Javad has nothing to say.

After two days no one else bothers to go. But figuring that with Khomeini around, it can't hurt to show up, I go the first day, the second, then the third. After that it's just Javad and me. On a little piece of paper I write out "official" requests to meet Khomeini and hand them to him.

I keep telling him: "When Imam raises his arm and everybody in the crowd raises their arms, you know, it's a little bit like Germany in the thirties with the Nazi salute. It doesn't look so great." I'm trying to think of anything that will convince him it's worthwhile for me to make some pictures on the inside. Finally, after three or four days, I spot a little hint of recognition in his eyes. "Let me see what I can do," he says. He goes off for a few minutes. When he returns he says, "Please, come with me."

A contact sheet shows Khomeni in his room at the
Refah School having tea, speaking with his advisers,
then greeting his followers.
Tehran, February 5, 1979

I grab my camera bag, an old beat-up canvas Hardy fishing bag I'd picked up in London at the shop on Pall Mall for well-heeled fishermen that's patronized by at least as many photographers, and we start down the hall. I feel tension in the pit of my stomach. Instead of leaving the room through the hallway leading outside, we plunge into the bowels of the school, wending our way through a warren of basement hallways, up a flight of stairs, and down other corridors. Dozens of people are gathered in small groups, having tête-à-tête conversations in the dark shadows of the dimly lit interior as if they were standing on a movie set. We are definitely going *toward* something.

We reach a hallway where a knot of men are standing around wearing a combination of clerical robes, combat fatigues, and cheap suits. As we approach a door, quite a normal looking door with nothing written on it, Javad touches my arm softly. "Can you please remove your shoes?"

I'm wearing my nylon and leather combat boots, the high-ankle variety I more or less lived in while in Vietnam. With all the laces, it usually takes a full minute or so to unlace them. Today, both boots are off and tucked into a corner by the door in half a minute. I check my cameras. More than once, like every other photographer in history, I've shot picture after picture with no film. This time, there won't be any screwups. I flip up the rewind lever on each camera, back-winding until I feel the tug of the roll. Then, guessing at what I think the light might be in the room, I set the exposure. I nod to Javad that I'm ready.

The door opens. It's so quiet inside, it's startling; on the outside, it is noisy, loud, hundreds of well-wishers pushing and shoving and screaming. But inside, the glass window overlooking the playground is closed, and it's as if I'm looking through a TV screen with the sound turned off.

As we walk in, one of the mullahs is holding a tray to pick up an empty teacup from Khomeini. The ayatollah is sitting on the floor with his back against the wall about eight feet from me. Seeing him up close, the first thing I think is that he actually looks like I thought he'd look. I mean, Khomeini looks exactly like his pictures.

I make a couple of quick shots. Then I vaporize, heading for the opposite corner of the small room. Khomeini is cool and calm, speaking in soft whispers to his fellow mullahs. He never makes eye contact with me and I have the impression he doesn't even know I'm there.

After a few minutes, he gets up and walks out. I sit down, check my film in each camera, and wait for him to come back. In a few minutes I hear a hubbub outside the door, and I stand to see Khomeini strolling back into the room, nearly tripping on my camera bag, which I'd set near the door to be out of the way.

His aides open the windows for him to greet the people. Arm up, Khomeini doesn't so much wave as present his hand in greeting. A tremendous surge of noise floods the room, shouts reverberating off the walls. The energy from the crowd is phenomenal, and all of it is directed to this man a few feet away, almost as if it was directed at me.

In an instant, Khomeini turns toward the door and walks out. Even with all the noise, in my head the room suddenly goes silent.

"He is gone to prayers," Javad says. "I think you are finished."

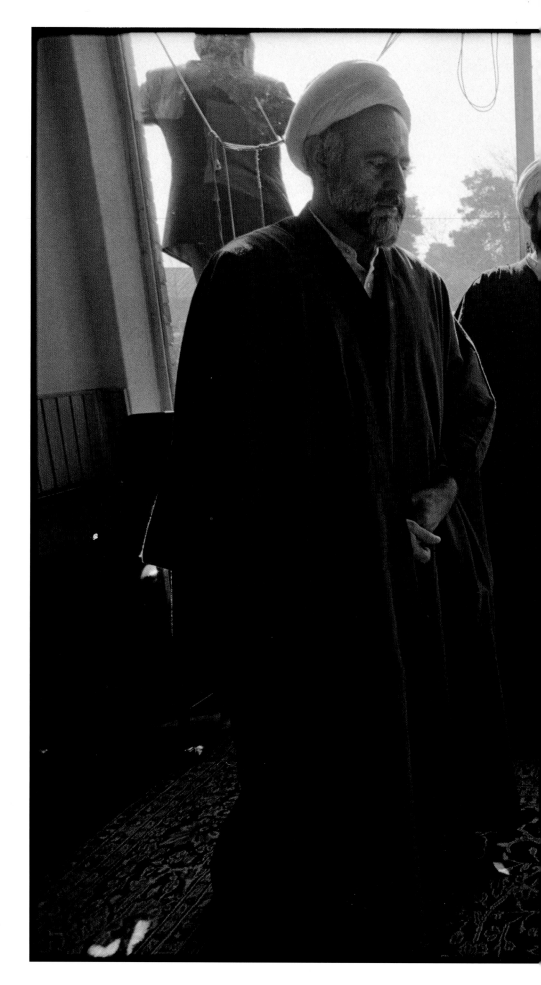

Ayatollah Khomeini is served tea in his room at
the Refah School by Sadegh Khalkhali, who later
became known as "the hanging judge."
Tehran, February 5, 1979

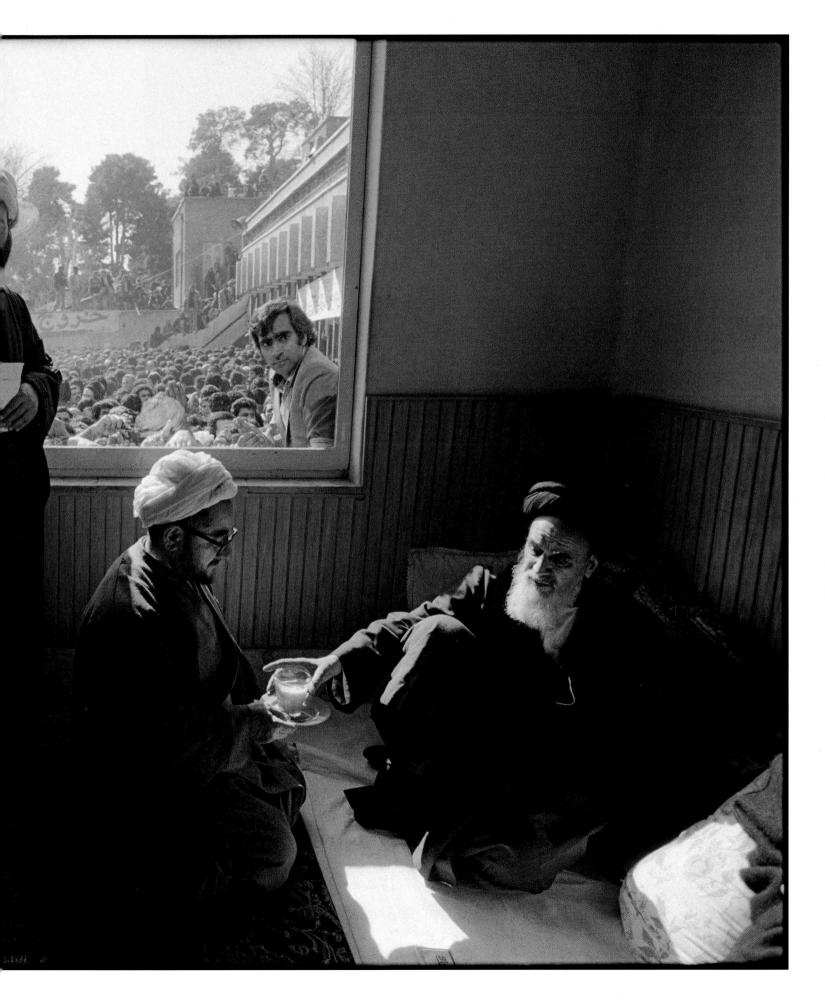

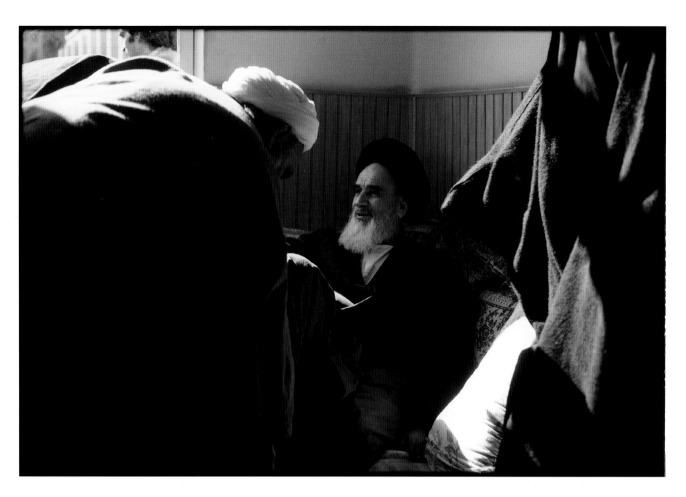

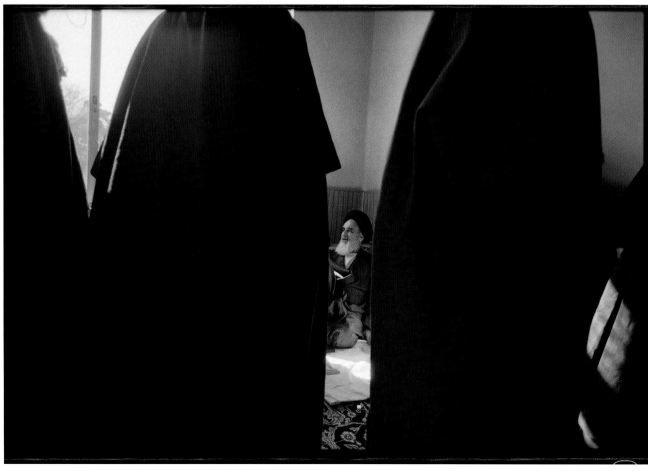

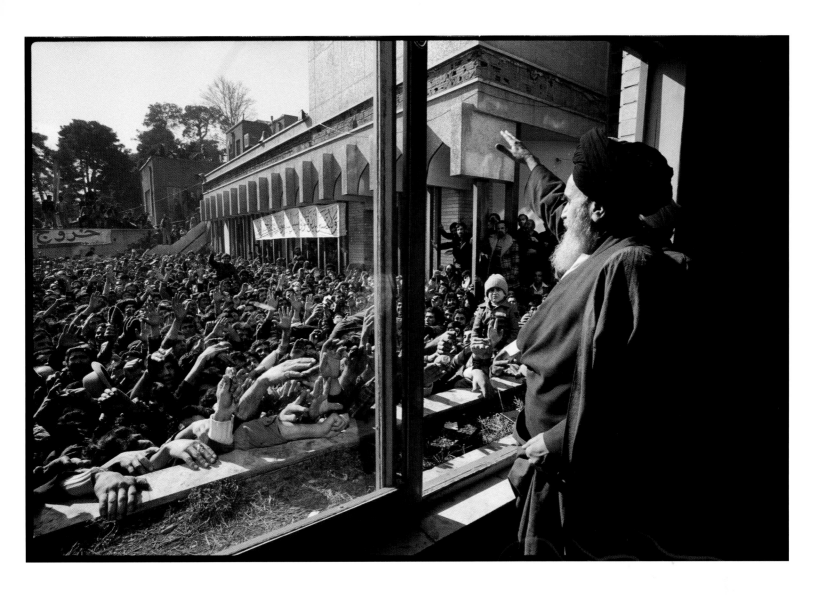

OPPOSITE TOP AND BOTTOM: Ayatollah Khomeini with
his staff at the Refah School.
ABOVE: Khomeini greets the multitudes.
Tehran, February 5, 1979

A pro-Bakhtiar supporter during a
demonstration inside a sports hall.
Tehran, February 7, 1979

DAY 44

FEBRUARY 7, 1979 I go back to Leon's with Elaine Sciolino of *Newsweek*. Elaine, like a dozen other journalists, has arrived on Khomeini's Air France jumbo jet. I remember her name from the previous summer when her snapshots of the *Double Eagle II*, the first manned balloon to cross the Atlantic, appeared in *Newsweek,* quite a feat for a writer. We arrive in a hotel taxi and tell the driver to pick us up a little before 9 p.m., leaving us enough time to get back before the curfew.

Leon's is one floor down below sidewalk level, and inside the atmosphere is subdued, even suspicious. The staff is welcoming, but all of us are aware that the world has changed in the past few days. As in Rick's Café Americain in *Casablanca,* desperation lurks just below the surface.

Perusing our menus, we look around the room at the other diners, trying to gauge just what this new world has on offer. We order blini with caviar. Then, in hushed tones, we ask the waiter if it might be possible to get some vodka. Hearing the word "vodka," a pained expression crosses his face; he's torn between his training as a waiter and the militants breaking liquor bottles in the streets. Hoping his embarrassment isn't too deep, we settle into our meal. But when we next sip from our water glasses, it isn't water anymore. Our supper, served in the very first days of the Islamic republic, is accompanied by the finest Russian vodka.

After paying the bill, we head outside to our car. But instead of finding our driver, we run into a rather ugly surprise: a team of mujahideen, a group of six men in their 20s and 30s, outfitted in combat fatigue jackets and sporting rifles. They don't look happy.

Elaine and I pretend not to notice, but they don't buy it. In halting English, they demand to know if alcohol has been served in the café. We both say no, but one young man, incredulous, approaches to within inches of my face: "Breathe!" he commands. I exhale lightly, hoping he might go away. No such luck. "You must come with me," he says, reaching for me. Before I can react, Elaine grabs my arm, wrapping hers around mine. "If he goes, then I go with him." The militant considers the situation. There is no way he wants to touch some unknown Western woman, trying to unravel her from my arm, so in total frustration he lets us go just as our car arrives.

We bound into the taxi, give the driver directions for the hotel, and don't look back.

END OF THE MONARCHY

At the end of December 1978, U.S. President Jimmy Carter dispatched Col. Robert Huyser to Tehran to dissuade the Iranian military from staging a coup d'état to keep the shah in power. Acceding to Huyser's wishes, the armed forces remained relatively quiet through the dramatic changes of the following month. But after Ayatollah Khomeini's return on February 1, 1979, there were increasing signs that the unity of the 400,000-man military, which was constitutionally bound to support the Bakhtiar government, was beginning to fray.

Khomeini, who referred to the shah's departure as merely "a first step" in establishing an Islamic republic, announced the formation of a provisional revolutionary government five days after his arrival in Tehran, in effect creating a shadow government. Soon his aides also opened secret negotiations with the army, the only source of the prime minister's power.

The coup de grâce of the 53-year-old Pahlavi dynasty came within a week. On February 10, 1979, a group of cadets at the Doshen Tappeh Air Base, east of Tehran, staged a pro-Khomeini demonstration. Refusing to disperse, 20 were killed by the Imperial Guard. This prompted a pitched weekend-long battle between heavily armed soldiers and insurgents that killed hundreds, including veteran *Los Angeles Times* reporter Joe Alex Morris, who was shot through a window after taking refuge in a building near the base.

When the smoke cleared on Sunday, February 11, 1979, the military had declared its neutrality, abandoning Bakhtiar. The last government of the monarchist era resigned en masse. Bakhtiar himself went into hiding before escaping to Paris, where on August 7, 1991, he was assassinated in his home by Iranian revolutionary agents.

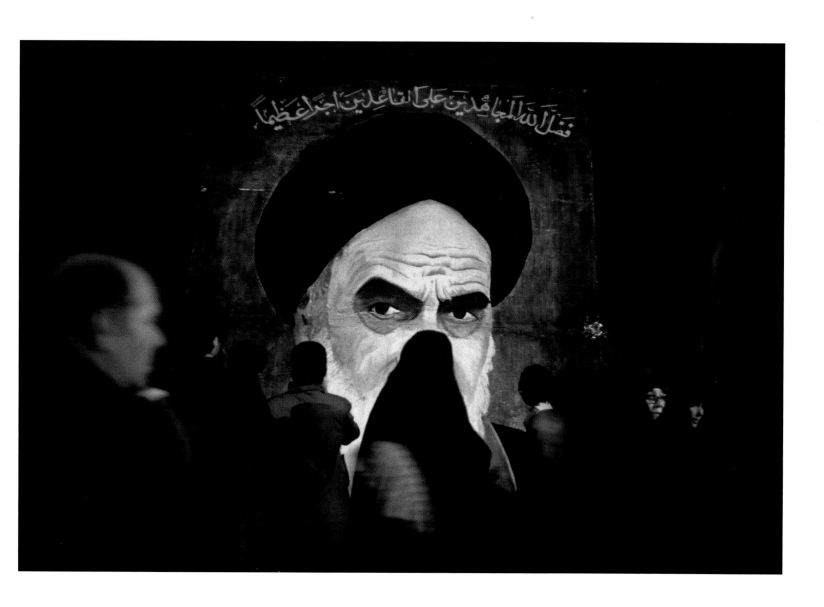

Billboard with a portrait of Ayatollah Khomeini. Tehran, February 1979

EPILOGUE: THE U.S. EMBASSY ATTACK

Just days after the fall of the monarchy, at about 10 a.m. on Valentine's Day, February 14, 1979, the fortified U.S. embassy in central Tehran came under a full-scale attack as hundreds of militants clambered over the walls and poured through the breached gate. For two hours, heavy gunfire raged as 19 U.S. marines attempted to protect the compound.

The embassy's defense was handled personally by the ambassador, William Sullivan, who, using a walkie-talkie, eventually ordered the destruction of all classified material and equipment, and instructed the marines to surrender. Amid wafting tear gas, embassy employees were led outside with their hands raised above their heads.

Within several hours, men loyal to Ayatollah Khomeini, led by the new deputy prime minister of the revolutionary government, Ebrahim Yazdi, arrived at the embassy and managed to convince the attackers to disperse.

Although only one Iranian employee had been killed and one marine wounded, the event both foreshadowed and set the groundwork for the seizure of the American embassy nine months later, following the admittance of the shah into the U.S. for treatment of cancer. This second takeover, on November 4, 1979, orchestrated by a group of fervent pro-Khomeini students called the Muslim Student Followers of the Iman's Line, resulted in the capture of 52 Americans and a 444-day hostage crisis.

The seizure of the "den of spies," supported by the Ayatollah Khomeini, led within days to the resignation of the moderate Iranian government of Mehdi Barzagan and, after a failed rescue attempt and the death of the shah, the defeat of President Jimmy Carter in the 1980 U.S. elections. A watershed experience that significantly damaged American prestige abroad and wounded its collective psyche at home, the crisis emboldened enemies of "The Great Satan"—as Khomeini dubbed the U.S.—and reshaped the course of global affairs. In time its aftershocks would reverberate through conflicts in Lebanon, Afghanistan, Central America, the destruction of 9/11, and the war in Iraq.

Thirty years later, effects of the Iranian/U.S. schism continue to be felt throughout the world.

—THE EDITORS

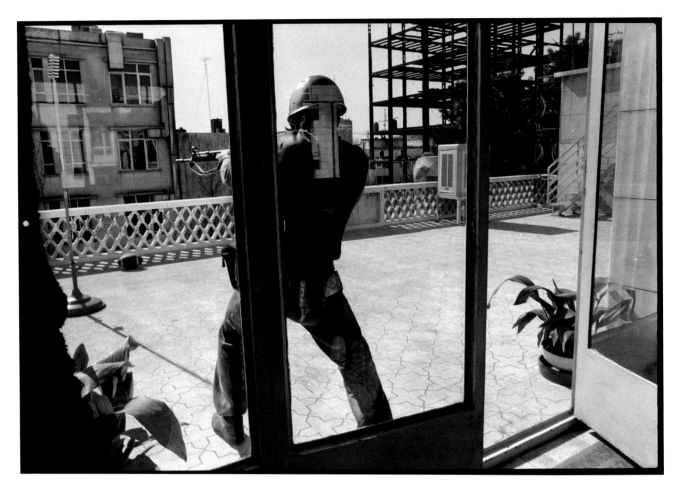

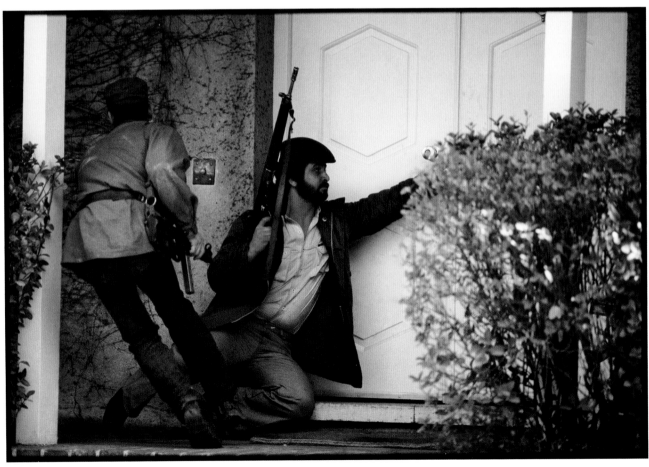

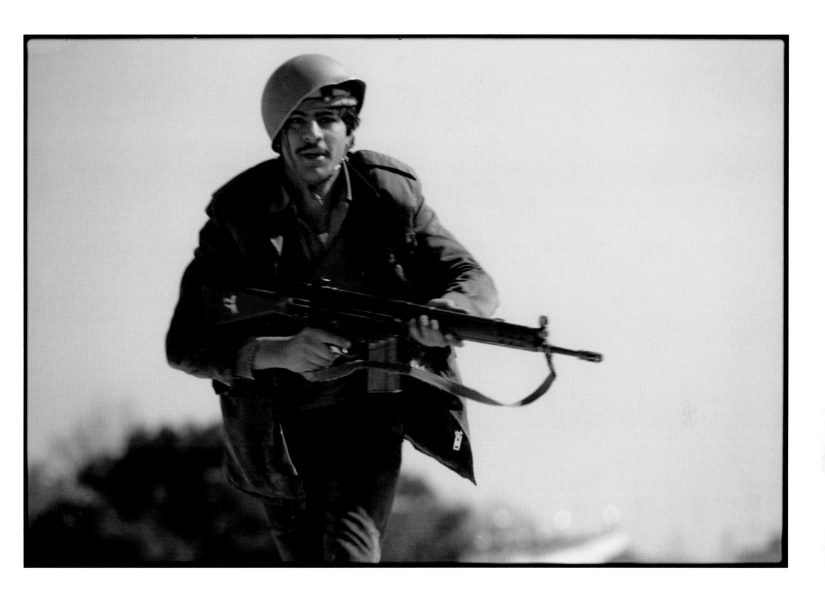

Militants assault the U.S. Embassy.
Tehran, February 14, 1979

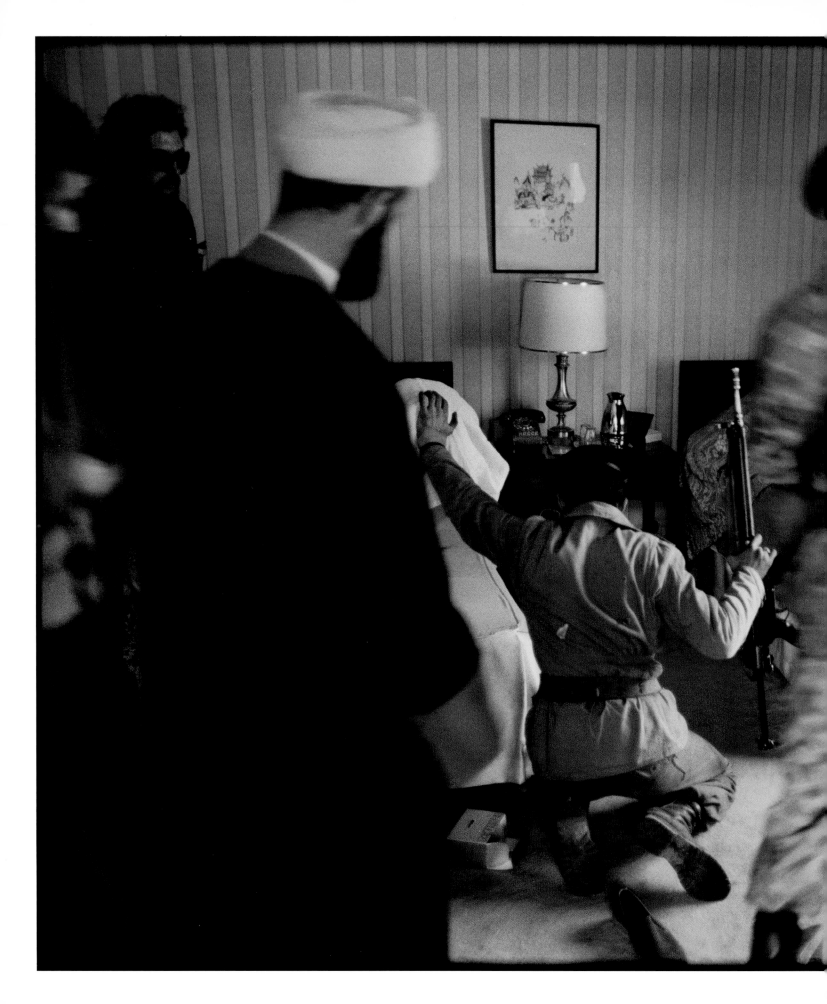

Gunmen search for arms in the U.S.
Embassy. Tehran, February 14, 1979

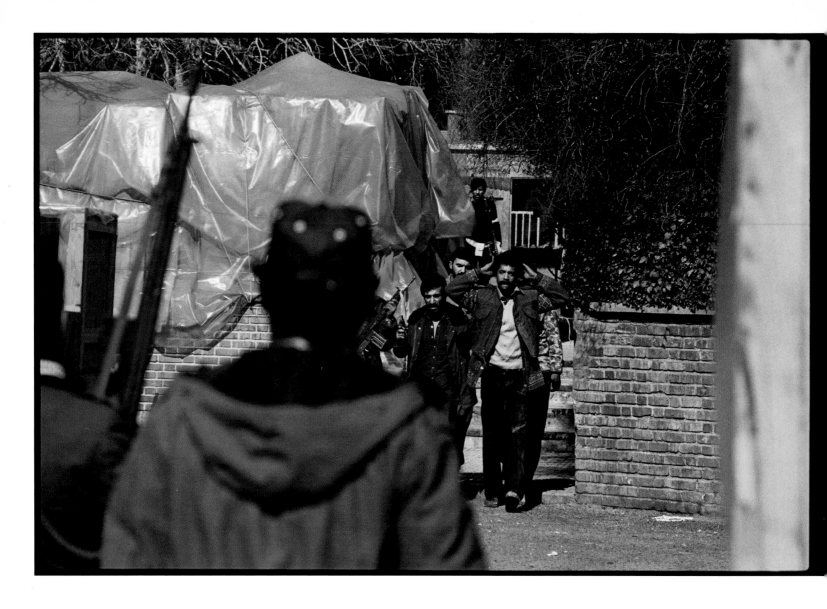

Gunmen search the private quarters
of the U.S. Embassy.
Tehran, February 14, 1979

AFTERWORD

About a week after Khomeini's return, the political struggle for power slows to a grinding wrestling match. Thinking this will continue well into spring, I decide on a weekend in Paris, my first days off in six weeks. Norm Lloyd, a CBS cameraman I'd known since Vietnam, warns me against it, but I need a break. I book an Air France flight and once more pass through those departure lounges I've searched for travelers to ferry my film to Europe. Now it's my turn, and I carry with me film from Rebbot, Mingam, and Dejean. Now *I'm* the pigeon.

I realize my mistake in leaving almost immediately. That afternoon, after landing at Roissy Airport in Paris, word of more unrest in Tehran comes over French radio. I go straight from the airport to the Iranian Embassy. Normally it takes several days to get a new visa, but having just arrived, I plead my case and manage one in just a few hours. Now I need to think about travel. As of Saturday, it's announced that Iranian airspace is closed.

By Sunday morning permission for takeoff is granted, but in situations like this guarantees are never hard and fast. After flying for several hours, Turkish authorities radio that we're not permitted to fly into Iranian airspace. Iran is closed. We land in Ankara instead. After several hours of trying to negotiate, it's too late to fly to Tehran and we find a place to stay for the night. On Monday we gather back at the plane and eventually take off. After flying for what seems like forever—it's hardly a straight line—we land just before dusk. As the plane slows to a stop on the tarmac, we find ourselves surrounded by cars and vans, some from the airport authorities, others with press and TV people. I walk off the plane and spot several of my colleagues grinning. "We missed you!" they say. But what they really mean is, "You missed it!"

With thoughts of café au lait and croissants still dancing in my head, I wander over to the Time/AP office a couple of days later to see what's happening, still somewhat chastened by the debacle of my Paris trip. Parviz is steadily taking phone calls, as usual. A professional-class Iranian employed by a Western news agency, I don't think he's in any direct danger, but his deeply furrowed brow shows the worry of a man whose world has been swept away in a weekend. Still, he's all newsman. When the phone rings again, his face lights up, eyes wide. He puts the receiver down and shouts to the office, "There is gunfire at the American Embassy!"

He doesn't need to say more. I grab my gear and hop into a car with one of the AP stringers. We drive like mad, trying to get as close as possible to the embassy entrance. Several blocks away, when we start to hear shooting, we ditch the car. I run up to a small apartment building where I think I might get a good view. On the ledge above me several young men in military garb and helmets are trying to get inside the same place. Bullets are flying through the air, and I begin making pictures of the militants running in a squat across the entryway of the building, attempting that elusive combination of speed and safety.

One of the men gets inside the apartment. I follow him, also in a crouch, and we wander through the entryway, past the living room, and onto the deck in the back, which faces the

embassy. It's unclear who's shooting, but every few seconds a round zings by, occasionally hitting the wall inside the apartment. At one point, several bullets fly by me in succession, each a distinct and precise high-pitched ping. I try to make myself as flat as I can. Staring down at the terrazzo stone floor of the deck, all I can think is, A few days ago you were in *Paris*.

At times like this you inevitably wonder at what moment you might have opted out. I once watched Don McCullin walk down a stretch of very exposed road in Vietnam. Maybe Don felt that it was safe enough. But watching him, I hesitated. Would I have the same luck? Would that road be safe enough for me? Only a few lucky journalists really know where those lines are painted, or think they do. For the rest of us, it's the kind of thing we slip into, find ourselves getting deeper and deeper, and then, with the realization of what's actually happening, hope to get out of again. But often that's where the best pictures are. And that's why we stay.

That morning in Tehran, wondering what's keeping me there, the shooting stops. I run down the stairs, out of the apartment building, then slowly round the corner into the open gates of the embassy. A strange sensation: No guards, no marines with M-16 rifles, no one to say "Halt!" or to point you to the visa office. I walk toward the main building amid a swarm of young militants, most armed, some with helmets and camouflage jackets. I wander through the embassy buildings. Documents are sitting on desks. Briefcases are sitting by chairs, open. The place has a sense of time suspended. There are no U.S. personnel, only evidence of what they left behind. At one point, looking at some papers on the ambassador's desk, I feel almost embarrassed, and wonder when I stop being an American and start being an "international journalist." This question doesn't arise often. Usually I know what my work is about, and how I fit into reporting the events of the world. But it's a spooky moment when your own country and your own ambassador are the victims.

Amazingly, the militants don't trash the offices. Some sheaves of paper are tossed about, others taken. But for an embassy takeover, it's quite restrained. Then, after a half hour of snatching images here and there, I hear loud voices outside. Racing to the main driveway, I see a U.S. marine, one of the guards, being led away with his hands over his head. Soon, other members of the staff pass by, escorted by armed men and Ebrahim Yazdi, Khomeini's deputy, who's now ostensibly in charge.

"Don't let them take any pictures!" he shouts in Farsi. The Iranian photographers stop shooting. But unaware of what Yazdi is saying, I keep taking pictures, convinced I won't be able to keep my film anyway. In the end, however, the staff is released, the militants leave, and I escape with my photographs. Not wanting to risk losing them to some trigger-happy militant or overzealous soldier, I race the rolls straight back to the office.

—**DAVID BURNETT**, Washington, D.C., April 2009

An American taken prisoner during
the attack on the U.S. Embassy.
Tehran, February 14, 1979

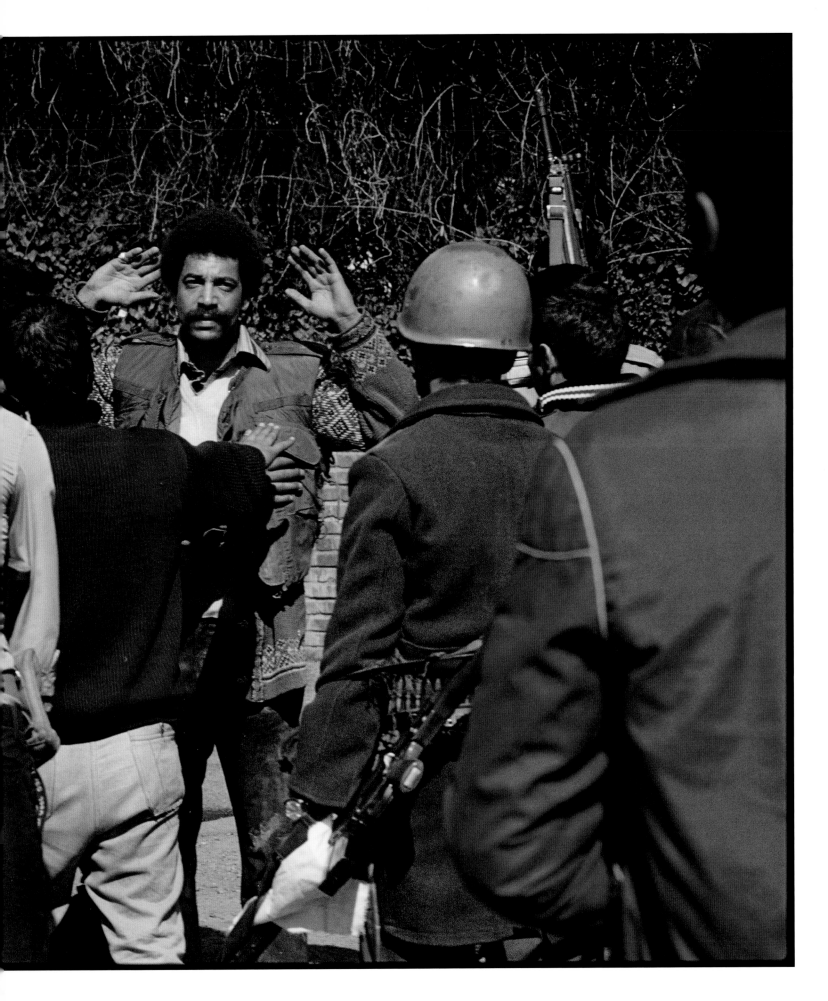

EDITOR'S NOTE

Historical upheavals are rarely covered in their entirety by a single photographer, and certainly not with the diversity of situations and players managed by David Burnett. In his photographs of the Iranian Revolution we find the shah and his army, Khomeini and his followers, and the people—the men, women and students, the fabric of society—who were the engine, actors, victims, and onlookers of the tidal wave whose development no one predicted and whose consequences no one foresaw.

Truly, the world has never been the same since.

It was Burnett's patience, and his willingness to go see for himself, that earned him the privileged position of being history's witness. That same patience accounted for the 25-year wait before work on this book began in 2004. At that point, the editors had just published *Red-Color News Soldier: A Chinese Photographer's Odyssey Through the Cultural Revolution* by Li Zhensheng, and it was a natural movement to progress from a revolution that ended in 1976 to another that began in 1978.

As in that previous volume, our intention was to present this work in the shape of a history book that joined the photographer's images with text derived from his role as a personal observer to one of the most important and far-reaching events of the late 20th century. To achieve this, Burnett's entire archive of contact sheets and color slides from Iran were meticulously organized, he himself submitted to dozens of hours of interviews, and substantial research was undertaken to verify his recollections and to craft the historical text sections in this book that give his images their proper context.

In many ways the revolution in Iran had a classic, nearly Shakespearian trajectory, and accordingly the book is structured along the lines of a three-act play: the last days of the shah, the interregnum, and the first days of Khomeini. Whereas many photographers were in Iran for one of these parts, Burnett was there for them all. These were the 44 Days of the title which, while making reference to the 444-day hostage crisis that began in November 1979, represent the turn of the screw: the fall of the monarchy and the establishment of an Islamic republic.

The photographs in this book—a significant representation, if only a fraction of Burnett's total archive—were not chosen solely on aesthetic grounds, nor are they intended to be viewed as art. Rather they are remarkable historical documents, the contents of a time capsule from another era. To maintain their authenticity, they are presented entirely unmanipulated, with no conversions from color to black and white, never cropped, and sequenced, to the best of our ability, in their exact chronological order. There are gaps, to be sure, but such is the nature of the lone photojournalist's work.

—ROBERT PLEDGE
& JACQUES MENASCHE

CONTRIBUTOR BIOGRAPHIES

DAVID BURNETT was born in 1946 in Salt Lake City, Utah, and early in his career became the last photojournalist to cover the Vietnam War for *Life* magazine. He has since worked in over 75 countries. A co-founder of Contact Press Images in 1976 with Robert Pledge, he is the winner of many awards, including the Robert Capa Gold Medal, the World Press Photo Premier Award, and the Overseas Press Club of America's Best Reporting from Abroad in Magazines and Books Award in 1979 for his work from the revolution in Iran. Burnett is a regular contributor to *Time* magazine.

ROBERT PLEDGE began his career in journalism reporting on African affairs. He co-founded Contact Press Images in New York in 1976. Since then he has curated critically acclaimed photographic exhibitions throughout the world and produced major books, including 2003's *Red-Color News Soldier*, for which he received the Overseas Press Club of America's Olivier Rebbot Award.

JACQUES MENASCHE began his career in journalism as a clerk at the *New York Times* and has since reported on culture and conflict from around the world. He is the author with Robert Pledge and Li Zhensheng of *Red-Color News Soldier*. His 2006 television report on heroin addiction in Afghanistan, "The Brothers of Kabul," received Australia's Walkley Award.

CHRISTIANE AMANPOUR, CNN's chief international correspondent, has reported from the world's many hotspots, including Iraq, Afghanistan, the Palestinian Territories, Iran, Israel, Pakistan, Somalia, and Rwanda. Born in Iran, she has secured exclusive interviews with many world leaders. She has received numerous awards for her reporting.

JOHN KIFNER joined the *New York Times* in 1962, and has covered wars and conflict in Lebanon, Iraq, Iran, Afghanistan, Bosnia, Kosovo, the former Yugoslavia, and Iraq. His reporting from the Iranian Revolution earned him the George Polk Memorial Award in 1979. In 2006, he retired from the *New York Times* after four decades.

ACKNOWLEDGMENTS

The two months I spent in Iran, covering the revolution in the winter of 1978/79, while full of various precise dates and times, still remain in many ways a riddle. What did we really see, and how do we perceive those things now? In ways that the written word, with its need to be precise, often misses, the inherent value of a photograph is more a feeling than a fact. A photograph might cut right to the core, or present a more diffused view, pose a question rather than answer one. It is, in the end, the power of the photograph to provoke and prod our sensibilities that makes photography a singular tool for regarding history.

Two years ago, having returned from an assignment to New York, I walked into a back room at my agency office—Contact Press Images—to see a surprising sight. In my absence, and from edits made by Robert Pledge and Jacques Menasche, hundreds of small photocopies of revolution photographs were taped up around the walls of that room in a time-line mosaic, from my arrival in Iran on Christmas Day, 1978, until I departed the following February. Seeing that narrative all at once on three walls of a single room was immensely powerful. For the first time I saw the work as flowing continuum, a story with a beginning, a middle, and very dramatic ending.

With Menasche's help, I began penning recollections (it's astonishing what you can forget in 30 years!) to parallel the historical narrative he had methodically woven. Meanwhile, Robert Pledge—who while I was in Iran saw my film even before I did—continued curating the archive he has meticulously overseen for the past three decades. With his gift of editing and understanding of how pictures become history, he gave this book an exciting pace and edge the way only he can.

Menasche constantly reshaped the story to make it real; Jeffrey Smith wrote, made numerous calls, and produced email and hand-delivered pitches to try to interest publishers in a subject that many believed was "important" but ultimately "not right for us," bringing writers on board,and negotiating the book deal. The rest of the team at Contact looked after the films, the scans, the captions, and helped to make this happen. My sincere thanks to Dustin Ross (whose elegant design gave rise to the *44 Days* cover); Audrey Jones, Samantha Box, Ronald Pledge, Bernice Koch, Catherine Pledge, and Nancy Koch in New York; Dominique Deschavanne and Tim Mapp in the Contact Paris office; and Mahnaz Zahedi, who reviewed the text for accuracy.

This was truly a team effort in which the story—my pictures and experiences—was developed and honed, and given a new sense of importance by the work of my colleagues at Contact and the creative forces at National Geographic. I also want to thank Christiane Amanpour and John Kifner, whose personal reflections on that period provided a new level of understanding of what I had seen through the lens.

In thinking back to those tumultuous days, and the friends I worked with, there are many colleagues I wish were still alive to share in its fruition. Working with them, whether at the bureau or in a crowd of a million people made us all friends in that funny way that happens with journalists: Dean Brelis—*Time* reporter extraordinaire; Olivier Rebbot—*Newsweek* photographer and the pal I spent so many mornings with at Mehrabad Airport, trying to find a pigeon for our films; Catherine Leroy, a fearless photographer and veritable force of nature; Alain Dejean, Sygma, perhaps the most elegant war photographer I have ever known; and Kaveh Golestan, the Iranian photographer who never failed to graciously share information or shed light on a sometimes murky political situation.

Just weeks after my return from the revolution I was the "pool" agency photographer at the White House to cover the signing of the Camp David Peace Accords. In an effort to produce many "original" slides, I shot like mad during the signing and was out of film in all five cameras when Carter, Begin, and Sadat stood to embrace. I missed the picture. That night I had a blind date with a young woman who worked at the State Department, Iris Jacobson. I was very depressed by my work that day, but somehow managed to convince her I was a wonderful guy. We have just celebrated our 25th anniversary, though the one day we really take note of is that first date, March 26, 1979. She has been here for everything in my life that came after the revolution, now 30 years ago, and it has been quite a ride together. My mother, Barbara Burnett, a journalism major at Stanford in 1938, never had a chance to practice her craft on a daily basis. However, I like to think that some of the same curiosity and drive that led her in that direction made its way to me.

—DAVID BURNETT,
Washington, D.C., April 2009

44 DAYS

IRAN AND THE REMAKING OF THE WORLD

BY DAVID BURNETT

CONTRIBUTIONS BY CHRISTIANE AMANPOUR AND JOHN KIFNER

EDITED BY ROBERT PLEDGE AND JACQUES MENASCHE

PUBLISHED BY THE NATIONAL GEOGRAPHIC SOCIETY

John M. Fahey, Jr., *President and Chief Executive Officer*

Gilbert M. Grosvenor, *Chairman of the Board*

Tim T. Kelly, *President, Global Media Group*

John Q. Griffin, *Executive Vice President; President, Publishing*

Nina D. Hoffman, *Executive Vice President;*
 President, Book Publishing Group

PREPARED BY THE BOOK DIVISION

Barbara Brownell Grogan, *Vice President and Editor in Chief*

Leah Bendavid-Val, *Director of Photography Publishing and Illustrations*

Marianne R. Koszorus, *Director of Design*

Carl Mehler, *Director of Maps*

R. Gary Colbert, *Production Director*

Jennifer A. Thornton, *Managing Editor*

Meredith C. Wilcox, *Administrative Director, Illustrations*

STAFF FOR THIS BOOK

Rebecca Lescaze, *Editor*

Melissa Farris, *Art Director*

Robert Waymouth, *Illustrations Specialist*

Al Morrow, *Design Assistant*

MANUFACTURING AND QUALITY MANAGEMENT

Christopher A. Liedel, *Chief Financial Officer*

Phillip L. Schlosser, *Vice President*

Chris Brown, *Technical Director*

Nicole Elliott, *Manager*

Rachel Faulise, *Manager*

The National Geographic Society is one of the world's largest nonprofit scientific and educational organizations. Founded in 1888 to "increase and diffuse geographic knowledge," the Society works to inspire people to care about the planet. It reaches more than 325 million people worldwide each month through its official journal, *National Geographic,* and other magazines; National Geographic Channel; television documentaries; music; radio; films; books; DVDs; maps; exhibitions; school publishing programs; interactive media; and merchandise. National Geographic has funded more than 9,000 scientific research, conservation and exploration projects and supports an education program combating geographic illiteracy. For more information, visit nationalgeographic.com.

For more information, please call 1-800-NGS LINE (647-5463) or write to the following address:

National Geographic Society
1145 17th Street N.W.
Washington, D.C. 20036-4688 U.S.A.

Visit us online at www.nationalgeographic.com

For information about special discounts for bulk purchases, please contact National Geographic Books Special Sales: ngspecsales@ngs.org

For rights or permissions inquiries, please contact National Geographic Books Subsidiary Rights: ngbookrights@ngs.org

Library of Congress Cataloging-in-Publication Data
Burnett, David, 1946-
 44 days : Iran and the remaking of the world / by David Burnett ; edited by Robert Pledge and Jacques Menasche.
 p. cm.
 ISBN: 978-1-4262-0513-2
 1. Iran—History—Revolution, 1979—Pictorial works. I. Pledge, Robert. II. Menasche, Jacques, 1964- III. title. IV. Title: Forty-four days.
 DS318.81.B87 2009
 955.05 '4—dc22
 2009012741
Printed in China

09/RRDS/1